# Performing Identity/ Performing Culture

# Intersections
# in Communications
# and Culture

Global Approaches and Transdisciplinary Perspectives

Cameron McCarthy and Angharad N. Valdivia
*General Editors*

Vol. 1

PETER LANG
New York • Washington, D.C./Baltimore • Bern
Frankfurt am Main • Berlin • Brussels • Vienna • Oxford

Greg Dimitriadis

# Performing Identity/ Performing Culture

## Hip Hop as Text, Pedagogy, and Lived Practice

## Revised Edition

PETER LANG
New York • Washington, D.C./Baltimore • Bern
Frankfurt am Main • Berlin • Brussels • Vienna • Oxford

**Library of Congress Cataloging-in-Publication Data**

Dimitriadis, Greg.
Performing identity/performing culture: hip hop as text,
pedagogy, and lived practice / Greg Dimitriadis. — Rev. ed.
p. cm. — (Intersections in communications and culture; vol. 1)
Includes bibliographical references and index.
1. African American youth—Social life and customs.
2. African American youth—Social conditions. 3. Hip-hop.
4. Rap (Music)—Social aspects. 5. Performance art—Social aspects—United States.
6. African American youth—Education. 7. Performance—
Social aspects—United States. I. Title.
E185.86.D55   305.2350896'073—dc22   2008042724
ISBN 978-1-4331-0538-8
ISSN 1528-610X

Bibliographic information published by **Die Deutsche Bibliothek**.
**Die Deutsche Bibliothek** lists this publication in the "Deutsche
Nationalbibliografie"; detailed bibliographic data is available
on the Internet at http://dnb.ddb.de/.

Cover design by Clear Point Designs

The paper in this book meets the guidelines for permanence and durability
of the Committee on Production Guidelines for Book Longevity
of the Council of Library Resources.

© 2009 Peter Lang Publishing, Inc., New York
29 Broadway, 18th floor, New York, NY 10006
www.peterlang.com

Printed in the United States of America

# CONTENTS

# ACKNOWLEDGMENTS

It is my great fortune to acknowledge here, publicly, all those involved in seeing this book from inception to completion. This book began as an independent study at Boston College during the 1991–1992 school year. The late William Youngren—an English professor who taught courses on jazz—agreed to work with me for a semester of independent study credit during my senior year. When it became clear that our work was not going to be done in a single semester, he agreed to two. He told me I was asking questions that would take a lifetime to answer. I didn't believe him. I do now. I greatly appreciate his early faith in me and encouragement toward my work.

The following year I tried turning my various papers and essays on rap into a book. The book never materialized, but I had the great fortune to work with a book agent, John Wright, who gave me invaluable advice on the writing process that continues to serve me well. I thank him wholeheartedly. Like many failed popular writers, I retreated to the academy (SUNY at Buffalo)—first, to earn a master's degree in English; then, a master's degree in American studies. In English, Bill Fischer was a great source of encouragement. Bill helped me make links between music and literature that would prove critical in developing and extending my own already established predilection for interdisciplinary work. While in American studies, I had the profound pleasure of working with Charlie Keil. Charlie's deep vision for life, for music, for what academic work might be

brought me through a difficult period in my life and provided me with a lifetime of inspiration. I still turn to *Urban Blues*, *Tiv Song*, and *Music Grooves* when I'm in need of emotional, intellectual, or political sustenance.

I earned a Ph.D. degree in speech communication at the University of Illinois at Urbana-Champaign in 1999. My advisor, George Kamberelis, went above and beyond the call of duty in helping me to develop the ethnographic dimensions of this work on rap and to begin to address pedagogical questions and concerns. George attended many of the focus group sessions described here and read countless drafts of papers, articles, and dissertation chapters, always providing incredibly perceptive and helpful feedback. George is, quite simply, the model of a mentor. I owe an incalculable debt as well to my dissertation chair, frequent coauthor, and now book series coeditor (along with Angharad Valdivia), Cameron McCarthy. Cameron's astounding imagination, his expansive social and pedagogical vision, his generous spirit and artful prose have all been integral to my self-fashioning as an academic and as a writer. I look forward to many more productive collaborations and dialogues with him. I also owe a tremendous debt to my dissertation committee members, Norman Denzin and Peggy Miller. Norman's clarity of mind, creative spirit, and overwhelming work ethic were and are sources of inspiration. Finally, while I was working in the interstices of education, communication, and psychology, Peggy's poignant and often deceptively understated suggestions about my work proved invaluable at key moments time and again. Friends and fellow graduate students who provided critical feedback include Steve Bailey (who also read a full draft of this second edition), Grace Giorgio, Carrie Rentschler, and Jonathan Sterne.

I am now back at what was formerly SUNY at Buffalo—now the University at Buffalo, The State University of New York—as a professor in the Department of Educational Leadership and Policy. I have worked here under what could scarcely be more encouraging or enabling circumstances. I would like to thank all my colleagues and students, but especially Lois Weis. I thank, as well, all those involved in the first and second editions of this book at Peter Lang, including Bernadette Shade. I would especially like to thank Chris Myers for encouraging this new edition.

I would also like to thank all the young people and staff members at the community center where the majority of this research was conducted. In particular, Tony and Rufus, whom you will read about in chapter 3, opened their lives and hearts to me in ways difficult to repay. It has been a pleasure and privilege to be a part of their lives. In addition, the staff members I call Bill and

(most especially) Johnny were the best teachers I had outside of school. I hope they find this book worthy of their faith and investments in me.

Finally, I offer profound thanks to my whole family. I especially thank my mother, Marie Dimitriadis; my father, James Dimitriadis; my sister, Christina Dimitriadis; my godfather, John Dimitriadis; and my goddaughter, Naomi Venizelos. I thank as well my uncle, the late Constantine Comas, and his wife, my Aunt Teresa. I also thank my late grandfather, George Dimitriadis; my grandmother, Mary Dimitriadis; and my late grandparents, Alexia and Frank Comas.

Chapter 1 draws on concerns first developed in *Popular Music*, 15(2) and *Text and Performance Quarterly*, 19(4). A different version of chapter 2 appears in *Cultural Studies/Critical Methodologies*, 1(1). A different version of chapter 3 appears in *Anthropology and Education Quarterly*, 32(1). A different version of chapter 4 appears in *Theory and Research in Social Education*, 28(1). Finally, chapter 5 elaborates on concerns I first developed with George Kamberelis in the collection *Sound Identities: Popular Music and the Cultural Politics of Education* (Peter Lang), edited by Cameron McCarthy and colleagues. Though written in the first person, chapter 5 reflects an extension of these ideas; George is listed as my coauthor here.

Please note, as well, that names and some identifying characteristics have been changed throughout.

# PREFACE TO THE SECOND EDITION

**I**

Hip hop has all but defined our contemporary cultural landscape in the United States and around the world. Indeed, hip hop has permeated all aspects of our collective lives—from everyday language and fashion, to music and dance, to advertising and commerce, to sports, to local, national, and global discussions around the politics of class, gender, race, and sexuality. As many among the so-called hip hop generation (those born between 1965 and 1984) enter early adulthood and middle age, hip hop is no longer solely a "youth culture" (though youth remain primary; Kitwana, 2002). The teachers and researchers, business-people and politicians, parents and children who now constitute our citizenry have grown up with hip hop as a dominant cultural fact. These are rich and poor men and women who identify across the racial, ethnic, and international spectrum. Hip hop is as pervasive today, it seems, as the air we breathe.

Hip hop album sales, however, have been plummeting—at a faster rate than those of other genres in an industry marked by rapidly declining sales. In 1999, *Time* magazine reported that hip hop was the top-selling music genre in the United States, with 81 million CDs sold (Farley, 1999). Eight years later, that figure had decreased by 44%—and it is falling still. Like any seeming crisis, this

one has been marked by much finger pointing—from the rise of illegal music downloading, to the music's relentless focus on sex, violence, and money, to the corporate take-over of a once seemingly authentic culture, to the rise of (free) mix-tape culture. For many, this signals hip hop's waning influence on youth. I disagree. If nothing else, rap music and hip hop culture have continued to act as "foot soldiers" for the material, technological, and cultural shifts which so mark our moment (Willis, 2003). As Henry Jenkins (2006) argues in *Convergence Culture*, entertainment can no longer be located in one media platform alone (whether CDs, videos, films, video games, the Internet, or cell phones). Young people today (still very much hip hop's consumer base) are working across these media forms and platforms in new and intriguing ways. So, for example, as *XXL* magazine reported, seven of AT&T's ten top-selling ring tones in 2007 were based on hip hop songs (Ex, 2008). While many decry this as part of the art form's creative decline, it underscores one persistent fact: When a new articulation of different media forms come along together (here, the combination of mobile phones and music), hip hop seems to be there first to exploit its potential. Among other places, one can see this in the proliferation of YouTube videos, straight-to-DVD movies featuring hip hop artists, and MySpace pages managed by rappers and labels. As the compact disc format continues to recede in the popular imagination, hip hop is the first to fill the space it has vacated.

While the industry is changing, it is important to note that hip hop continues to be an astoundingly creative outlet. Even a cursory glance at the contemporary scene reveals a wide and diverse array of talent, much of which operates outside of traditional industry circuits. Indeed, perhaps the most prolific and important artist working today is Lil' Wayne. Although he is signed to a major label, Wayne has thrived on a seemingly endless stream of guest verses on rap songs and a steady stream of mix tapes. Mix tapes are quasi-legal compilations of artists' verses compiled by DJs and circulated outside of official commercial circuits. In theory, they are used to promote artists (i.e., they are for promotional use only), and so they are often given away or copied or downloaded from the Internet. They are made either with or without the consent of artists and are often used to test out verses or songs that may appear on official albums or artists who may release a full-length CD. Because mix tapes are released for free (most often, in fact, as CDs or MP3 files), they often feature music samples not cleared through official copyright channels. Rappers often rhyme over competitors' songs or beats—"jacking beats," as Ice Cube put it more than a decade ago.

No one has used (or been used by) this medium more effectively than Wayne, who has appeared, perhaps most notably, on the collections *The Drought Is Over* (volumes 1–5), *Dedication* (volumes 1–2), and *The Greatest Rapper Alive* (volumes 1–5), among others. Wayne's endless, innovative verses attest to the continuing vitality of hip hop. In fact, *Vibe* magazine recently published an article entitled "The 77 Best Lil' Wayne Songs of 2007" (Fennessey, 2007)— many of which were unofficial releases. When his studio album *The Carter III* was released in 2008, it went platinum (1 million–plus sales) its first week—an astounding feat for an album today.

This de-centering of the traditional music industry highlights a consistent fact: Hip hop has always been about more than music alone. As a 2008 article in the *Journal of Business Research* asserted, "Hip-hop culture influences styles of behavior and dress: from sagging pants to oversized tees, hip hop style is an important business venture for not only the recording industry, but also clothing, fashion, accessories and beauty industries worldwide" (Motley & Henderson, 2008, p. 243). This has been an axiom for some time now. Witness the increasing prevalence of rappers branding a range of products—from clothes to shoes to alcohol to bottled water. For example, rapper 50 Cent has launched a successful G-Unit clothing line, a brand of Reebok sneakers, a video game (*50 Cent: Bulletproof*), a vitamin water drink (Glacéau), and a movie based on his life (*Get Rich or Die Tryin'*). Artists Jay-Z, Damon Dash, and The Game, among others, have pursued similar ventures. In fact, artists such as P Diddy (formerly Puff Daddy) are better known for their ancillary products and activities—in his case, the Sean John clothing line and the *Making the Band* television show—than for their music. Hip hop is truly a lifestyle, and it reaches around the world.

## II

Hip hop, then, remains entirely relevant for people young and older, people in the United States and around the world. I conducted the empirical ethnographic research for *Performing Identity/Performing Culture: Hip Hop as Text, Pedagogy, and Lived Practice* during the mid- to late 1990s and published the first edition early in 2001. Much has remained the same since then. Much has changed. I will open this second edition with some thoughts on the state of hip hop scholarship today and by re-situating this text against these contemporary currents.

The impulse behind *Performing Identity/Performing Culture* was largely ethnographic. The goal was to document the ways young people connected with and made sense out of these "texts" (broadly defined to include music, film, videos, etc.) in ways that helped them understand themselves, their social networks, and the world around them. While this work resonated most clearly with those in the field of education, I originally conceived it as a fairly straight-forward media audience analysis—one very much in line with those of Janice Radway (1984), Ian Ang (1985), Henry Jenkins (1992), John Fiske (1987), David Morley (1980), and others. For more than two decades, such work had struggled to place the audience front and center stage—to de-center the authors' own interpretations of these media texts. I wanted to bring this work to the then very underexplored area of hip hop—a music I had been listening to and looking closely at, in various ways, since the mid-1980s.

*Performing Identity/Performing Culture* remains one of a very few ethnographies of young people and hip hop. It remains one of still fewer books which take up these questions in the United States. On first blush, this might seem paradoxical. After all, hip hop has been and remains an art form rooted largely (but not exclusively) in the experiences and histories of African Americans in the United States. To date, however, the ethnographic focus has largely been outside the United States—in countries such as Japan (Condry, 2006), New Zealand (Mitchell, 2001), South Africa (Dolby, 2001), Germany (Tempelton, 2006), and Canada (Lashua, 2005). In many ways, this makes a good deal of sense. The uptake of hip hop around the world is intriguing—marked, as it has been, by a continuous assertion of the local. That is, as hip hop has circulated around the world, it has become a vehicle for disenfranchised youth to articulate their own local needs and concerns. So, for example, we see indigenous youth in Alberta attempting to complicate and negotiate their particular "urban" reality through hip hop while asserting the particular concerns of First Nations people. One sees a similar phenomenon around the world, from Arab youth in the *banlieues* of Paris, France, to Afro-Germans in Berlin, Germany, to Maori and Pacific Islander youth in New Zealand. It has raised a set of questions which have intrigued a new generation of scholars in education, sociology, anthropology, and other disciplines. The results of this work on hip hop around the world are impressive.

There is no comparable body of ethnographic work in the United States, where scholars have yet to see hip hop, broadly, as producing a set of questions about everyday life that need rigorous empirical investigation. The first generation of scholars have positioned themselves, in some respects, as "insiders"

within the culture. One sees more here in the way of historically inflected social commentary, as in the profoundly important work of scholars such as Michael Dyson (2002), Bakari Kitwana (2002), and Jeff Chang (2005). Their work raises critical questions. In particular, Kitwana's *The Hip Hop Generation* has set the agenda for a new generation of scholars wrestling with hip hop's role in a post–civil rights form of politics, one that cannot rely on the racial or political certainties of earlier generations. Kitwana argues that the "hip hop generation" faces a new set of crises—"high rates of suicide and imprisonment, police brutality, the generation gap, the war of the sexes, Blacks selling Black self-hatred as entertainment, among others" (2002, p. xi). Kitwana uses hip hop to "jump start the dialogue necessary to change our current course" (p. xxii). While this is, of course, a critical move (Kitwana's book has deservedly become a classic in the field), the absence of young people is noticeable. Indeed, scholars in the United States—particularly scholars of color—have worked from positions of apparent expertise about the culture and the music and its audience. The kind of broad de-familiarization often associated with ethnographic work has not been taken up around hip hop in the United States.

There have been a few attempts at such ethnographic or empirical work in the field of education in the United States. For example, Ernest Morrell and colleagues including Jeffrey Duncan-Andrade have looked at the ways in which hip hop can be used as a "bridge" to more formal kinds of literacies and school-based subjects. While empirical and ethnographic, this work has largely held out a defined endpoint: school-based knowledge. So, for example, Morrell (2004, 2008) and Morrell and Duncan-Andrade (2002) have looked at the ways in which hip hop can be used to connect young people to more traditional texts and literatures—in this case, Romantic and Elizabethan poetry. As Morrell points out, such work in "critical literacy" "is not insignificant to…academic literacy development. Two of the key challenges the urban literacy educators face are disengagement from the work and the ability to access content. The critical focus is essential when dealing with both" (2008, p. 112). In turn, others scholars, such as David Stovall (2006), have looked at the ways radical hip hop artists can be used to politicize a social studies class. Stovall's goal is to use hip hop to connect youth to broader political and ideological struggles (as defined by the author). While critically important interventions, the impulse to understand the lives of young people has been circumscribed from the outset by this focus on school-based knowledge and other *a priori* outcomes. In this sense, such work has not relegated or given up control in the way that is often necessary for breakthrough forms of understanding.

There are some exceptions. For example, Marc Hill's *Beats, Rhymes, and Classroom Life* (in press) looks to understand in nuanced, ethnographic detail how young people negotiate their identities though hip hop. He does this remarkably well, showing how young people understand themselves and their social worlds though hip hop culture, and how these young people relate to him as a young African-American researcher/educator/hip hop listener. For example, Hill discusses the ways in which a 1995 song by The Notorious B.I.G., "Things Done Changed," became the platform for a complex intergenerational conversation about how things used to be in their neighborhoods. Hill highlights the role of nostalgia as it works across generations—for these young students, for him, for the white classroom teacher. Such a discussion allows us to (begin to) get past static notions of "the good old days," which remain remarkably durable across time, place, and generations. One gets a real sense of how identity is "worked through" around hip hop, the complex positioning and re-positioning around texts and between peoples. Such a discussion might allow a more fruitful dialogue about how young people see themselves and their communities, and how their collective pasts can inform their collective futures.

Nevertheless, what is happening in hip hop and, more to the point, between youth and hip hop remains an open question. In this sense, then, educators in the United States still have much work in front of them. The impulse to understand the lives of young people as they enter our classrooms is very much an unfulfilled one.

## III

Updating *Performing Identity/Performing Culture* seemed to be a necessary endeavor. Of course, both the excitement and the anxiety of dealing with popular culture and its audiences stem from the fact that the terrain changes so quickly. It is a testament to ethnographic work that the examples that emerged from discussion with my participants in the mid-1990s remain relevant today— as important a finding as any in retrospect. My participants anticipated the evolving terrain of hip hop in ways I could never have predicted, even with my extensive knowledge of the art form.

In chapter 3, I discussed Southern hip hop—a phenomena that has exploded in popularity since I did my research. I referenced an underground Memphis group, 666 Mafia, which has since changed its name to Three 6 Mafia and has gone on to win an Academy Award—the first for a black hip hop group—for

the song "It's Hard Out Here for a Pimp," from the soundtrack to the film *Hustle & Flow*. Southern hip hop flourished in the wake of the so-called East Coast/West Coast war of the mid-1990s. Regional scenes and artists in Atlanta, Georgia (e.g., T.I. and Outkast), Memphis, Tennessee (e.g., Eightball and MJG as well as Three 6 Mafia), and especially Houston, Texas (e.g., UGK, Scarface, Chamillionaire, Paul Wall, Slim Thug, Mike Jones), have proliferated in ways that have come to mark hip hop writ large. While the sounds are, of course, distinct, the narratives of struggle for survival, the musical influences of blues and gospel, the continuing assertion of dance and the body, and the displays of "ghetto fabulous" style (e.g., the restyling of cars) in the face of overwhelming poverty and racism have marked this movement. The South has, in many respects, come to define hip hop today.

In chapter 4, I discussed the ways young people "used" the film *Panther* (about the Black Panther Party for Self-Defense) to create a workable version of history. In particular, I stressed the ways young people connected this film to other popular cultural forms, including those around hip hop. While the proliferation of media forms and technologies has complicated this picture, young people are still very much co-embedding hip hop texts in other media forms. As Henry Jenkins (2006) notes, media forms no longer exist in isolation from each other; this "working across" has come to mark what he calls our contemporary "convergence culture." We see prefigured here the "leakiness" around texts—the ways *Panther* was connected to other films starring the same actors (*Menace II Society*, *Friday*), local gangs, professional wrestling, hip hop culture, young people's own social networks, and beyond. Revisiting this chapter, I argue, offers a useful corrective to the monadic approaches to popular culture and education which still very much mark the field—that is, the notion that one can study a single media text as disembedded from a range of other media forms and social relations. Paying attention to the ways in which young people "use" hip hop texts clearly explodes this monadic myth. That this chapter discusses how young people understand and deploy history makes this point all the more pressing, as young people are increasingly living in a media-saturated world with competing versions and visions of the past, present, and future.

In chapter 5, I discussed the discursive life, death, and rebirth of rapper Tupac Shakur. Some ten years after their deaths, Shakur and his East Coast rival The Notorious B.I.G. remain mythic figures. The passion these young people brought to understanding the contours of Shakur's life now stretches across generations, and it is far from exhausted. Interest in their lives and deaths has continued unabated for more than a decade and has been the subject of

numerous films and books. I note here the feature-length documentary *Tupac: Resurrection* (2003), as well as the numerous books which have tried to make sense out of Shakur's complex life (the most notable of which is Mike Dyson's *Holler If You Hear Me* [2002]). I note, as well, the biopic *Notorious*, about The Notorious B.I.G., set to be released in 2009. Of course, both rappers have also had several best-selling posthumous releases, including Tupac's *Better Dayz* and *Loyal to the Game* and Biggie's *Duets* and *Born Again*. Indeed, one cannot walk through an urban center in any part of the world today and *not* see a young person with either a Tupac or Biggie T-shirt or hear their music in a club or a car, or blaring out of an apartment window. Tupac, in particular, set the bar for a generation of rappers. Perhaps best-selling artist 50 Cent said it best when he rapped on his first album, "I want them to love me like they loved Pac!" The sentiment is broad and deep. The young people in my study give continuing insight into the power of these myths and the investment in these figures. I had the dubious "luck" to be able to trace this investment in Tupac while he was alive, when he was shot, and as the myths around him sprung up. Returning to this chapter today is instructive.

These empirical studies, again, speak to the ongoing power of such work— and clearly explode the myth that ethnographic work is too particular, too local, or too idiosyncratic to have broader resonance. Returning to these empirical studies nearly a decade later, of course, raises the specter of such concerns. Might hip hop's now global, all-pervasive, and permeating cultural reach render such local and particular studies irrelevant? Might the scale of hip hop today make such work seem disproportionately small? Nearly ten years later, this study speaks in fact to the exact opposite. These young people anticipated changes in hip hop I could not have predicted. Often arrogant assumptions about what count as macro- or large-scale interventions (e.g., sweeping critical commentary) as opposed to micro- or small-scale investigations (e.g., the experiences of particular young people in specific times and places) simply hold no explanatory power here. Reading the voices of these youth a decade later is quite sobering.

# IV

The point is worth reflecting upon. As I discuss throughout this book, hip hop has emerged as a critical out-of-school curriculum for young people in the United States and around the world. While critical "readings" of these texts

are important, they cannot serve as a substitute for empirical engagement with the particulars of young people's lives. The danger is a familiar one—that we as researchers, educators, or interested adults may inscribe our own agendas on the lives of youth. The danger is particularly acute for those of us who would bring these texts into classroom settings. The danger is that we may miss an extraordinary opportunity to re-engage with youth on fresh and largely unexplored terrain. That, it seems to me, is the promise of popular culture as an object of study: It forces us to rethink the ground upon which we stand.

This has become an increasingly vexing gesture since this book was first published. Growing, massive disparities in wealth, the rise of high-stakes testing, and the realignment of the global economy have, in some sense, made the place of the "truly disenfranchised" even more precarious. We live in a post-9/11, post-Iraq, post-America world—one which increasingly renders the lives of the poor superfluous (Zakaria, 2008). If young people used to "learn to labor," they now "learn to do time," as urban schools (in particular) have come to serve as fertile terrain for prisons—one of the very few growth industries (Nolan & Anyon, 2004; Nolan, 2007). Serious study of political economy has never been more pressing—more so, I think, than when I first wrote this book.

In the end, the young people in this study "used" these texts as vital resources for survival, in environments that were already extraordinarily precarious. These texts were not simply reflections of a pathological and dangerous cultural disposition—the kind of "nihilism" Cornel West wrote about in the early 1990s. They were ways for young people to mitigate the vulnerability they experienced in their everyday lives. Already, they alerted us to issues and problematics deeply entrenched in our urban centers—ones largely rendered invisible through textual analysis alone. Returning to and re-situating this study seems, here as well, quite valuable.

# PREFACE TO THE FIRST EDITION

School culture today has been overtaken by media culture broadly defined to include music, film, television, video games, and the Internet. All of these have provided models for self-fashioning that are more disparate and now more compelling than the ones offered in traditional schools and through traditional curricula. The coherence often assumed to be inherent in schools and school curricula has been replaced, I maintain, by an everyday reality suffused with these multiple, overlapping, and contradictory influences. School life has fragmented into disparate orbits as unpredictable processes of self-fashioning have occluded any and all fixed narratives of pedagogy among teachers, researchers, and policy makers alike. As such, understanding youth culture and school life today demands that we look past traditional disciplinary frameworks toward more interdisciplinary ones, including those offered in cultural studies and its iterations in applied disciplines such as communication and education. That this book is in the series "Intersections in Communications and Culture: Global Approaches and Transdisciplinary Perspectives," a series that "seeks to engage and transcend...disciplinary isolationism and genre confinement," seems wholly fitting.

Drawing together historical work on hip hop and rap music as well as four years of research at a local community center, *Performing Identity/Performing*

*Culture: Hip Hop as Text, Pedagogy, and Lived Practice* is an ethnography of young people's uses of popular texts. I argue here that contemporary youth are increasingly fashioning notions of self and community outside of school in ways that educators have largely ignored. As the Acknowledgments might imply, the road leading to this book has not been a particularly straight one. It has taken me through a failed attempt at writing a popular book on rap to two aborted attempts at doctoral degrees, one in English and one in American studies; to a degree in speech communication; and further, to a position in a Department of Educational Leadership and Policy (in the sociology of education concentration). While the trajectory has been (at best) hazy at times, what has been very clear to me all along is the overarching though often dismissed power, importance, and relevance of contemporary popular culture. To use some perhaps antiquated language, "popular" or "unofficial" culture has always seemed more vital and important to me than the "high" or "official" culture typically sanctioned in dominant institutions such as schools.

Guided by this belief in the power of the popular, this project took nascent shape during the late 1980s and early 1990s—my late teen and early adult years, as the conservative assault on the public sphere rapidly reached a devastating climax. During this period, an already existing schism between "in school" and "out of school" culture grew, with unofficial curricula (e.g., rap music, film) and learning settings (e.g., community centers, churches) taking on increasing salience in the lives of the young. During this period, hip hop emerged against all logic and against all odds as the preeminent expressive form for contemporary youth. Periodic declarations of its "death" have all proved false and, as I write this in the year 2000, hip hop shows no sign of abdicating its place in the popular imagination.

If nothing else, hip hop's phenomenal commercial success speaks to the urgency with which youth from across economic, ethnic, and racial spectra are trying to define and redefine themselves in the face of massive and ever-present uncertainties about identity—uncertainties exacerbated in this particular historical moment by globalization and its multiple effects. This uncertainty is evidenced wholly by the massive crossover of hip hop from cities to suburbs in the United States to cities and suburbs around the world and back again. This dynamic circulation of expressive forms marks youth culture today as an exciting and unpredictable space, one which exceeds the stable and predictive categories teachers and researchers have to talk about it. It highlights, as well, all the ways in which young people are fashioning themselves with resources broader and more disparate than those currently offered in schools.

Yet, to echo George Lipsitz (1996), popular culture represents a kind of "dangerous crossroads," one with enormous possibilities as well as grave dangers. Indeed, while expressive forms are circulating between youth in unprecedented ways today, popular culture has never been more clearly divided along racial lines. What counts as "black" music and culture (e.g., rap) and what counts as "white" music and culture (e.g., county and western) has never been more clearly defined. While there has been a burgeoning and dynamic dialogue across ethnic and racial difference, inequities have grown exponentially, sharply dividing citizens materially and geographically in unconscionable ways.

Contemporary black popular culture speaks both to a profound faith in the deep and abiding links that draw us together and to the sharp and decisive schisms that simply cannot be wished away in the ecstasy of the local embrace. These dynamics are exceedingly complex. We face a cultural landscape that does not make sense in old ways or with old frameworks—making the study of black popular culture an incredibly challenging endeavor. My own efforts to find a framework to understand this music and related social phenomena took me through approaches that focused too narrowly on texts and too broadly on context, to the undefined space of cultural studies and applied disciplines such as education and communication. I have drawn selectively from these disciplines as well as related ones, including performance studies, ethnomusicology, sociology, anthropology, and media studies. Throughout, I have stayed focused on the importance of popular culture in the lives of the young—an issue educators ignore at the risk of their continued efficacy.

# INTRODUCTION

Hip hop culture originated during the mid-1970s as an integrated series of live community-based practices. It remained a function of live practice and performance for a number of years, exclusive to those who gathered together along New York City blocks, in parks, and in select clubs such as the now-famous Harlem World or T-Connection. Early MCs (or "rappers") and DJs, graffiti artists, and breakdancers forged a scene entirely dependent on face-to-face social contact and interaction. Indeed, the event itself, as an amalgam of dance, dress, art, and music, was intrinsic to hip hop culture during these years. As one might expect, the art's earliest years went largely unrecorded and undocumented. In 1979, however, Sugarhill Records, a small label in New Jersey, released a single entitled "Rapper's Delight." It was an unexpected event for many of hip hop's original proponents, those pioneers immersed in the art's early live scene. Grandmaster Flash comments:

> I was approached in '77. A gentleman walked up to me and said, "We can put what you're doing on record." I would have to admit that I was blind. I didn't think that somebody else would want to hear a record re-recorded onto another record with talking on it. I didn't think it would reach the masses like that. I didn't see it. I knew of all the crews that had any sort of juice and power, or that was drawing crowds. So here it is two years later, and I hear "To the hip-hop, to the bang to the boogie," and it's not Bam, Herc, Breakout, AJ. Who is this? (Quoted in George, 1993, p. 49)

Many of those who were a part of early hip hop were also puzzled, asking similar questions. This all-but-unknown group, the Sugarhill Gang, was not a part of the early hip hop scene in any real sense, as Grandmaster Flash makes clear. "Rapper's Delight" ruptured the art form's sense of continuity as a live practice known to all its "in-group" members—largely poor, black and Latino youth in ghettoized urban areas like Harlem, New York. This rupture was a defining one for hip hop as it came to mark the art's entrance into the public sphere of worldwide cultural discourse, where it has remained ever since. The decentralized face-to-face dynamic that marked early hip hop has thus given way to a different dynamic, one mediated through commodity forms and media such as vinyl, video, film, CD—and now MP3s and the Internet. These configurations have separated hip hop's vocal discourse (i.e., rap) from its early contexts of communal production, encouraging closed narrative forms over flexible word-play and promoting privatized listening over community dance. This shift toward in-studio production has affected the art in a number of crucial ways, especially by redefining hip hop culture by and through the relatively narrower and more easily appropriated idiom of rap music. In turn, rap music has become a constitutive part of black popular culture as well as American popular culture more generally. As *Time* magazine reported in 1999, we live in a "Hip Hop Nation" (Farley, 1999). One would be hard pressed to dispute hip hop's ubiquity today—dispersed, as it is, by and through a range of commodity forms.

Accordingly, the term "text," which I will use throughout, indexes a wide range of overlapping cultural productions—from films like *Juice* (1992), to the ubiquitous rap videos shown regularly on television and the Internet, to rap songs on vinyl, CDs, MP3 downloads, and mix tapes, to the mythologized biographies of individuals like Tupac Shakur and Biggie Smalls. For many young people today, as will be clear by the end of this book, these cultural productions are inextricably linked. For example, for the young people with whom I worked, it would be all but impossible to separate the recordings of Tupac Shakur from his films (such as *Juice*) or from the details of his life, documented off-the-record in magazines, on the Internet, and elsewhere. All are of a piece.

Concomitant with this redefinition and commodification of hip hop, it is critical to note that rap texts have been made available to broader communities of participants, who use them in often unpredictable ways. As I will indicate throughout this book, young people today are using these texts to construct locally validated selves and senses of community, linked to shared notions of what it means to be black and marginalized in the Unites States and around

the world. In some sense, we see fully realized the dynamic Walter Benjamin prophesied in "The Work of Art in the Age of Mechanical Reproduction" (1968; original German version published in 1936). In this classic essay, Benjamin discussed how the mass reproduction of artworks both robbed them of their particular, near-mystic "auras" and opened them to wider and more dispersed audiences. In a similar fashion, early hip hop performances were unique events, available only to participants and accessed only through participation. The art's aura, its ritual-function so to speak, was a strong and defining one. Yet, with hip hop's movement into commodity form and commodity culture, this aura evaporated. Rap texts became available to anyone, anywhere, to be put to multiple—virtually limitless—uses. These texts have become part of the "performances of the everyday," deployed moment-to-moment in multiple contexts of use, by often intensely disaffected young people.

Thus, it seems fitting if paradoxical that I, growing up in New York City during the 1970s and 1980s and now recalling ubiquitous talk about early hip hop parties and shows as well as flyers for such "jams" up around my junior high school, had to travel, some 15 years later, to a small Midwest city to understand the importance of rap texts in the imagination of the young and disenfranchised. Though I had already written a series of historical and textual studies that looked at rap music's evolution in historical and social context (e.g., Dimitriadis, 1996, 1999a), I became interested, following work in communication, cultural studies, and education, in how young people actually used these texts to understand themselves and the world around them. I began conducting focus groups and interviews about rap music in the spring of 1996 at a local community center that served an almost wholly black and poor population. Here I saw a range of youth—from children as young as 7 to teenagers as old as 18—suffused in a culture that I had accessed through similar popular texts, though in distinctly different ways. As such, this book is a record of my overarching effort to draw together textual analyses of rap music with more nuanced ethnographic treatments of how such young people used these texts in their lives. These texts included the hardcore "gangster rap" recordings of artists like Eightball and MJG and Master P, contemporary black films such as *Panther* (1995), and the lives and works of rap icons like Tupac Shakur. I saw these texts put to myriad uses by these young people in their daily lives, in ways that wholly exceeded my predictive powers.

I recall here the dramatic events surrounding the death of rapper Tupac Shakur in Las Vegas late in 1996—his shooting on September 7, his death six days later, and the work these young people did in "resurrecting" him, through

myth, over the next year or so (when such talk was most common). As I will demonstrate more clearly in chapter 5, these young people were devastated by the loss of Tupac (or 2Pac or Pac). I was at the community center the night he expired from his mortal wounds (September 13) and was witness to the feelings of outrage and grief, devastation and loss that many immediately felt. Young children cried; older teens were enraged; virtually all stayed glued to BET (Black Entertainment Television) to watch the unfolding events. This grief, however, soon changed in the days and weeks following to elaborately constructed rumors about Tupac's complicity in faking his death. These stories, circulating across the nation and around the world, on the Internet and television and in daily talk, differed in their details but were similar in constructing Tupac as the prime mover in these events. One young person commented: "I think Tupac got set up. They shot him but he survived. But then nobody knew he survived, 'cause I think he probably, say like during the night he, he had snuck out...he, he had started feeling better and snuck out." He continued, noting how Tupac was caught and was now in jail: "They got him on some top security. They know...Tupac's smart, he can deal some schemes, try to get out and stuff, but they got him on top security." The stress on both Tupac's physical invulnerability ("they shot him but he survived") and his mental acumen ("Tupac's smart, he can deal some schemes") marked many such stories.

As one might imagine, I never believed such stories to be true, and I said so (albeit playfully) often. Indeed, when one young girl told me that Tupac was really alive, that a doctor had admitted to faking the death certificate, I asked immediately why the story wasn't being picked up by the popular media the same way his shooting had been; or, as I ineptly put it, "If he were really alive, wouldn't we know?"—to which she responded, matter-of-factly, "We do." Clearly, an interpretive gulf existed between me and these young people, one I came to see in time and with experience as speaking to the intense vulnerability many young people felt with respect to the vicissitudes of daily life, their need for a figure who could resist overt and more subtle injuries. As I will demonstrate later, Tupac was as capable of delivering a tender ode to his mother (i.e., "Dear Mama") as he was of spitting out a brutal invective aimed at his rivals (i.e., "Hit 'Em Up"). Tupac spoke to the needs of these young people (from small children to older teenagers) in powerful and often paradoxical ways to which I did not have ready access. I was surprised, again, some six months later, when Tupac's rival Biggie Smalls (or The Notorious B.I.G.) was killed and no such rumors circulated, although they plainly could

have. In fact, Small's last album, finished while he was still alive, was titled *Life After Death*.

The uses to which these texts were put never ceased to surprise me, a fact of course underscored by my position as a white person in a nearly all-black setting (a theme I will pick up in chapter 3). I recall the fall of 1997, when the Ku Klux Klan, fresh from a march in a nearby city, proposed a controversial rally in the city where I conducted this research. Though I knew the Klan more than capable of horrific acts of violence, I certainly did not think any of the younger people at the club were in any immediate danger, and I was not, strictly speaking, afraid of the group. However, the intense fears and anxieties of these young people (especially young children and adolescents) soon became apparent. I remember sitting at the front desk of this community center with the unit director, signing young people in, the day the news hit. As soon became clear, these young people were literally unsure whether the Klan would come to their houses, attack them in the streets, or follow them home to hurt their families. All the ways that violence (or the threat of violence) can completely overtake and disorient us became exceedingly apparent quite quickly.

In the immediacies of this moment, my adolescent participants turned to *Panther* (1995), a film about the Black Panther Party for Self-Defense. As became evident in several focus groups devoted to films about black history, the highly charged, action-filled *Panther* spoke to these young people and their very compelling fears in ways that films like *Malcolm X* (1992), a true story about the killed Nation of Islam leader, and *Rosewood* (1997), about the violent extermination of an all-black town early in the twentieth century, did not. *Panther*, a Hollywood endeavor, was "real" to these young people—more real, in fact, than the PBS *Eyes on the Prize* documentary about the group, which I showed as well. This film conjured up a useful kind of reality in ways mediated and complicated by a whole host of specific factors and forces that I could not have predicted *a priori*.

In particular, these young people made intertextual links between this film and others (nonhistorical ones) that featured the same actors—films like *Menace II Society* (1993), *Friday* (1995), and *Jason's Lyric* (1994); they made connections between the Black Panthers, their own friendship networks (or "cliques"), modern-day gangs like Black P-Stone, and such wildly successful professional wrestling associations as the New World Order (NWO); they gelled around the movie's violent scenes while they ignored those with a lot of talking ("the boring parts"); and, finally, they drew upon their own local knowledge and experiences

to connect with and comment on the film's antipolice subtext. These were the situated, contextual factors that mediated their understanding of black history, that made *Panther* "real," that allowed them to deal in specific ways with events that unfolded in 1997 in this city.

The research described above—which will be detailed in chapters 4 and 5—was conducted by way of small focus groups most often composed of friends. This research highlighted the unpredictability and specificity of how young people in local social networks used such texts. Even more revealing, however, was the more intensive one-on-one work that took me more directly into the lives of teens in less circumscribed ways. Indeed, of all my work over that four-year period, no part was more revealing than the story of Tony and Rufus and their uses of Southern rap. As I will demonstrate in chapter 3, in the popular imagination about black teenagers, Tony and Rufus followed the only two available paths: One (Rufus) was "good," while the other (Tony) was "bad." Over the years I knew them, Rufus by and large stayed out of trouble and stuck close to the community center and its staff members. He was well liked by everyone with whom he came into contact and received a number of awards at the center. Tony had a less sanguine life. He had numerous discipline problems at school and with the law throughout his life, and he was a member of a local chapter of a national gang. When I first met the pair, they referred to each other as "cousins," though they were in fact best friends. Tony and Rufus spent their earliest years in the same small Mississippi town, and both had made the trip to the city where I conducted this research about a decade earlier. As I will demonstrate, these teens recreated notions of the South—specifically, a sense of community—in this city by using popular cultural resources which linked them to important familial networks in their new home as well as "down South."

Yet, of even more importance, each of these teens lived through this reality differently. As I will show in chapter 3, for Rufus being Southern meant enacting a kind of ethic of egalitarianism—giving oneself over to others in selfless ways. For Tony, however, being Southern was very much linked to a sense of personal respect that had to be sustained and maintained at all costs—even violently. These teens thus created or performed notions of community in distinct and specific ways, ways that had always to be maintained and sustained in the face of multiple threatening contingencies. Understanding their story made it quite clear to me that reception practices were unpredictable and became more so when moving from social networks to individual biographies. This insight was central to this research and is a central theme of this book.

# Some Approaches to Popular Culture and Critical Pedagogy

Thus, I highlight throughout this book the ways these young people in my study construct, sustain, and maintain notions of self, history, and community through popular cultural texts. These texts are circulating in a space vacated by traditional schooling institutions and curricula, both of which have become more and more routinized, increasingly at the service of corporate imperatives and out of touch with the particular concerns of young people (Apple, 1993). As Michael Apple, Henry Giroux, and Cameron McCarthy, among others, have made so very clear, schools today do not speak to the needs and interests of often intensely disaffected young people. "At the local, state, and national levels," Apple writes, "movements for strict accountability systems, competency-based education and testing, management by objectives, a truncated vision of the 'basics,' mandated curricular context and goals, and so on are clear and growing" (1993, pp. 121–122).

These movements reached a devastating crescendo in 2001 with the passage of the No Child Left Behind legislation. The effects of this legislation have been broad and deep—including the attenuation of curricula, in terms both of substance and of pedagogical practice—though they have been particularly profound for the most vulnerable of public schools. At the most basic level, a corporate language has overtaken school discourse, a language that implies clear inputs and outputs, assessments and measurements that can be correlated and compared across disparate sites. Knowledge itself has come to be treated like a perfectly transparent commodity, one that can be dispensed independent of particular actors and context.

These logics have had a profound impact on everyday life in schools. In particular, we see a constant pressure to "teach to the test"—to "hit the numbers" in business terms. Indeed, both anecdotal evidence and current research tell us that teachers are more and more altering their pedagogical practice with a sharp eye toward these tests. On one level, this is evidenced by the amount of time now devoted to testing in school. As Gail Jones, Brett Jones, and Tracy Hargrove discuss in a recent study of North Carolina schools, 80% of elementary school teachers said they spend more than 20% of their teaching time preparing for high-stakes tests; 28% said they spend more than 60% of their time on such tests; and 71% said they spend more time on these tests than they did three years earlier (2003, p. 64). On another level, this stress on tests is evidenced by the kinds of teaching practices encouraged by high-stakes tests.

These include, in particular, "item teaching," or the narrow focus on teaching items identical or similar to the ones on high-stakes tests. As the authors note, "the problem with item teaching is that students learn the knowledge and skills tested, but not the other knowledge and skills in the domain" (p. 66).

These imperatives have left little room for educators to creatively and humbly attempt to engage the complex lives of young people. As a result, a schism has grown between in-school and out-of-school culture, with unofficial curricula (e.g., rap music, film) and learning settings (e.g., community centers, churches) taking on increasing salience. Indeed, as several authors, including Steven Johnson (2006) and Henry Jenkins (2006), have recently argued, popular culture itself has become a more complex space, demanding increasing cognitive "work" on the part of so-called consumers. In short, as school curricula are increasingly narrowed and codified, young people are turning elsewhere for a relevant education. This book, above all else, will serve as a testimony to what I see as this incontrovertible reality.

I am not alone here. Critical pedagogues have begun to bridge this schism, looking more closely at the implications of popular culture for education, traditionally defined. Two approaches have tended to dominate in this relatively new area of study. First, critical pedagogues, including Henry Giroux, argue that media and popular culture play important roles in young people's lives and must be explored as a kind of alternative "lived" curriculum. Yet, as with much curriculum history and theory, textual analysis has reigned supreme here, and much of it simply demonstrates how these texts reproduce dominant cultural imperatives, while assuming high levels of predictability from text to subject. For Giroux (1996) and others, we can "read" popular texts such as *Menace II Society* and *Boyz N the Hood* to understand more clearly how young people are being demonized in popular culture. He writes:

> Recent films focusing on black urban violence, such as *Boyz N the Hood* (1991), *Juice* (1992), *Menace II Society* (1993), *Sugar Hill* (1994), *Fresh* (1994), and *New Jersey Drive* (1995) have attracted national media coverage because they do not simply represent contemporary urban realities but also reinforce the popular perception that everyday urban life and violent crime mutually define each other. Cinema appears to be providing a new language and aesthetic in which the city becomes the central site for social disorder and violence, and black youth in particular become agents of crime, pathology, and moral decay. (1996, pp. 55–56)

On the logic of such readings, these texts create the image of young people as without complexity, as one-dimensional and evil; indeed, they can play into

conservative and ultimately debilitating agendas. We see similar approaches from a range of critics working in cultural studies, media studies, and education today, all of whom foreground textual analysis and background young people and their messy and unpredictable relationships to and with popular texts (Kellner, 1995; Steinberg & Kincheloe, 1997, 2004).

Giroux and other critical pedagogues, including Kenneth Saltman and Lawrence Grossberg, have turned their attention, more recently, to the ways popular media forms have been implicated in the post-9/11 world of continual war, terror, and violence. As Giroux writes, "The new media often combine notions of violence and vulnerability, fear, and uncertainty with modern communication technologies that are changing the character and function of representations, the way everyday life is experienced, and even the conditions of politics itself" (2006, p. 20). For Giroux, today's spectacular "screen culture"—with its constant mind-numbing images of violence, terror, and war—has overwhelmed the quotidian life of young people around the world. Media today are very much a part of this broader militarization of society—including the corporatization and militarization of schools. Here, too, we see a stress on media texts and their implied impact on the lives of contemporary youth.

Second, there has been a growing and important body of ethnographic work on young people and their uses of popular culture that offers a powerful counter to the above. Much of this work has been celebratory, validating the kind of creativity and effort that young people invest in the nonelite arts. Paul Willis, a key early figure here, has documented the multiple uses to which young people put popular culture, or, as he writes, the "common culture" that young people create and sustain. Willis, for example, celebrates the ways that young people subvert dominant music and fashion industries by taping music from the radio for free and buying secondhand clothes and using them in exciting and interesting ways. He writes of this nexus between the media and common culture:

> The omnipresent cultural media of the electronic age provide a wide range of symbolic resources for, and are a powerful stimulant of, the symbolic work and creativity of young people. The media help to mediate the new possibilities of common culture. Time and again in our research we were brought back to the pervasiveness of the cultural media in youth experience. The media enter into virtually all of their very creative activities. But whilst the media invite certain interpretations, young people have not only learnt the codes, but have learnt to play with interpreting the codes, to reshape forms, to interrelate the media through their own grounded aesthetics. They add to and develop new meanings from given ones. (1990, p. 30)

Willis does much to highlight the work that young people invest in popular culture and the ways in which popular culture is occluding contemporary school culture for many.

This stress on the participatory nature of popular culture has been picked up and extended by many working in the realm of fandom research. Perhaps most notably, Henry Jenkins's notion of "textual poaching" (1992) has been extremely influential. By "textual poaching," Jenkins's highlights the ways fans "speak back" to key media texts, often reworking and re-inscribing them with their own local needs and concerns—hence, the proliferation of fan fiction that takes characters from, say, the *Star Trek* or *Star Wars* films and places them in new and often unfamiliar circumstances. More recently, scholars have challenged both the notion of what counts as a fan text and the traditional focus on single media platforms (Gray et al., 2007). Henry Jenkins's notion of "convergence culture" (2006)—the moving across different media platforms (from television to the Internet to cell phones, etc.)—has come to mark much of this work. As I will argue here and throughout, understanding these multiple, complex, and often contradictory forces is crucial if we are to understand the role of popular culture in the lives of young people. Yet, the young people in such work remain largely faceless. We have little sense of either particular life courses or valued, local social networks and the institutions young people traverse.

Though they are limited in key ways, both of these approaches have aided us enormously in understanding critical issues vis-à-vis youth and popular culture. Textual approaches have helped us understand more clearly how the lives of young people are circumscribed in and by popular cultural texts. However, this work assumes high levels of predictability from the text as deciphered by the critic to the lived lives of young people. Thus Giroux, in his brilliant readings of such films as *Menace II Society*, does not account for all the various ways that film might be mobilized by young black teens, nor does he account for all the ways personal biographies and local social networks (for example) can radically circumscribe how young people understand popular culture. This will be a central theme in this book, especially in chapter 3.

In turn, ethnographic approaches have given us a clearer picture of the uses to which young people put popular culture in their everyday lives. Yet, this work is often uncritical of the limits inherent in the resources young people draw on here. Thus, in the quote above, Willis implies the limitless uses to which these texts can be put without asking, so clearly, what effects these texts in fact have. Texts are not epiphenomenal in their particularity. This is a central critique made by Douglas Kellner, who sums up much when he argues that it is wrong

"to claim that media culture has no discernable effects." Yet, he says, it is equally wrong "to blindly claim that audiences simply produce their own meanings from texts and that texts do not have their own effectivity" (1997, p. 97).

What is needed, it seems, is an approach that looks critically at popular texts as well as at how young people are both enabled and constrained in their uses of these texts. This kind of approach is especially necessary in working with black teens and with black popular culture. Indeed, while rap music and hip hop culture have redefined the popular American landscape in fundamental ways, virtually all the work on black popular culture and rap music to date has been historical and textual (Rose, 1994). There have been scarcely any long-term ethnographic studies of rap music in the daily lives of black youth in the United States. Textual analysis of rap lyrics has dominated popular and academic discussion on both the right and the left (Sexton, 1995). Much of this work, importantly, has been used to diagnose an entire generation of black youth as nihilistic and pathological, setting the stage for increasingly draconian public policy (Males, 1996).

Such draconian public policy is nowhere more evident than in two current, intertwined pushes: the increased militarization of public schools (including the proliferation of new and complex security apparatus) and the new links between schools and jails. If young people used to "learn to labor," they now "learn to do time" (Nolan & Anyon, 2004; Nolan, 2007). Current rates of incarceration have turned many public schools into de facto holding cells for young people about to enter prison—a disturbing reality for many. This militarization of public schools has gone hand-in-hand with the logics of "permanent war" in a post-9/11 context. These logics have produced new kinds of marginalities: While the black/white racial binary defined most of the discussion around difference in the twentieth century, new marginalized groups (e.g., Middle Easterners and other immigrant groups) have reconfigured this schema in key ways. Understanding of the lives of urban youth cannot be exhausted with the text/practice binary that so marks current scholarship.

I try here to fill this lacuna in extant scholarship. In doing so, I do not want to fall into the trap of boosterism, which already marks much of the critical work on rap specifically and popular culture generally. How my young participants used these texts in their daily lives had clear implications and consequences for how they understood their world and their place in it. I do not want to shy away from such topics. I approach the ethnographic dimension to this work in the spirit of sober reflection, as I do my treatment of hip hop's rich, complex, and sometimes disturbing history.

## Locating the Performative

I have thus sought a framework for understanding how young people use and are used by, so to speak, popular cultural texts. I find the notion of "performance" to be useful for drawing these concerns together. Indeed, performance has become a key trope for many scholars, with Dwight Conquergood arguing, most persuasively, that "performance . . . is the borderlands terrain between rhetoric and ethnography" (1992, p. 80), highlighting, as it does, all the ways our realities are suffused by symbolic systems already in performance, symbolic systems that we invest and reinvest with value and meaning in particular times and places for particular ends and purposes.

The notion of the performative has, of course, a long and complex history in various disciplines, both in the humanities and in the social sciences. According to folklorist and ethnographer Richard Bauman, through performance, "the act of communication is put on display, objectified, lifted out to a degree from its contextual surroundings, and opened to scrutiny by an audience" (1992b, p. 44). While in this sense all the world is now and has always been a stage, these tendencies have been highlighted and even exacerbated in this particular social, cultural, and material moment. Our contemporary "media culture," according to such theorists and researchers as Denzin (1997) and Abercrombie and Longhurst (1998), has permeated all our lives and disconnected space from place and individuals from communities, opening up all our lives to constant spectacle or scrutiny (Kellner, 1995). In some sense, all our actions are forever "put on display, objectified, lifted out to a degree from [their] contextual surroundings, and opened to scrutiny by an audience" due to the proliferation of interpretive frameworks circulating in media forms today. "The world and everything in it," according to Abercrombie and Longhurst, "is increasingly treated as something to be attended to" (1998, p. 78).

Linked to these emerging "media cultures" are new anxieties around postcolonialism, multiculturalism, and globalization. Dwight Conquergood (1991), again, has argued most persuasively that *a priori* assumptions about culture and identity are no longer relevant, that culture and identity must be constantly negotiated, configured, and reconfigured in the present tense. Accordingly, cultural critics face a new set of questions here vis-à-vis the performative. Most especially: "What are the conceptual consequences of thinking about culture as a *verb* instead of a *noun*, process instead of product? Culture as unfolding performative invention instead of reified system, structure, or variable? What happens to our thinking about performance when we move outside of

Aesthetics and situate it at the center of lived experience?" (Conquergood, 1991, p. 190). Conquergood's concerns echo those of James Clifford (1997), who suggests that cultures are no longer to be found in stable "roots" but in "routes," partial and temporary lines of connection and interconnection. I similarly use the term "performance" to highlight the idea that texts—whether symbol systems or lived experiences—are always in performance. They contain no essential or inherent meaning but are always given meaning by people, in particular times and in particular places.

This focus on performance has implications for textual as well as empirical work. For textual work, it allows us to see how popular cultural texts are complex and evolving, how particular constructions of race, class, and gender emerge in texts and practices as they unfold in specific contexts of use (e.g., music targeted to clubs, for cars) (Dimitriadis, 1999a). As I will show in chapter 1, looking at such contexts of use allows us to see, for example, how racialized notions of masculinity emerged in rap as technologies and producer culture took center stage. When we take this kind of approach, such constructs no longer seem immutable, though they remain very and entirely real. For ethnographic work, the notion of the performative throws into sharp relief how young people per-form their own realities in particular times and places with available—though often quite limited—resources. We thus see how history, tradition, and identity are all performances, all the result of invested actors who position themselves vis-à-vis others in a complex and unfolding social reality not of their own making. Performance, used in this way, assumes that the uses of texts and prac-tices are multiple and radically contingent—open, at least potentially, to other pedagogical uses (a point I will take up in chapter 6).

Performance is thus a key site where social, cultural, and material constructions are put into motion, are articulated and re-articulated in new and (often) powerful ways. More broadly, this "performative turn" looks toward an "interactionist epistemology," one where "context replaces text, verbs replace nouns, structures become processes. The emphasis is on change, contingency, locality, motion, improvisation, struggle, situationally specific practices and articulations, the performance of con/texts" (Denzin, 2003, p. 16). There are no safe spaces here, no alibis for our effectivities, both in their enabling and constraining dimensions (Lee, 1999). The world is always already performa-tive, always already in motion. This interactionist turn has critical implications for pedagogy and research, de-centering the privileged and delimited role of the teacher in the classroom. It forces us to look toward the new "in between" spaces where culture is being "performed" in the everyday.

This performative turn has opened up new spaces for qualitative researchers to "work the hyphens" between pedagogy, politics, and research. That is, the performative turn has helped to de-center the so-called research act, opening up spaces to think about the political and pedagogical work that is often an inherent (if unacknowledged) part of research. With no firm ground to stand on, we must acknowledge the multiple directions our work might take in as well as the multiple roles we play "in the field." I will pursue these concerns throughout this book, drawing on specific theoretical and methodological traditions as necessary. These include interviews, focus groups, participant observation, life history and narrative analysis, audience analysis, and ethnography. I offer this work very much in the spirit of the *bricoleur*, as I draw on "the multiple methods of qualitative research" throughout (Denzin & Lincoln, 1994, p. 2). As I will discuss later in the book, my role in the field changed over time in ways that afforded me new insight into these young people and hip hop. This is a methodological discussion I will take up in more detail later in the book.

## The Chapters

This second edition of *Performing Identity/Performing Culture: Hip Hop as Text, Pedagogy, and Lived Practice* is divided into three sections. The first section, "Hip Hop's Contexts of Production" (chapters 1–2), looks at the unfolding contexts of hip hop production, with a particular eye toward their pedagogical implications. The second section, "Hip Hop in Practice" (chapters 3–5), looks at the ways young people in this study "lived" hip hop in their everyday lives, focusing on the three empirical examples noted above. The final section, "Hip Hop and Education: Implications and New Directions" (chapters 6–7), looks at the implications of this work for educational research and practice, with a particular, new emphasis on qualitative research methodology.

In chapter 1, "Hip Hop to Rap: From Live Performance to Mediated Narrative," I will introduce the idea of performance vis-à-vis hip hop culture generally and rap music specifically. I will argue for a treatment of musical and performative processes that pays careful attention to the historical evolution of concrete contexts of production and consumption, "contexts of use" to echo de Certeau (1984, p. 33), acknowledging that the division between the two is no longer easy or self-evident. As I will argue, when we take the performance itself as our primary unit of analysis, we begin to see hip hop texts and practices as complex and evolving, registering and responding to history in the concrete.

We begin to see how particular constructions of race, class, and gender emerge in texts and practices as they unfold in performative contexts, thus opening up spaces for resistance and negotiation. When we take such an approach, we can no longer treat popular media texts as static, ahistorical signifiers in the service of particular political or methodological agendas. Furthermore, if we acknowledge performance as our primary unit of analysis, we can broaden the range of activities that can be said to constitute what Christopher Small (1998) calls "musicking," to include talk about music or even one's own private, personal relationship with music. As Small defines it, musicking is "to take part, in any capacity, in a musical performance, whether by performing, by listening, by rehearsing or practicing, by providing material for performance (what is called composing), or by dancing" (p. 9). All these activities—from talking about music to composing music—are part of making texts come alive in the "present tense," so to speak. Specifically, I trace a line from hip hop as a live, face-to-face art form in the mid-1970s to the current popularity of local or regional scenes such as those out of New Orleans or Houston.

In chapter 2, "Pedagogy and Performance in Black Popular Culture," I excavate one important moment in hip hop history—the emergence in the mid- to late 1980s of hip hop as a self-contained art form, attentive to its own history and pedagogical and artistic possibilities. Importantly, this moment of extreme self-awareness came just at the point when hip hop "crossed over" to a broader and more expansive audience with artists such as Run-D.M.C., the Beastie Boys, and LL Cool J. Looking back at this extraordinarily important moment—in particular, the early work of artists such as Boogie Down Productions and Rakim—allows us to interrogate an important rupture in the art form. As I will argue, hip hop's first major moment of mainstream success was met with local responses that affirmed the art's performative, pedagogical, aesthetic, and self-consciously historical role. It is a wise caution to us all as we look at this art form's (now) 30-plus-year history.

I then move, over the next three chapters, to look more closely at the everyday uses of popular culture at a local community center. These chapters are largely the same as the ones that appeared in the first edition. As indicated, these chapters are based on informal observations as well as on numerous one-on-one interviews and focus group sessions conducted at this center over a four-year period. Taken together, these chapters are an extended argument for the importance of exploring in detail and with nuance the ways such texts are taken up by youth—not as a simple "add on" to textual or critical analysis but as constitutive of how we understand this (now) global phenomenon. In the

first of these chapters, "Popular Culture, Constructions of Place, and the Lives of Urban Youth," I focus on Tony and Rufus and how they used key popular texts to construct a sense of place in the small city and at the community center where this research was conducted. As I will demonstrate, popular media forms made a whole host of constructs available to my young participants, constructs that were picked up in fairly predictable ways. Yet, I did find some important surprises as I explored local friendship networks and individual biographies in institutional contexts. These two teens mobilized these popular constructs in very specific ways, both finding links between and across them and also using them to index their relationships with biological and extended family, in this city and "down South." These two young people were able to draw together and co-articulate various themes and tropes, forging them into a hybrid and highly valued discourse, a discourse of the South and Southern values and mores that provided an important source of stability in the face of an intensely fraught contemporary reality.

Next, chapter 4, "Mobilizing History at a Local Community Center: Popular Media and the Construction of Generational Identity among African-American Youth," looks at how historical knowledge is mediated across generations, both to construct a sense of "blackness" rooted in history and to deal with often profoundly dangerous contemporary contingencies. Specifically, I look at how historical consciousness is mediated in school and especially out of school for young people, how young people choose to mobilize such knowledge, and the consequences they face therein. Focusing on the film *Panther* (1995), I look closely at the popular texts with which young people identify and how they pick up these texts and use them to deal with historical contingencies, here a proposed march in town by the KKK. I want to stress and will demonstrate that how young people inhabit particular discourses has very real consequences for their everyday lives as well as their broader life courses.

In the last of these three chapters, "The Symbolic Mediation of Identity in Black Popular Culture: The Discursive Life, Death, and Rebirth of Tupac Shakur," I focus more clearly on questions of self and on what kinds of possible selves were valued by the young people at this community center and how these selves dovetailed with their investments in popular icons. I will look, specifically, at talk about the life, death, and "rebirth" of rap icon Tupac Shakur, an icon with whom many young people profoundly identified. I will stress, theoretically, the mutual articulation of conversationalized discourses and myths of invulnerability in their investments in this powerful figure. Drawing on narrative analysis, I will offer a close reading of how these young people collectively

co-constructed a myth about Tupac, in part to help deal with their profoundly uncertain realities.

In the last two chapters, I explore key questions about pedagogy, popular culture, and urban youth. In these chapters, I pay particular attention to future directions for researchers and practitioners as they think through some critical contemporary issues. In the penultimate chapter, "Black Youth, Popular Culture, and Pedagogy: Some Implications," I argue that young people today are engaging with black popular culture in very specific though unpredictable ways. A closer look at these engagements, I argue, will give us a clearer picture of black youth today—how black youth have created specific, though circumscribed, notions of tradition, history, generation, and self. I argue that such work will help us consider more clearly questions of texts-in-performance in the dual sense developed above, helping us understand in less prefigured ways the affective investments marginalized young people have (or perhaps might have) in particular texts, popular and otherwise, as well as potential links between and across them. Informed by both textual analysis and ethnography, work in these performative pedagogical spaces should be less prefigured and sutured in its assumptions about the connections between texts and lived experience.

In the book's brief closing chapter, "Performing Methods in Popular Culture," I both situate the book's methodological approach and look toward the future of such work in popular culture. Taking the performance turn seriously, I look at how this research operated at the intersections of pedagogy, research, and political activism. I look, as well, at the ways my own research role was articulated and re-articulated over time as I moved from and between different roles at the club (or research site). Finally, I explore how the study of popular culture, in many ways, became increasingly contextualized as I got closer and closer to the lives of these youth, until popular culture became no longer my focus of study. Indeed, my objects of analyses—the questions I framed upon entering the site—shifted profoundly over time. The study of popular culture, I argue, must look toward a deeper kind of contextualization—one that may de-center popular culture as a primary object of inquiry.

In closing this introduction, I stress that *Performing Identity/Performing Culture* is offered in a humble spirit, by someone who has wrestled throughout adolescent and adult years to understand the profound importance and resonance of contemporary black popular culture, in my own life and in the lives of others. While I have tried to understand what it means to live in a "hip hop nation," the seemingly discrete subject has resisted easy closure and has resisted all my efforts to wholly contain it in and within neat theoretical frameworks.

I emerge here with one reading of hip hop history and one set of impressions about one group of young people at one community center in one small Midwest city. This has proven a Herculean task in and of itself. With these thoughts in mind, I turn to the first chapter, "Hip Hop to Rap: From Live Performance to Mediated Narrative."

# I

# HIP HOP'S CONTEXTS
# OF PRODUCTION

## · 1 ·

# HIP HOP TO RAP: FROM LIVE PERFORMANCE TO MEDIATED NARRATIVE

In this chapter, I examine hip hop's complex 30-plus-year history. I look, most specifically, at hip hop's changing contexts of production and consumption— its multiple "contexts of use," to echo de Certeau (1984, p. 33). I look at how these contexts have authored—and have been authored by—extant rap texts. Evoking the work of ethnomusicologists Chernoff (1979), Keil (1994), Small (1998), and Waterman (1990), I focus on performance as the primary unit of analysis. Such a focus is uncommon in academic and popular criticism to date and will allow us, as I will demonstrate, to get beyond a traditional impasse in music criticism: the impasse between looking at texts too narrowly and looking at context too broadly (Dimitriadis, 1999a). Such a focus will also set the stage for the following chapters, where I look more closely at how young people use rap texts in particular contexts. These contexts of use, as I argue in the conclusion, can include community centers as well as schools—any place where young people perform identity and perform culture.

I begin this survey with the period roughly from 1979 to 1982, when hip hop existed as a performance-based art form, thriving in clubs in and around New York City. I then trace the shift that took place circa 1983 with the rise of Run-D.M.C., LL Cool J, and the Beastie Boys as hip hop became more of a mass-disseminated popular art form, one which circulated by way of privatized media forms. Next, I extend this discussion to include black nationalist rap (e.g., Public

Enemy) and gangsta rap (e.g., Eazy-E), both of which rose in prominence in the late 1980s and early 1990s, and both of which highlighted key, seemingly dichotomous cultural narratives. After this, I look at "hardcore" rap that rose to prominence beginning in the early-to-mid 1990s. I pay particular attention to the proliferation of "crews" (e.g., NYC's Wu-Tang Clan and New Orleans's Hot Boyz) and regional sounds, which increasingly proliferated during this time, especially through mix tapes. Finally, I look at the rise of key entrepreneurial icons—most specifically, rapper Jay-Z. I pay particular attention to the ways artists such as Jay-Z have worked across multiple media platforms, "branding" their personalities through a range of products—from music to fashion to food and drink and beyond. While deploying textual analysis throughout, I will link these "readings" to concrete, situated contexts, arguing that one must understand their mutual implication to speak in any kind of informed way about these most powerful musical practices.

# Hip Hop as Event

Hip hop began as a situated cultural practice, one dependent on a whole series of artistic activities or competencies (Dimitriadis, 1996). Dance, music, and graffiti were equally important in helping to sustain the event. Like many African musics and popular dance musics, early hip hop cannot be understood as aural text alone but must be approached and appreciated as a multitiered event, in particular contexts of consumption and production. Tricia Rose gets at some of this interplay in *Black Noise*:

> Stylistic continuities were sustained by internal cross-fertilization between rapping, breakdancing, and graffiti writing. Some graffiti writers, such as black American Phase 2, Haitian Jean-Michel Basquiat, Futura, and black American Fab Five Freddy produced rap records. Other writers drew murals that celebrated favorite rap songs (e.g., Futura's mural "The Breaks" was a whole car mural that paid homage to Kurtis Blow's rap of the same name). Breakdancers, DJs, and rappers wore graffiti-painted jackets and tee-shirts. DJ Kool Herc was a graffiti writer and dancer first before he began playing records. Hip hop events featured breakdancers, rappers, and DJs as triple-bill entertainment. Graffiti writers drew murals for DJ's stage platforms and designed posters and flyers to advertise hip hop events. (1994, p. 35)

The artistic activities that helped constitute hip hop, thus, were multiple and varied, though entirely integrated by and through these "stylistic continuities" (Rose later uses a flow, layer, and rupture metaphor to describe these

continuities [p. 38]). In an issue of *Rap Pages*, Harry Allen notes that these were "mutually supporting art forms" and that "each gave the other resonance and depth" (Allen, 1994, p. 41). This sense of stylistic continuity was implicitly acknowledged by writers such as Steven Hager, whose 1984 book *Hip Hop* was subtitled "The Illustrated History of Break Dancing, Rap Music, and Graffiti."

The role of the artist was relatively diverse at this time. There were many ways to participate in the culture, though they all demanded engaging in situated activities. Events took place in parks, tenement basements, high school gyms, and especially clubs like Harlem World, Club 371, Disco Fever, and the Funhouse. Accessing the scene meant accessing such places, in ghettoized New York City areas such as the South Bronx and Harlem—areas ravaged by failed attempts at urban renewal and general deindustrialization (Rose, 1994). Unlike the current rap scene, this participation went beyond the production and circulation of musical texts alone to include practices such as dance and other face-to-face community-building activities. Though I will take a more focused approach here, it is critical to note that this performative ethic was linked, more broadly, to the music-making practices of the African-Caribbean diaspora. In fact, early DJs Kool Herc and Grandmaster Flash traced direct familial lines to Jamaica, where "sound system" parties resembled these early hip hop jams quite closely (Hebdige, 1987).

Rap's indissoluble connection with live performance is evinced, quite clearly, on early rap singles (1979–1982) and on bootleg tapes from early shows, from groups like the Furious Five and artists such as Busy Bee. The performative spaces mentioned above resonated in and across these early texts. Singles such as "Rapper's Delight" (1979), for example, were full of the kinds of "floating" or "stock" phrases that circulated in and throughout NYC hip hop parties during the mid-1970s. Examples include the now-famous "you don't stop," a then-ubiquitous party chant. Such phrases were public domain at this time, called upon and used by numerous artists in varied contexts. Producing an original text was less important than the rapper's or DJ's ability to "move a crowd." Producing coherent and autonomous texts was simply not valued. Bootleg tapes, when available, were a by-product of this activity, as were early singles. The performance itself was most important (Chernoff, 1979).

Like the live events themselves, the earliest rap singles were long and sprawling, with little sense of internal lyrical (or musical) progression. "Rapper's Delight" is, in fact, more than 15 minutes long. These early recordings were entirely unlike the self-contained three- to five-minute narrative tracks

that became popular in the late 1980s. Such singles seemed to run on and on and at some point to simply end—as if someone abruptly ended the party. The closure implied in the three-part narrative form (i.e., beginning, middle, and end) was missing. Each, rather, intertwined loose boasts and brags, with longer narratives, with (canned) artist-audience chants—tools ubiquitous in live hip hop events. Such tools were loosely combined and delivered in live contexts as rap was a more fluid and open-ended expressive form at that point, a practice wholly linked to live events. These singles indexed such events as unfolding activities, situations in which a clearly delivered and thematic narrative might not be entirely appropriate to help "move" an ever-shifting and milling crowd.

The earliest hip hop singles evidence this indissoluble focus on the occasion or event in a number of ways. First and foremost, the prevailing theme in these singles is partying, getting crowds involved in the unfolding event. Lines such as "Come alive y'all and give me what you got" abound, flowing in and out of the more structured narrative sequences, as in a live show. Concurrently, the pronoun "you"—that is, the live hip hop crowd—reveals a familiar and friendly relationship between artist and audience. This holds true for "Rapper's Delight" and for nearly all early singles, including "Spoonin' Rap" (1980) by Spoonie Gee, "Money (Dollar Bill Y'all)" (1983) by Jimmy Spicer, and "Superrappin'" (1980) by Grandmaster Flash and the Furious Five. In all these examples, the "you" indexes the participants necessary to sustain the event, active agents who engage and sustain the culture in complex and multiple ways in particular sites.

In a helpful counter-example, the pronoun "you" would come to refer to a very different audience in years hence, as the form and function of the music changed. Most specifically, the "you" would often interpolate dominant society as a whole—as in KRS-One's line "You built up a race on the concept of violence, now in '90 you want silence?" or Ice-T's "You don't like my lifestyle? Fuck you. I'm rolling with the New Jack Crew." Quite clearly, these were not the active agents who sustained the event by engaging in collective and situated activity. They were nameless representatives of dominant society to whom these products were increasingly available for consumption outside of clubs. Indeed, the early "Rapper's Delight" speaks to a music still aware of itself as a dance or party music, as a music realized in situated performance. It speaks to a music that indexes embodied participation in complex social activities, not wide dissemination in disembodied texts. Any other use of "you" would have been entirely anomalous.

This sense of the event, of the recursive nature of interaction and communication, is evidenced, as well, in the use of "call-and-response" routines. These routines were ubiquitous in live hip hop shows and are also featured on nearly all the earliest rap singles. Examples include:

> Go Hotel, Motel, What ch'a gonna do today? *Say what?* [in-studio audience]
> Say I'm gonna get a fly girl, gonna get some spank, and drive off in a def O.J.
> —"Rapper's Delight" (1979) by the Sugarhill Gang
> When I say "rock," you say "roll," when I say "ice," then you say "cold"
> Then when I say "disco," you say "the beat," I say it's "like honey,"
>     then you say "it's sweet"
> —"Adventures of Super Rhymes" (1979) by Jimmy Spicer
> Before you hear the party people yell "Sugarhill"
> So what's the deal? *Sugarhill!*
> —"That's the Joint" (1979) by Funky Four + One More

These call-and-response routines give clear testimony to the intimacy of the club or party situation with which these performers were perhaps most familiar. Rap grew out of a dialogic and interactive tradition, one that linked artists and audiences in some concrete fashion. These important but largely ignored aspects of early hip hop become evident when we begin investigating early texts and contexts of use together.

## Run-D.M.C. and Rap as Commodity Form

These call-and-response routines disappeared from hip hop during the early to mid-1980s, a period marked by the rise of Run-D.M.C. and related artists. Run-D.M.C. was the first mega-successful rap group, earning rap's first gold, platinum, and multiplatinum album awards (for *Run-D.M.C.* [1984], *King of Rock* [1985], and *Raising Hell* [1986], respectively). They were the first rappers to appear on MTV, the first to grace the cover of *Rolling Stone*, and the first to have a major endorsement deal with an athletic wear company (Adidas). Rap became a popular American music with the ascent of Run-D.M.C., one that circulated widely in self-contained commodity form. Rap came to rely more and more on the in-studio producer specifically and the music industry generally at this critical juncture. Producing self-contained texts became more important than sustaining the live and often multitiered event. The voice of the crowd, the voice of response and participation, was silenced as rap entered this

much wider and more commercial sphere, most especially by way of privatized contexts of use.

Run-D.M.C. was the first in a line of rap artists for whom the recording—not the party—became the all-important focus. The history of Run-D.M.C. is, in fact, inseparable from the history of Def Jam Recordings and its various behind-the-scenes producers and businesspeople. Def Jam Recordings was founded in the early 1980s by Rick Rubin and Russell Simmons. Like other famous producers, including Berry Gordy (from Motown) and Phil Spector, Rubin and Simmons helped craft and develop their artists and their images in unique ways. In many respects, the cast of characters necessary to sustain hip hop/rap as an event shifted at this point. As Howard Becker writes, "Every art...rests on an extensive division of labor" and this division is contingent over time (1982, p. 13). Thus, as I noted elsewhere, while breakdancers and graffiti artists became less crucial for constituting the art during this period, producers such as Rick Rubin became more so, crafting the art from behind the scenes in important ways.

In a particularly telling interview, Rick Rubin commented that his biggest contribution to rap was "the structured-song element." He noted further, "Prior to that, a lot of rap songs were seven minutes long; the guy would keep rapping until he ran out of words." By separating songs into "verses and choruses," Rubin, along with Russell Simmons, helped to turn rap into much more traditional, commercial pop music, with a focused lyric content, that could be easily consumed in private settings (Light, 1990, p. 110). Rubin and Simmons brought an explicitly producer-based aesthetic to hip hop, streamlining this otherwise more open-ended music into a more commodity-driven form. Many of their efforts achieved platinum-plus sales, due, in large part, to this popular approach. The move to self-contained commodity form and away from the particulars of the event is evinced from the very beginning of Run-D.M.C.'s career, on their very first single, "It's Like That," released in 1983.

This single, like many that followed, marked a sea change in the art. Many of the earliest hip hop tracks, including "Rapper's Delight," did not feature focused thematic content or organizing choruses. Such songs were a loose mix of boasts, brags, artist-audience routines, and short narratives. In contrast, "It's Like That" is a tight, thematic track, one that explores the trials and tribulations of poverty. Lines like "Bills fly higher everyday/We receive much lower pay" abound and are divided up by the collectively delivered chorus "IT'S LIKE THAT." This chorus is used in traditional "pop" fashion to organize the track thematically. Such choruses would become a staple of Run-D.M.C. (e.g., "My

Adidas"), fellow Def Jam artists such as LL Cool J (e.g., "I'm Bad"), other rap artists.

It is crucial to mention that Run-D.M.C. also reworked this practice "collective delivery" in key ways. Many early collectives, such as the Cold Crush Brothers and the Furious Five, used collective delivery freely in face-to-face performance. Chants like "THE COLD CRUSHIN' MOTHER FUCKIN' TOUGH ASS FOUR MC'S" were used to frame loosely delivered boasts and brags traded between members in live interactive contexts. These collective chants were not used to organize individual raps thematically but to sustain collective performance, a practice carried over onto vinyl by groups such as the Treacherous Three (e.g., "BECAUSE WE ROCK NONSTOP" from "The Body Rock"). Run-D.M.C., however, uses collective delivery here to push the message of this song forward, to make it louder, to proclaim it more clearly. "IT'S LIKE THAT" is a clear, meaningful refrain or chorus used to divide up, organize, and accentuate this more focused, more organized pop cut.

This move toward rap as self-contained commodity is evinced perhaps most clearly in Run-D.M.C.'s acknowledgment of mass-media forms in many of their songs. Indeed, as with early hip hop, the activity and practices surrounding this moment in hip hop registered in these singles in ways that blur the line between text and context—thus, the line "When we're on the tape, we're fresh out the box/You can hear our sounds, for blocks and blocks." Rap was now mass-disseminated, capable of being configured and mediated in new ways in a number of different settings and places. The event as a place-specific and dependent activity was now radically reworked. Disembodied texts capable of being consumed and disseminated in a large number of contexts became most important. Hip hop moved, in short, from a place-dependent art to a more mobile one.

This move to rap music and away from hip hop enabled the art's locus of production to expand. Hip hop had been a localized music. Specific clubs such as Harlem World, T-Connection, Disco Fever, Rooftop, and Funworld (all in the South Bronx or Harlem) were at the center of early hip hop activity. However, during the early to mid-1980s, the outlying areas of New York City such as Hollis, Queens (the home of Run-D.M.C.), became increasingly important, as did areas around the country, including Los Angeles (the home of Uncle Jamm's Army and the World Class Wreckin' Cru). The so-called suburbanization of hip hop began during this period, as a much wider group of performers and audiences began to have access to the art. Rap was now a separable discourse that did not demand a strict integration in live multimedia production. Artists

rs first and recording artists second. In the face of
success, the event was largely overshadowed by the
on of select iconic figures through commodity form,
ons for the idiom as a whole.

often consumed by way of boom boxes. These large
young people to take music with them, to play it
..., where they chose. Yet, unlike privatized Walkman radios, these radios pro-
jected music to people who might not want to hear it. Thus, questions about
public space and the ownership of space through sound became increasingly
important in the 1980s—questions we can trace emerging in and through select
texts. Indeed, LL Cool J (also on Def Jam Recordings) places the radio at the
center of his musical universe on cuts such as "I Can't Live without My Radio,"
articulating his vision of race and masculinity through technology with lines
like "Walking down the street to the hardcore beat while my J.V.C. vibrates the
concrete." LL appropriates and celebrates this sense of rebellion when he raps
of claiming space in his neighborhood by putting his "volume way past 10." As
Robin Kelley writes:

> The movement of young blacks, their music and expressive styles have literally become
> weapons in a battle over the right to occupy public space. Frequently employing high-
> decibel car stereos and boom boxes, they "pump up the volume" not only for their own
> listening pleasure but also as part of an indirect, ad hoc war of position to take back
> public space. (1996, p. 134)

Again, with the rise of artists like LL Cool J and Run-D.M.C., hip hop moved
away from a more place-bound activity to a more mobile one, allowing for a
qualitatively new activity, with new political possibilities and constraints.

Indeed, LL's lyrics would have been anomalous early on, when rap was a
more place-bound and in-group art form. Yet, these changing activities reg-
istered on myriad levels, including in rap's vocal content. One key instance:
Rap lyrics focused on partying during the late 1970s. The "you," as argued
above, was typically directed toward other party-goers, as in "You don't stop!"
Yet on this track LL raps, "I'm sorry if you can't understand, but I need a radio
inside my hand." Clearly, the "you" represents an outside audience, one that
would not share LL's love for rap music. The move from face-to-face activity
(as embodied in dance) to the production and dissemination of self-contained
narrative texts changed the nature of the activity here in fundamental ways.
The texts themselves became increasingly self-contained and structured, the
participants less easily identifiable. The dominant paradigm, in which artists

transfer messages to audiences, became more important than indexing the quality of the musical event or occasion itself, the agents involved in the situated activity. Indeed, even when artists addressed seemingly "live" audiences in their songs (e.g., on tracks such as Eric B. and Rakim's early "I Know You Got Soul"), it was always by way of self-contained and densely verbal texts, with clear choruses and verses, targeted to largely hypothetical audiences. The linear model, in large measure, eclipsed a more circular and recursive one at this point, though it opened up the possibility for addressing wider audiences with select concerns.

The more mobile use of self-contained texts is evinced, as well, in the increasing importance that accrued to media-specific producer styles in the late 1980s, as media forms other than boom boxes became important. When asked where the most important place for hip hop was, Cypress Hill producer DJ Muggs commented: "It's the muthafuckers just poppin' the cassette in the box. You gotta be in your car, in your [W]alkman, in your house, fuck a club, fuck a radio" (Cross, 1993, p. 247). Indeed, Walkmans, cars, and homes became key sites for hip hop from the mid- to late 1980s, as rap moved toward commodity-driven forms. Different production styles began to reflect different regions of the country and their means of listening to music. For example, West Coast rap has become more bass- and beat-heavy, as it is targeted for consumption in cars and jeeps. East Coast rap, in contrast, has become more midrange, because it is often consumed by way of private stereos with small speakers. Producer DJ Pooh, who has worked most notably with the West Coast rapper Ice Cube, comments:

> L.A. is on a car trip, and if the shit don't sound good in my car, fuck it, I don't want to hear it, so I make my music for your car. The East Coast is way different. They're looking for something they can play at home. (D-Dub, 1992, p. 11)

The sound is aimed at the listener's technology, technology that is most often consumed in dispersed and mobile settings. These sonic shifts began to occur during the mid- to late 1980s with the rise of a rap-as-commodity form.

Rap's oft-noted move to masculinist ideals and values came as a parallel phenomenon to the proliferation of producer-based technologies. With the means of producing rap becoming increasingly consolidated, questions of access (or lack thereof) became crucial. Tricia Rose writes:

> Young women [are] not especially welcome in male social spaces where technological knowledge is shared. Today's studios are extremely male-dominated spaces where technological discourse merges with a culture of male bonding that inordinately

problematizes female apprenticeship. Both of these factors had a serious impact on the contributions of women in contemporary rap music production. (1994, p. 58)

By many accounts, including Rose's, women were an active part of early rap (Guevara, 1996). Early rap artists included Sha-Rock (who recorded a few very early singles with the Funky Four Plus One), Pebbly Poo, Sequence (featuring Blondie, Cheryl "The Pearl" Cook, and Angie B), Lisa Lee, Debbie Dee, and Wanda Dee (all associated with Afrika Bambaataa's Zulu Nation). Early breakers include Baby Love, and early graffiti artists include Lady Pink. Yet, none of these artists had much financial success, and their careers petered out during the early 1980s, right at the point Run-D.M.C. entered the picture. Rap began to be constructed as a more masculinist art form during this period, one that both largely denied opportunities for female access and opened a space for the proliferation of existing deeply misogynist cultural discourses. Indeed, while in years hence female rappers such as Lil' Kim and Foxy Brown would rise in prominence, their hypersexualized and often explicitly violent work resonated in a popular field defined *a priori* almost wholly by men. In fact, both these artists were linked (often paternalistically) to male mentors—Lil' Kim to Biggie Smalls and Foxy Brown to Nas.

As noted, there were many different ways to participate in hip hop early on, many different ways to engage the culture. However, LL Cool J's popular racialized macho posturing (discussed in more detail in the following chapter), coupled with the lack of female access to increasingly important and consolidated producer technology, helped elide this. In fact, Simmons and Rubin alone effectively defined the face of rap from the early to mid-1980s. Dance and other event-oriented practices were eclipsed by commercial and (popular American) cultural imperatives. Rap became less an embodied practice and more about the production and dissemination of self-contained products. These came to be consumed not in communal, dance-oriented sites (such as clubs) but in privatized spaces where particular kinds of activities were enabled and constrained. As Gilroy so succinctly put it, "It is not possible to dance in a car, however large and loud a system it may contain" (1997, p. 22). Concurrently, particular constructions of masculinity and race began to emerge in rap texts in ways that would help define the idiom. We see these, again, when we start looking closely at complex cultural forms in situated, historical contexts of use. When we do so, these constructs no longer seem immutable; they seem instead to be the products of actors and institutions operating in particular moments in complexly overdetermined ways.

# Public Enemy and Black Nationalism in Rap

The widening reach of rap music—the increasing importance of media and the multiple though privatized uses to which it could be put—also opened the art up to new possibilities around this time. Specifically, a kind of black nationalist identity politics became apparent in rap during the late 1980s as its community stretched irretrievably beyond local boundaries. A brief example of how recorded media engendered black nation building within the idiom will prove illuminating. Public Enemy released a song in 1987 entitled "Raise the Roof," from the album *Yo! Bum Rush the Show*. An aggressive boasting and bragging party track, it contains the line "This jam is packed so I just figure, all we need is the house to get bigger." Chuck D later raps, "It's an actual fact, it takes a nation of millions to hold me back." There are definite political overtones here and throughout the single as chaotic abandonment bordering on the riotous is evoked (reminiscent, perhaps, of Martha and the Vandellas' "Dancing in the Street"). Yet at best, the language on the track is coded, not explicit. The first-person "I" abounds, reflecting the loose kinds of self-aggrandizement that were so much a part of early party rap. A radical social consciousness was emerging in rap, though it was tied to the local "party" tradition.

Public Enemy's next album, *It Takes a Nation of Millions to Hold Us Back* (1988), was quite different from *Yo! Bum Rush the Show*. The more personal "me" of "Raise the Roof" was replaced by the more inclusive "us," reflecting the album's encompassing black nationalistic theme. The band's political agenda became more pronounced on this second release, as demonstrated by titles such as "Rebel without a Pause" and "Prophets of Rage." Indeed, Chuck D and Flavor Flav wed a pro-black stance with Nation of Islam ideology on these and other tracks, including "Bring the Noise." Terms such as "devil" and "black Asiatic man" abound, referencing the intricate genesis beliefs preached by Nation founders W. D. Fard and Elijah Muhammad. The Nation of Islam became a pronounced force in rap at this time, its blend of militancy and pro-black ideology finding enthusiastic support among many young African Americans.

Public Enemy's radical conception of the idiom as a nation-building force was intrinsically a part of their new and innovative uses of mass-disseminated technology. Unlike most early rap albums, *It Takes a Nation of Millions to Hold Us Back* is not a collection of singles. Rather, *It Takes a Nation* is structured as a 58-minute, self-contained radio broadcast, its individual songs linked together along conceptual lines. Tracks are interspersed with portions of a British concert, static, the sound of a radio dial turning, and bits and pieces of radio shows.

Communication itself became most important as Public Enemy envisioned an African-American community that could be linked together through post-modern media technology. Thus, their second release marked a shift in the rap aesthetic. Community performance and entertainment on a decentralized scale gave way to worldwide mediation by and through more centralized recording media. Rap became, in short, an idiom that could create solidarities beyond the boundaries of face-to-face communication.

The relationship between technology and nation building is explored by Benedict Anderson in *Imagined Communities: Reflections on the Origin and Spread of Nationalism*. He notes, early on, that nations are "imagined communities" that foster feelings of deep solidarity between peoples who do not know and might never meet each other:

> [A nation] is imagined because the members of even the smallest nation will never know most of their fellow-members, meet them, or even hear of them, yet in the minds of each lives the image of their communion...It is imagined as a community, because, regardless of the actual inequality and exploitation that may prevail in each, the nation is always conceived as a deep, horizontal comradeship. (1991, pp. 6–7)

As Anderson observes, mass-disseminated technology—most notably print technology, or "print capitalism"—was essential to envisioning these large-scale imagined communities. This revolutionary technology "made it possible for rapidly growing numbers of people to think about themselves, and to relate themselves to others, in profoundly new ways" (p. 36), throughout disparate areas of Western Europe, beginning in the eighteenth century (p. 11). Similarly, recorded technology allowed artists such as Public Enemy to envision their audience as a wide and encompassing nation within a nation, one that transcended any and all local contexts of production. Indeed, unity was the cry of the moment late in the 1980s, as groups such as X-Clan and Boogie Down Productions stressed similar though not identical black nationalist aesthetics on albums such as (respectively) *To the East, Blackwards* and *By All Means Necessary*.

## Gangsta Rap—Redefining the Real

It is an ironic and uncomfortable reality that gangsta rap emerged at almost exactly the same time on the West Coast as Public Enemy and other nationalist rappers did on the East. While many have attempted to draw sharp distinctions

between the lyric content of "positive pro-black" artist
and "negative gangsta rap" artists such as NWA, these g
one characteristic. Both groups encountered and engaged w
mass-mediated, primarily verbal art form—one no longer contin
ated and processed in live practice and performance. Public Enemy
for example, seem less like small-scale community performances and mor
major-label rock extravaganzas. Elaborate props and rigid codification give the
performances a kind of large-scale grandiosity foreign to most early—clearly less
formal—hip hop music. The group, for example, is often flanked on stage by
Security of the First World (or S1W), a "paramilitary outfit" that carries fake
Uzi submachine guns, dresses in camouflage, and performs an elaborate stage
show behind band leaders Chuck D and Flavor Flav. NWA, now disbanded,
shared a similar aesthetic. The group made similar use of elaborate stage props,
including "Do Not Cross—Police Line" tape, which was sometimes spread
across the group's performance space. The message, again, was "Do Not Cross"
the line between those on stage and those off. Like many popular rock stars,
both bands replicated their album tracks on stage ("in concert") with maximum
spectacle and pageantry, formalizing the line between artist and audience as in
much "classical" European music (Small, 1998).

This stress on mass-mediation and large-scale dissemination, as opposed
to small-scale community performance, helped to forge in rap a more
"informational" narrative-based music. The now-familiar "rap as ghetto
reporter" equation entered West Coast parlance during this period as Chuck
D's oft-quoted "rap as black America's CNN" entered the East Coast's. Former
NWA member Ice Cube notes:

> I give information to the people in Atlanta, that the people in Atlanta never even
> thought about. It's a form of unity, it does form a unity that we're startin' to put
> together...[Rap is] a formal source to get our ideas out to wider groups of peers.
> (Quoted in Cross, 1993, p. 206)

Characters, plots, and "messages" became most important for West Coast
gangsta rap as the art's verbal discourse alone was severed from its context of
live congregation and production. "Repetition and variation of short motifs"
was replaced by narrative storytelling within a closed song structure (Manuel,
1988, p. 23).

An example from Ice Cube's work will prove helpful. "Dead Homiez" is from
Ice Cube's *Kill at Will* EP, released a short time after his 1991 album *AmeriKKKa's
Most Wanted*. Cube tells a vivid story on this track, narrating, in the first person,

, who died early and violent deaths. The
t stress word-play or metaphor, and no
acknowledged in this text. This is not a
ging live crowds. Rather, "Dead Homiez"
ation, albeit with passion and emotional
arly poignant and follows the action of the
"I still hear the screams from his mother"
igh—by a grieving woman.
h more prevalent part of rap during the late
ough the influence of MTV's *Yo! MTV Raps.*
The video medium ... ailing currents in hip hop music during this
period, moving it toward a kind of literality that was exceedingly appropriate
for all kinds of mass-mediation. The gun-carrying gangster was and is capable
of signifying parallel messages in sight and sound. For example, there was a clear
link early on in rap between the power to communicate orally and the power of
a weapon. The microphone was often metaphorically referred to both as a gun
and as a phallus. However, after 1989 or so, with the increasing importance of
the video, there was a move to a kind of literality rooted in the visual. The gun
came to signify (referentially) a gun, and a gun alone. The power of this sym-
bol stood on its own. Realism in the realm of the mass mediated became more
important than engaging live crowds or working with the language itself.

The gangsta rap narrative struck a chord in American popular culture, most
especially with solvent young white teens. Artists such as Ice-T, NWA, Eazy-E,
Dr. Dre, Ice Cube, MC Ren, and Snoop Doggy Dogg achieved platinum-plus
sales, prompting artists and record companies alike to attempt to replicate their
formula for success. Part of the gangsta's wide cultural currency comes from the
universally extractable nature of his narrative. The violent outlaw, living his life
outside of dominant cultural constraints, solving his problems through brute
power and domination, is a character type with deep roots in popular American
lore. Indeed, the gangster holds a very special place in popular American imagi-
nation. He embodies such capitalist values as rugged individualism, rampant
materialism, strength through physical force, and male domination, while he
rejects the very legal structures defining that culture. He is both deeply inside
and outside of mainstream American culture, his position not unlike that of
African Americans in the Americas for more than 400 years. It is thus not
surprising that the black gun-toting gangster has had such limitless appeal for
so many young males, both black and white. The gangsta is a romantic figure,
a ready-made tool for teen rebellion.

One key example: Eazy-E's "Boyz-n-the-Hood," released in 1988 on the album *Eazy-Duz-It*, embodies many of the themes and tropes that would come to define the gangsta rap genre, including the stress on money and crime ("The fellows out there, makin' that dollar"), masculine invulnerability ("Ran in the house and grabbed my clip, with the Mac-10 on the side of my hip"), and misogyny ("Reached back like a pimp and slapped the hoe"). In typical pop fashion, the chorus, "Cuz the boyz in the hood are always hard, you come talkin' that trash we'll pull your card," is repeated throughout. This kind of narration, which has a strong visual feel to it, allowed and enabled a number of popular artists working within the genre, including Ice Cube, Ice-T, and MC Eiht, to make a successful transition to film. These artists blur the line between "ghetto reporting" and cinematic fantasy in these films, as have many rap artists entering the realm of popular American culture. In fact, Ice Cube's first film, which in many ways set the stage for the "hood" films that began to rise in prominence in the late 1980s, was titled *Boyz N the Hood*.

The gangster narrative became an intrinsic part of the art at this time, engendering an entire musical genre. Its wild financial success has helped to shape the contours of rap's present landscape, the "language" through which rappers articulate their raps. Most artists today acknowledge the genre either implicitly or explicitly, as values such as "hardness" and "realness" now dominate across the board. "Hardcore" artists of the 1990s such as Method Man, Nas, Redman, and Jay-Z all embraced the violently impenetrable outlaw stance on some level, though they have all proclaimed a love for rap as an art form as well. They all employed performance tools such as word-play and freestyle-sounding delivery, though they are all operating on a popularly determined landscape, both in medium and in message.

One sees this clearly on Method Man's "Bring the Pain," released on his album *Tical* in 1994. Method Man displays a flexible control over language in this frenetic nonnarrative piece, one which emerges from the hardcore aesthetic that became pronounced in the late 1980s and early 1990s (e.g., "I came to bring the pain..."). His delivery resonates with freestyle vocal improvisation, a practice intrinsic to rap's continuum as a live practice. Lines such as "In your Cross Color clothes you've crossed over, then got totally krossed out and Kris Kross—who da boss?" seem to tumble out of his mouth freely and without effort; they also contain multiple puns—that is, on the clothing label Cross Colors, on the pop group Kris Kross, and on the popular TV show *Who's the Boss*. This control over language is crucial, for Method Man frames "Bring the Pain" as a vocal "battle" or competition. Such battles have been an intrinsic part

of hip hop almost from its inception. Artists such as the Cold Crush Brothers and the Furious Five routinely engaged in verbal "cutting" contests during the late 1970s and early 1980s, as did jazz musicians and blues singers before them. "Bring the Pain" has much of the sprawling energy of such battles, though it is very much contained within a kind of pop formalism.

The chorus, "Is it real son, is it really real son," for example, frames the song's three verses. Such devices became important as hip hop left the context of live dance-hall production and entered the realm of the recorded. Early face-to-face battles were, as one might imagine, more dialogic than were later popular recordings such as "Bring the Pain." Early competitors both knew each other and had to react to each other's challenges. Boasts and brags and insults were often personalized during these early battles, an aesthetic clearly evinced during a famous match between Kool Moe Dee and Busy Bee Starski at Harlem World in 1981.

During the competition, Kool Moe Dee insults Busy Bee's trademark "bom ditti bom" routine ("Busy Bee I don't mean to be bold but put that 'Bom ditti bom' bullshit on hold"), as well as his general lack of originality. Busy Bee, according to Kool Moe Dee, "bit" his name from Lovebug Starski and "hugs" other MC's "jocks." Note that these insults are individualized and center on the act of MCing itself. Method Man's single is, in contrast, inscribed within a one-sided gangster narrative, a narrative that often blurs the line between rhetorical competition and violent threat. Lines such as "Niggaz get tossed to the side and I'm the dark side of the Force" are neither personalized nor contained clearly within the realm of the performance. Tricia Rose notes that much of the hardcore rap of the 1990s is directly indebted to gangsta rap:

> During the later 1980s Los Angeles rappers from Compton and Watts, two areas severely paralyzed by the postindustrial economic redistribution, developed a West Coast style of rap that narrates experiences and fantasies specific to life as a poor young, black, male subject in Los Angeles. Ice Cube, Dr. Dre, Ice-T, Ezy-E, Compton's Most Wanted, W.C. and the MAAD Circle, Snoop Doggy Dog, South Central Cartel, and others have defined the gangsta rap style. The Los Angeles school of gangsta rap has spawned other regionally specific hardcore rappers, such as New Jersey's Naughty By Nature, Bronx-based Tim Dog, Onyx and Redman, and a new group of female gangsta rappers, such as Boss (two black women from Detroit), New York-based Puerto Rican rapper Hurricane Gloria, and Nikki D. (1994, p. 59)

Method Man, thus, recoups much of rap's freestyle energy on "Bring the Pain," though he is operating within a context made popular and prevalent by West Coast gangster narratives. Interestingly, in years to come, Tupac Shakur would

"interpolate" this song on his album *All Eyez on Me*, an album which, as I will note later, helped fuel a vicious conflict between the East and West coasts, with Tupac representing the West.

Method Man, as he raps on "Bring the Pain," is part of the collective Wu-Tang Clan ("Of course it's the Method Man from the Wu-Tang Clan"). The original Clan lineup included Method Man, Raekwon, The RZA, The Genius, Masta Killa, U-God, Inspectah Deck, Ghostface Killah, and Ol' Dirty Bastard. The group initially released an independent single, "Protect Ya Neck," which was full of intricate word-play, boasts, and brags and featured all members trading verses. The group—collectively and individually—often employed the kind of nonnarrative techniques evidenced above, weaving clever metaphors and stylized word use with violent images. The feel was often chaotic, with members delivering and trading rhymes in a seemingly random fashion. The sound harked back to old school groups such as the Cold Crush Brothers and the Furious Five, though the Wu-Tang Clan more clearly embraced elements of the gangsta mentality (they also had a denser, more noisy producer-based sound than did these early collectives, who seemed more influenced by the cleaner sounds of disco).

In fact, the Wu-Tang Clan underwent a telling metamorphosis beginning with Raekwon's 1995 album *Only Built 4 Cuban Linx*, released a year after Method Man's. Members reinvented themselves as prototypical gangsters and superheroes: Raekwon as Lou Diamonds, Method Man as Johnny Blaze, Masta Killa as Noodles, The RZA as Bobby Steels, Ghostface Killah as Tony Starks, Inspectah Deck as Rollie Fingers, The Genius as Maximillion, Ol' Dirty Bastard as Dirt Megirt, and U-God as Lucky Hands. The references are somewhat arcane. Johnny Blaze, for example, is the alter ego of comic character Ghost Rider, while Tony Starks is Iron Man's. In addition, Maximillion was a character in Sergio Leone's crime film *Once Upon a Time in America*, as was Noodles. They were, as one song proclaimed, the Wu-Gambinos—the Gambinos being, of course, one of the five major Mafia crime families in New York. The Wu-Tang Clan, so invested in the tribal ethic, thrived off these traditional Mafia notions of "family," notions reinforced by and patterned after movies and other popular media forms. Films like *Scarface*, in fact, were wholly embraced by many rappers during this period, and much dialogue, from this film and others, wound up on rap albums. Again, a stress on family was all-pervasive—Raekwon, for example, rapped about "keep[ing] Wu-Tang money all up in the family" on one track.

Many such "rap families" or crews pervaded the art beginning in the mid- to late 1990s with the rise of the Wu-Tang Clan, No Limit Records (home of the No

Limit Soldiers), Death Row Records, and Bad Boy Records. These were record labels or "organizations" that extolled a group or ganglike ethic, on record and off, with myriad effects. In fact, the prevalence of such "crews" prompted several high-profile feuds, as between the West Coast Death Row and the East Coast Bad Boy camps. Both camps handled many aspects of their artists' careers, and each generated relatively stable group sounds and ethics—including ones defined in opposition to the other's. Indeed, a series of shootings and murders ended the rivalry in the worst way possible—with the deaths of stars Tupac Shakur and Biggie Smalls. This discussion—so critical for understanding the lives of contemporary youth—will be extended in chapter 3 and, especially, in chapter 5.

## Regionalism and Mix-Tape Culture

For now, it is important to underscore the kind of regionalism that became increasingly pronounced in the late 1990s and early 2000s—a regionalism that went hand-in-hand with the "crew" ethic noted above. While most of the above discussion is rooted (primarily) in the East Coast and (secondarily) in the West Coast, it is critical to note that the South became a force around this time in the music as a whole (a point I will pick up in chapter 3). As hip hop circulated nationally and internationally, communities around the country reclaimed it in particular ways. For communities in the South, reclaiming or reasserting hip hop's roots as a club-based music—a music about social interaction—was paramount. While the themes were ones that emerged in hip hop at this time (i.e., the ones associated with so-called hardcore rap), much of this music was influenced by a distinctly Southern flair. For artists in New Orleans, this meant a sound often called "bounce."

Bounce is a distinctly New Orleans hybrid. Influenced by hard, percussive hip hop beats, as well as the big band, jazz-inflected sounds of "second-line" Mardi Gras music and dance, bounce artists made music for block parties and clubs. Born in live performance, bounce came to "wax" for perhaps the first time with Gregory D and DJ Mannie Fresh's 1989 song "Buck Jump Time." As Roni Sarig writes, "It's beat, inspired by Gregory and Mannie's days in the marching band, drew directly from second-line rhythms—the ringing cymbals and clanging cowbells dancing around the steady driving snares. Recreated by Mannie on the drum machine, with sampled horn bleats and a springy bassline, the resulting fusion was both credibly hip-hop and fully rooted in New Orleans"

(2007, p. 253). Like early hip hop, song lyrics often focused on partying and getting the crowd involved. The song consisted largely of "shout outs" to different projects in the city, including the Calliope, Melpomene, and Magnolia. Throughout, Gregory D chants, "Buck Jump Time," as if to a live, excited crowd. (Interestingly, when the single was included on a full-length album, *D Rules the Nation*, the local references became more general and generic national ones—California, New York, Miami, etc. The album did not sell well.)

Mannie Fresh eventually became the "in house" producer of Cash Money Records—a label whose roster of stars became an extraordinary force in hip hop beginning in the late 1990s. The label was co-founded by Bryan "Baby" Williams and Ronald "Slim" Williams and by 1998 could boast an extraordinary $30,000,000 distribution deal with Universal Music. The label drew together the bounce sound so popular in New Orleans and a thematic stress on a lavish "ghetto fabulous" material lifestyle along with a distinct "gangsta" mentality. Indeed, the phrase "bling bling"—that is, ostentatious jewelry—was coined by artist BG (or Baby Gangster). The label's signature artists came together in 1997 to form the Hot Boys, a supergroup featuring Juvenile, BG, Lil' Wayne, and Turk. Individually and together, these artists were among the most important of the new millennium.

Among the best-selling albums of this era was Juvenile's *400 Degreez* (1998). On this album, Juvenile evidences the spectrum of the Cash Money sound. "Back That Azz Up" is a bounce-inflected dance song on which Juvenile chants, "Girl, you looks good, won't you back that ass up!" Other tracks were more clearly rooted in the gangsta ethic of drug selling and violence. For example, on the song "Gone Ride with Me," Juvenile raps, "My nine [millimeter gun] is gonna die with me, pick up the supply [of drugs] with me." Finally, on the hit "Ha," Juvenile seemingly rambles through a long list of everyday events for a so-called G, or gangster. As the chorus goes, "You a paper chaser, you got your block on fire, remaining a G until the moment you expire."

Cash Money Records typified the New Orleans sound. Other regional sounds included those out of Houston, Texas. Here, too, we see a national music reclaimed in specific ways—in the case of Houston, around car culture and "syrup," or liquid codeine. Houston became a force in hip hop in the mid-1980s with the gangsta rap group the Geto Boys. The Geto Boys had several important independent releases on Rap-A-Lot Records, with rapper Scarface emerging as perhaps the region's most legendary lyricist. In many respects, the Geto Boys were the first major act from the South to become a national force. Perhaps the group's signature song was "Mind Playing Tricks on Me" (1991),

where each group member (Willie D, Bushwick Bill, and Scarface) narrated his own intense personal demons. It is a deeply psychological and psychologized song with a realist video. It begins with Scarface's memorable lines, "Four walls just staring at a nigga, I'm paranoid, sleeping with my finger on the trigger."

The Houston "sound" writ large, however, was informed more deeply by the region's particular terrains and tastes. Notable here was the prevalence of mix-tape culture—in particular, the "screwed up" sound associated with DJ Screw. In the early 1990s, DJ Screw started creating hip hop mix tapes, slowing down the music and "chopping" it up, often repeating key verses and phrases over and over again. The result was a sound distinct to the region—sprawling, laid back, and hypnotic. DJ Screw set up store at his home in Houston—Screwed Up Records & Tapes—and went on to sell massive numbers of tapes and CDs. These were remixed CDs, often featuring new layers of vocals by others in his Screwed Up Clique, such as Hawk and Big Pat. If East Coast music was often densely lyrical, this was a more expansive music—a music for driving and "sipping syrup." Both cars and syrup would be central to the Southern sound.

Car customization took on a particular resonance in the South and was celebrated in much Houston music. Just as the mix-tape DJ would adorn and rework existing music, car enthusiasts would adorn their cars with bright paint jobs (often called "candy colored"), bass-heavy sound systems, large gold wheel rims, interior wood trimming, and other features. These cars were made for showing off—cruising the large and expansive terrain of Houston. In its complex and symbiotic relationship with this car culture, screw music was the perfect accompaniment here. Screw music had a similar relationship to sipping syrup. Syrup is a form of concentrated liquid codeine that is often mixed with fruit juice and drunk from a Styrofoam cup or a decorative chalice. Syrup is a depressant and (sometimes) psychedelic. It is the perfect accompaniment to slowed-down and screwed-up music.

In many respects, the rise of DJ Screw's mix tapes mirrored early hip hop efforts. While wildly popular, the Screwed Up Clique never made a large-scale transition to mainstream success. That move would be made—as are many such moves—by those following in DJ Screw's footsteps. In particular, rival mix-tape DJ Michael "5000" Watts (Watts was from the north side of Houston while Screw was from the south) helped assemble a more format-friendly group of artists on his label Swishahouse Records—shorter tracks with clear verses and all-important choruses. While the label saw many artists come and go over the years and many internal feuds erupt, artists such as Paul Wall, Chamillionaire, Mike Jones, and Slim Thug were among its most prominent stars. All would

pick up the themes so important to the South—syrup, customized cars, lavish lifestyles, regionalism, and (of course) violence. As Slim Thug rapped on the chorus to his song "Like a Boss," "I call shots, like a boss, stack knots, like a boss, cop drops, like a boss." All would be vital for defining the emerging Houston scene as it entered the mainstream.

Other regions in the South reclaimed hip hop in other ways—for example, the "crunk" music of Memphis, Tennessee (e.g., Three 6 Mafia and Eight-ball and MJG) and the accompanying "gangsta walk" dance. Other important regions were Miami, Florida (e.g., Rick Ross), and Jackson, Mississippi (e.g., David Banner). Each of these scenes reclaimed hip hop and returned it to its roots in live, social interaction. Operating outside of the dominant commodity forms, this music often circulated by way of self-produced mix tapes. Indeed, DJ Screw (among others) solidified the notion of mix tapes as an alternative model for regions off the major-label radar. Screw helped to create something of an underground economy in Houston. As a 2005 *New York Times* article noted:

> DJ Screw's innovation gave Houston not only a sound but an economic model, too. With the rise of mixtape culture, Houston had a sprawling, decentralized distribution system to match its sprawling decentralized landscape, and the leading mixtape rappers found they didn't really need major-label deals or radio play or even nightclub hits. If they could sell 20,000 mixtapes in Houston and nearby cities, and they could book a steady string of live appearances, they could get by. (Sanneh, 2005)

This model and approach became increasingly pronounced over the next decade, with the rise of new technologies and alternative music distribution systems. Regions like Houston developed alternative models for reclaiming hip hop in specific ways—and profiting from it. Seeing these "texts" in performance—in the context of everyday social practices—is key.

## Rise of the Entrepreneurial Icons

As a music rooted in particular scenes, regions, and crews, hip hop also opened up new opportunities for artists to act as entrepreneurs. Perhaps Jay-Z said it best when he rapped on Kanye West's 2005 "Diamonds from Sierra Leone," "I'm not a businessman, I'm a business, man." Indeed, artists like Jay-Z, Puff Daddy, and 50 Cent embraced the idea that they themselves were icons who could be "branded" to sell a range of products—from alcohol, to music, to clothing, to food. On one level, this is nothing new. Artists have long performed this role,

using their image to sell a wide range of products. Yet, hip hop artists were unique in their self-conscious and reflective straddling of the complexities of capitalism—like Jay-Z, often rapping about them in their songs themselves. Jay-Z himself draws the distinction I noted above: He is not an artist who is also a businessman; he has become a commodity (i.e., a business)—albeit a strategic and entirely self-aware one.

Jay-Z embodies these various pressures and trajectories in hip hop—from hip hop as a complex lyrical art form to hip hop as a kind of "lifestyle brand" that transcends music itself. While Jay-Z raps in intricate ways about his "big balling" lifestyle and former (alleged) past as a drug dealer, he has also embraced his role as an aggressive capitalist entrepreneur who can move across social circles and classes. Aside from his music, which I will discuss briefly below, he was instrumental in starting his own record label (Roc-A-Fella) and clothing line (Rocawear); he has served in various corporate roles, including co-brand director for Budweiser beer and perhaps most notably president of Def Jam Records; and he is part owner of the New Jersey Jets and owns various other companies and businesses. He has, in addition, continued to record his own music (having 10 highly successful solo albums to date), tour, and perform with others—often rapping about his business ventures and acumen. He is the ultimate corporate hip hop "hustler."

Jay-Z recorded his first solo album in 1996: *Reasonable Doubt*. The album was self-produced on the label he shared with Damon Dash, Roc-A-Fella Records, which soon struck a distribution deal with Priority Records. The album begins with interpolated dialogue from the 1983 film *Scarface*—the scene where Tony Montana (played by Al Pacino) and his partner are approached about picking up drugs from a group of Colombians in Miami. At the time, Tony is working as a dishwasher in Little Havana. His climb to the top of the drug world in Miami begins here—quite violently, as it turns out. It is telling that Jay-Z begins his album with this scene. *Scarface* became a cult classic among hip hop artists—embodying, as it did, the ambivalent relationship that so-called gangsters have with capitalism. An immigrant to the United States from Cuba, Montana ruthlessly and aggressively builds a cocaine empire from the humblest of beginnings. Montana was the ultimate gangster and hustler, and his mythos has become a permanent part of hip hop.

We see here the cinematic appeal and scope of much hip hop—an impulse that would be fully realized on Jay-Z's concept album *American Gangster* (2007), recorded over a decade later. The album (his tenth) was inspired by the film of the same title, about the storied drug kingpin Frank Lucas (played by Denzel

Washington), who rose to prominence in the drug trade in the 1970s. As the film demonstrates (though many claim it's largely fictional), Lucas was one of the first major drug dealers who did not get his "product" though the Italian Mafia—instead, going straight to the source in Vietnam. Lucas built an empire, employing his family members from down South and always standing by his product. A major subtext in the film is that Lucas marketed a very special kind of heroin called Blue Magic—a high-potency brand around which he built his business. Like any capitalist, Lucas seized upon a product, made sure it was better than the competition's, then branded and marketed it aggressively. Of course, the product in question here is illegal and destructive—a paradox at the core of the film. Lucas clearly embodies both the "American" and the "Gangster" in the film's title.

For Jay-Z, the film was something of an inspiration. He notes, "When I saw the movie, the way Denzel portrayed the character, you know, we never seen a Black guy ascend this high in a movie before, to being over the mob. So immediately that struck with me. Like, the success of it all. Like, 'Wow, go!'" (Wilson, 2007). The album reflects the complex emotions and ambivalences, successes and struggles, associated with this lifestyle—comparing it in many places to the music industry. On "Pray," he raps about the prevalence and lure of drugs growing up. On "Sweet," he raps about the highs of drug-dealing life. On "Success," he raps about the ennui and ultimate hollowness of its material gain and reward. Finally, on "Fallin'," he raps about it all falling apart around him. Clearly, Jay-Z is painting a cinematic portrait of the "hustler's" lifestyle.

The album also charts hip hop's own aesthetic arc, as read through Jay-Z's biography and creative life. On the song "Blue Magic," for example, Jay-Z draws upon and reworks the classic Rakim song "My Melody" (1987) to discuss how heroin is packaged. On the original song, Rakim raps, "Whether playin' ball or bobbin' in the hall, I'm just writin' my name in graffiti on the wall...My name is Rakim Allah, R A stands for 'Ra,' switch it around, it still come out raw/So easily will I e-m-c-e-e, my repetition of words is 'check out my melody.'" On "Blue Magic," recorded two decades later, Jay-Z raps, "Whether right or south paw, whether powder the jar, whip it around, it still comes back hard/So easily do I w-h-i-p, my repetition with riches will bring your kilo business." Here, Jay-Z draws upon one of the most important and creative songs in hip hop history, creatively and eloquently turning it around to comment upon rap as a fully branded product.

As noted in the preface to this edition, hip hop has moved away from a sole focus on the recorded album to emerge as a kind of lifestyle ethic that permeates

all aspects of worldwide culture. Artists such as Master P, Puff Daddy, and 50 Cent have turned themselves into full-fledged businesses, branding a range of products—from food (as in Puff Daddy's restaurant Justin's), to clothes (as in Master P's P Miller line), to water (as in 50 Cent's Glacéau). In many respects, Jay-Z was the prototype for this move, one that has had ripple effects throughout youth culture worldwide. Moreover, he has never lost his creative edge. Unlike the others mentioned here, he is widely acknowledged to be one of the most talented vocalists in the art's history. Albums such as *The Blueprint* (2001) and the autobiographical *The Black Album* (2003) were both commercial and critical successes. As I will argue later in this book, these artists are symbols for a new generation of African Americans who want to engage mainstream American culture on their own terms, with their own idiom and art.

## Conclusions

In later chapters, I will take up other developments in hip hop. At this point, I would like to emphasize and underscore the importance of seeing hip hop texts in their contexts of production and circulation. These texts must be seen as always already performative—emerging in their contexts of use. The story is a complex if familiar one—one of commodification, decommodification, and recommodification. The earliest rap singles were sprawling, party-oriented endeavors. With time, hip hop emerged as a recorded and commodified art form—complete with narratives and three-part song structures. Yet, hip hop artists have exerted strong countervailing pulls here—most notably, perhaps, with the rise of mix-tape culture and its concomitant regional pulls. At the same time, hip hop artists have claimed this commercial space in new and complex ways—spreading hip hop in entrepreneurial ways that exceed recorded texts themselves. Hip hop, as noted, is a "leaky" art from.

Understanding the spaces where hip hop circulates is a critical endeavor today—particularly for educators. The spaces that have traditionally nurtured African-American community interaction and congregation—community centers, churches, and the like—are under attack, facing enormous pressure as they deal with the many ills of urban life today. However, they continue to steadfastly operate in a space vacated by traditional schools—a point powerfully developed by Shirley Brice Heath and Milbrey McLaughlin (1993), among others. Rap, as I will show, proliferates in such sites, serving as a kind of alternative curriculum through which often intensely disaffected young people have produced and

maintained notions of community, history, and self. I will extend, in chapters 3–5, this discussion of black popular culture, its production, and its particular proliferation. In chapter 3, I treat the question of place in rap music and talk more generally about the conversationalization and psychologization of contemporary public discourse. In chapter 4, I look at the discourse of generational identity in black popular culture, focusing especially on film and particularly on *Panther* (1995). Next, in chapter 5, I explore the conflict between rappers Tupac Shakur and Biggie Smalls, detailing its complex history and its mediation through emerging popular concerns with psychologized biography. However, my focus will remain on how young people live through the self-contained texts and discourses that emerged in the particular historical context outlined throughout.

Before this, I would like to take a key detour through hip hop history—one which has important pedagogical implications. I would like to look at a key moment when rap redefined itself as a pedagogical art form. I (re)turn now to the mid-1980s.

# · 2 ·

# PEDAGOGY AND PERFORMANCE
# IN BLACK POPULAR CULTURE

The previous chapter offered a brief overview of hip hop texts in performance contexts. I offered a way to see texts as open and permeable, as responsive to the complex and changing contexts of their appropriation and re-appropriation. This chapter looks again at hip hop texts in performance, but offers a uniquely pedagogical angle. I am particularly interested in looking at one period in hip hop (the mid-1980s) and exploring how key hip hop artists responded to the art form's first large-scale commercial shift—that is, the period when rap "crossed over" to ever-wider audiences, with the platinum-plus sales of artists like Run-D.M.C., LL Cool J, and the Beastie Boys. The response of this next—self-defined, as I will note—generation was critical. Artists of this era did not simply attempt to reproduce the success of the Def Jam roster but distanced themselves from this popular approach. While it is commonplace now to posit artists like KRS-One and Rakim, along with Run-D.M.C. and LL Cool J, as "old school" rap innovators, a close look at the work of the first two MCs evidences something more decisive and divisive. Indeed, while Run-D.M.C. called themselves "kings of rock," KRS-One rapped that he was not a "king" or a "b-boy," but a "teacher" and "scholar." KRS-One explicitly positions himself against the popular imperatives of Run-D.M.C. on tracks like "Criminal Minded" (1987), foregrounding, in stark counter-distinction, the pedagogical,

a move with significant implications for our understanding of hip hop and its complex and dynamic history.

Highlighting the underexplored "rupture" in hip hop history yields important insights for those of us interested in hip hop and pedagogy. In particular, it prompts us to de-center the question that has so preoccupied many of us in education: How do we "use" hip hop for pedagogical ends? Looking at hip hop artists themselves as pedagogues shifts this terrain, forcing us to give up the assumed control and competency that often gird such discussions. Seeing hip hop artists themselves as "performing" their own role as pedagogues offers us another angle of vision on the role of the "popular" in pedagogy. In untangling the complexities of this moment, I will focus on the work of noted rappers KRS-One and Rakim, who came to prominence in the mid- to late 1980s. I highlight three themes here: the rejection of the rap artist as a popular icon; the new density in language and word-play; and, perhaps most important, the emergence of a self-defined tradition concerned with, among other things, the origins of the art form. Understanding this nexus of themes—in their specificity and in their contingency—will allow us to see popular art forms such as rap as invested and mutable, open to multiple manifestations and possibilities. This is the space of pedagogy and performance *tout court*.

## Performing the Popular

I am thus concerned here with rap history, but history as performed *by* rappers themselves *about* the art form itself. Critics of rap music have tended not to take such an approach, often projecting their own theoretical and political agendas whole-cloth on to the art form and its lineage. Critics, for example, have tended to place the art in a long, African-influenced trajectory of art forms and political concerns (e.g., Eure & Spady, 1991) or to see it as endemic to a kind of postmodern cultural condition (e.g., Potter, 1995). Such approaches tend to ignore the historically situated work of agents in constructing their own discourses around rap and its origins—a crucial and paralyzing elision. This impulse to appropriate hip hop history in such instrumental ways avoids a serious engagement with its own, situated particularities. It is an impulse, as noted, with broad homologies in a range of disciplines, including those in education.

The work of scholars looking at cultural performance proves helpful in rethinking some of these concerns, raising key questions about performance and the mediation of tradition (e.g., Bauman, 1992a, 1992b; Tedlock & Mannheim,

1995). For scholars such as Dwight Conquergood (1991) and Judith Hamera (2006), tradition is not something handed down whole-cloth; it is something struggled and fought over, made "real" through the invested work of active agents. On this thinking, tradition is not a simple static category but a "strategic process" by which agents animate particular voices in specific ways, linking the present to the past in a way that has implications for the future. Tradition is not a noun but a verb here—porous and open to multiple articulations.

These concerns have been taken up in, among other places, the whole area of black performance and cultural studies, where the performative nature of race—its changeability and adaptability—has moved to the forefront of critique and concern (Joseph, 1999; Julien, 1992; Mercer, 1994; Ugwu, 1995). Filmmaker Isaac Julien (1992) explores the radical implications of the performative for our understanding of race in his essay "Black Is, Black Ain't." Here, he looks at the famous "Blackness of Blackness" sermon from Ralph Ellison's *Invisible Man*—a long call-and-response routine marked by the interspersed chants "Black is!" and "Black ain't!" He writes:

> Ellison's preacher defines the blackness that is recreated in the vernacular signifying tradition of the church sermon, where being black is an open-ended identity. The call and response dialectic is present in the sermon's oratorical exchange between the preacher and his congregation, as the fluid continuum of blackness is made and remade. (p. 255)

Here, black identities are always already performed as the past is ever-open to constant revision in the present. Among others, D. Soyini Madison (2006) takes up these concerns, as in her powerful staged drama with the "ghost" of the late Frantz Fanon over questions of empowerment, colonization, "blackness," and gender.

The implications for studying a popular art form like rap are important. On the logic outlined above, rap's mediation of racial and cultural identity, its purchase on its own traditions, is open to multiple manifestations and particular revisions. Indeed, while popular media have tended to construct a fairly linear and uncritical approach to rap and its history—the "old school" has typically been deployed to encompass artists as diverse as Run-D.M.C., Rakim, LL Cool J, and KRS-One—if we look more closely at the active work of agents "performing" history, we see a more decisive break. We see, in particular, artists resisting rap's connections with dominant, popular culture by stressing the pedagogical, while simultaneously constructing a nascent sense of a rap tradition and history. In the articulation or performance of different notions of the "popular,"

we thus see the classic conundrum of cultural studies—how to define "popular culture"—answered, in dialogue, in revision, in performance, as we see different meanings attached to the moniker over time.

Indeed, this notion of the "the popular," as Raymond Williams (1966) and others have argued, can be attached to a range of different cultural productions—from mass, commodified cultural objects to more traditional, community-based art forms. These different notions of the popular have different implications for educators (a point I will take up in more detail in chapter 6). In particular, the former tend to be treated as invidious and destructive, while the latter tend to be treated as precious and productive. In its most reductive iteration, the distinction is between culture as imposed from "above" and culture bubbling up from "below." Drawing on Antonio Gramsci as well as Stuart Hall, contemporary cultural studies sees popular culture as a "terrain of struggle" between these competing and contesting forces (Dimitriadis & Kamberelis, 2005).

In hip hop, we see something unique in this regard. We see artists themselves having this discussion—struggling over the meaning of "the popular" at precisely the moment when the art form crossed over. That these artists self-consciously and explicitly turned to the pedagogical is key for those of us who might make similar connections.

## Pedagogy and the Popular

The efforts of artists to define rap as pedagogical have critical implications for a whole host of disciplines and areas of inquiry, including education. Indeed, this focus on the work of artists-as-educators struggling to open a space for the pedagogical in rap offers a key counter to much work in pedagogy and popular culture, which tends to explore the complexity of popular culture not on its own terms, as noted, but as a resource for teachers to scaffold traditional curricula. This research does not take the pedagogical work of artists themselves as seriously as it might, eliding and reinforcing a key set of power dynamics and distinctions between educators and their constituencies—a point I raised earlier and will return to later in this book.

For example, Mahiri, in his powerful and important *Shooting for Excellence*, argues that black popular culture has overtaken the lives of young people today and that, in turn, teachers can use black popular culture as a resource to engage young people in complex literacy activities. One teacher, in a key instance, used popular accounts from magazines such as *Vibe*, *The Source*, and *Details*

and newspapers such as the *San Francisco Bay Guardian* to deal with issues like authorial intent and free speech. Mahiri writes that "in discussions of these writings, students were able to understand, explore, and make connections between issues in ways that mirrored strategies that we as educators would want to see employed in the rigorous explications of any academic or otherwise school-based text" (1998, p. 116). He continues, discussing an article that dealt with confrontations between rappers and hip hop journalists:

> The article on the hip-hop controversy is just as densely packed with issues that focus on authorial intention, textual ownership, and intellectual property rights and responsibilities. Essentially, students were able to probe these issues in pieces that attracted or intersected with their interests enough to sustain their investigation beyond merely superficial readings. In the process, we were able to model the conventions of more appropriate readings that are used to operate on a variety of texts, including other school-based texts. (p. 116)

Again, the work of Mahiri is an emblematic example of the way in which many educators are thinking about how to engage the lives and competencies of young people and how to link them to more traditional curricula. This kind of approach is evident in a range of research and theory today, research and theory that advocates "providing accessible avenues for student participation, such as incorporating rap music into language arts curricula to increase student engagement" (Keiser, 2000, p. 290). We see it, as well, in the work of Ernest Morrell (2008) and others in literacy studies who would look to "bridge" school curricula through hip hop.

But perhaps we can, in our interrogation of rap, broaden out the discussion to include the role of the performers themselves as pedagogues (Daspit & Weaver, 1999). Rap, at this critical juncture, defined itself as a kind of alternative curriculum, raising key questions about who needs to be educating whom and why. In many respects, this moment evoked the Black Arts movements of Ron Karenga, Amiri Baraka, and others who called for art forms linked to broad, emancipatory agendas for black people (Karenga, 1972). However, rap exceeded many of the *a priori* notions of racial origin and inheritance so important to the movement. To echo the work of Henry Giroux, rap elaborated a "public and performative" kind of pedagogy, one sensitive to the "shifting nature of knowledge [and] identity," one that operated in "new spaces" outside of school, traditionally defined (2000, p. 130).

Indeed, with the conservative assault on the public sphere reaching a crescendo around this time, a schism grew between "in-school" and "out-of-school"

culture, with unofficial curricula (e.g., rap music, film) and learning settings (e.g., community centers, churches) taking on increasing salience in the lives of the young. KRS-One, along with other performers, anxiously announced this move with releases like *Criminal Minded*—releases that circulated in spaces vacated by traditional school curricula.

## The Rejection of the Rap Artist as Popular Icon

Hip hop began as a situated cultural practice, as noted in chapter 1, one dependent upon a whole series of artistic activities or competencies in dance, music, and graffiti. Like many musics that rely less on the reproduction of an autonomous text (as does, for example, Western "classical" music) and more on the event itself, early hip hop cannot be understood as aural text alone. Rap's indissoluble connection with live performance is evidenced, quite clearly, on early rap singles (1979–1983) as well as bootleg tapes from early shows, where chants like "Throw your hands in the air and wave them like you just don't care!" proliferated. This performance-based approach was eclipsed during the early to mid-1980s, as noted in the previous chapter, a period marked by the rise of Run-D.M.C. and related artists.

With this codification of the recording process came a more explicitly racialized music. Early on, there was a strong Latino presence in hip hop, especially vis-à-vis arts like graffiti writing and breakdancing. In many respects, early hip hop was a more vibrantly multiethnic art form than was later rap, where more explicit and explicitly commodified notions of "blackness" proliferated. LL Cool J, especially, began to wed aggression against dominant society (as noted in the discussion of "I Can't Live without My Radio" in chapter 1) with an often racialized masculinity. He rapped on his 1987 cut "I'm Bad": "MCs retreat, 'cause they know I can beat 'em, and eat 'em in a battle and the ref won't cheat 'em. I'm the baddest, taking out all rookies, so forget Oreos, eat Cool J cookies. I'm bad!" By noting that his competitors are "Oreos," LL equates a lack of aggressive vocal prowess and presence with "whiteness." The implication is that being (metaphorically, of course) aggressive, violent, and "bad" would make one "authentically" black. LL Cool J's image is thus tied into a kind of racialized macho posturing. Indeed, he embraced these ideals in full force, often posing shirtless to show off his muscular figure and often boasting of his boxing prowess. The back cover of his second album, *Bigger and Deffer*, sports a photo of him working out on a heavy bag, complete with thick gold chains and Kango hat. This image—the violent and aggressive young black male—would lodge itself in the collective

psyche of America and its perception of rap music, drawing as it did on decades of affectively invested, dominant cultural discourses and ideologies.

In many ways, this kind of rap did not challenge popular assumptions and popular tastes. It fit well with a profoundly misogynist and popular "cock rock" ethic, an ethic that Simon Frith and Angela McRobbie explore in their ground-breaking article "Rock and Sexuality." They write: "By 'cock rock' we mean music making in which performance is an explicit, crude, and often aggressive expression of male sexuality... Cock rock performers are aggressive, dominating, and boastful, and they constantly seek to remind the audience of their prowess, their control" (1990, p. 374). The clearest example of the merging of "cock rock" and rap was Run-D.M.C.'s hit single "Walk This Way"—a duet with the 1970s hard-rock group Aerosmith. In many ways, Aerosmith and singer Steven Tyler represent the apex of cock rock, an approach with which the group clearly found common ground, especially in their sense of dominating masculinity. In fact, all the artists discussed above merged hard guitar-driven rock and rap on various tracks, including "Radio" by LL Cool J, "Fight for Your Right to Party" by the Beastie Boys, and "Rock Box" and "King of Rock" by Run-D.M.C. All evoked in sound what they did in lyric content.

Importantly, white artists like the Beastie Boys drew on these particular constructions of rap, further reinforcing the idea, following bell hooks (1992), that black men and white men have tended to bond over aggressive expressions of patriarchy. Tracks like "Rhymin' and Stealin'," where the group raps about (among other things) shooting guns and drinking alcohol, evidence the most extreme notions of racialized and masculinized violence and domination. The fact that the Beastie Boys were the first popular white rap group only reinforces the idea that these themes were equated with the broad, popular appeal of rap, here and in years to come.

It is critical to note, however, that the next generation of artists reacted and responded to this co-option of rap by dominant culture. Rap artists during the mid-1980s brought a greater degree of vocal sophistication to this art and an increased awareness of the role of rappers as poets and pedagogues. Key here was a loose collective of artists, Boogie Down Productions. KRS-One—the group's frontman and lead vocalist—stressed a more overtly pedagogical, more lyric-intensive music with the release of their first singles in 1986 and their first album in 1987, *Criminal Minded*. The opening cut on the album is aptly titled "Poetry," while the last is the title cut.

The feel of the track "Criminal Minded" is definitely conversational—a far cry from Run-D.M.C.'s tough on-syllable syncopated sound. Gone are clipped

shouts; instead long lines begin with "See" and "I mean," lines delivered above, below, as well as on the beat. KRS-One evoked the feel and flow of an educated and conversant poet here, moving away from the aggressive and rock-influenced shouting style made popular by Def Jam artists. In fact, more than anyone, KRS-One was consciously rejecting the then-pervasive hard rock/rap "b-boy" image of Run-D.M.C. The term "b-boy" originally connoted one who participated in all the facets of hip hop culture. Yet, with Run-D.M.C., it came to signify something less participatory, a kind of rough, aloof posturing soon associated with commercially successful rap. KRS-One rejects all this when he raps that he is not a "king" or a "b-boy," but a "teacher" and a "scholar."

KRS-One, it seems, is rejecting the very kingdom over which these "kings of rock" (a play on the title of Run-D.M.C.'s second album) have claimed control. It is crucial to note, however, that while rejecting this kingdom, he is claiming, in very specific counter-distinction, a greater sense of intellectual sophistication for himself. Indeed, "Criminal Minded" is replete with references to KRS-One's self-proclaimed status as a scholar. KRS-One—whose name stands for "Knowledge Reigns Supreme Over Nearly Everyone"—references his self-proclaimed status as "teacher" as well as his love for the seemingly erudite art of "poetry" throughout this song. KRS-One, according to "Criminal Minded," is rapping for 1987, "not for 1983"—1983, one might recall, is the year Run-D.M.C. debuted with the single "Sucker MC's."

KRS-One explicitly states alternative allegiances to these more popular ones. He wants not to be elected as a popular "king" but to be respected by "others" as an intelligent artist receiving "leftist contributions." These "others," it seems, exist outside of the popular, those who would "elect" the Def Jam roster—including Run-D.M.C., LL Cool J, and the Beastie Boys—to rule over the kingdom of rock/rap. KRS-One seems aware of just how fickle are the demands of these "popular" audiences, for, as he puts it, kings can lose their "crowns," while teachers always "stay intelligent." Here, as throughout the album, he posits resistance to the "popular" in and through a more overtly critical or intellectual consciousness, one tied to aesthetic as well as political concerns.

KRS-One's self-proclaimed status as a teacher and educator was reflected starkly on the cover of Boogie Down Production's second album, *By All Means Necessary*. Here, KRS-One is featured holding an Uzi, looking cautiously through a curtained window, evoking the famous photo of Malcolm X often captioned "By Any Means Necessary." In many ways, this cover signifies on the group's previous release, *Criminal Minded*, which shows KRS-One and

his partner Scott La Rock sitting at a table strewn with pistols and grenades, holding Uzi submachine guns. The visual signification was complex, multilayered, and even ambivalent: The guns evoked both the gangster-like imagery of songs such as "9mm Goes Bang" (a violent three-part narrative) and the educative power of rap itself (e.g., he refers to his mouth as a nine-millimeter gun). The message of *By All Means Necessary*, however, was considerably clearer, reflecting rap's increasingly explicit role as a tool for political communication and activism—as reflected on tracks like "My Philosophy" and "Stop the Violence," among others.

Rap, with the release of this and related albums, broadened out the issues it would—and could—address, offering itself as a kind of alternative pedagogy and curriculum for disenfranchised youth. As I noted, these popular texts circulated in the space vacated by school-like curricula, which took on less and less relevance with the ascent of conservative regimes in the 1980s. Left-leaning political concerns and critiques would be explored by KRS-One and others (including Public Enemy) in the coming years, as rap became a global medium for expressing political and spiritual concerns and asserting pride in identity (Decker, 1994).

### The New Density in Language and Word-Play

With these moves toward a more self-consciously intellectual music came increasingly complex metaphors and vocal phrasing. On "Criminal Minded," for example, the now-standard gun/mouth metaphor is employed for one of the first times. The power to communicate, always implicit in face-to-face communication, emerges as explicit in the language. Indeed, in years to come, rap's metaphors were to become more and more intense, with the gun/microphone image soon becoming commonplace. The act of communicating came to be equated with brute power, the power to "rock a party" or "move a crowd." Again, as rap emerged as a verbal idiom, artists became more self-conscious of their creative—and largely autonomous—roles. Rappers like KRS-One began to see themselves in traditionally defined "artistic" ways. Self-ascribed epithets of "poet" and "artist" were increasingly prevalent in the work of KRS-One (most obviously) as well as others, including Rakim, who is commonly considered the greatest rap vocalist ever.

Rakim, as evidenced by tracks like "My Melody," discussed in the previous chapter, brings a self-awareness of the power of communicative media to new heights. Rakim begins "My Melody" by addressing his listener's music

system: "Turn up the bass." While this kind of reference to technology can be heard on many of LL Cool J's cuts (e.g., "Radio"), it is extended into a real power on this track, a self-acknowledged power. Rakim, with his microphone, "freezes" other MCs as he heats up the listener's stereo system with his poetry. As noted, many rappers explicitly acknowledged the power to communicate at this point in time. Here that power is transmuted through the technology of the microphone and its ability to transcend time and space through aural transmission. This type of consummate—near-surreal—control and power through technology would become a very large part of rap and its images in the years to come. Rakim, however, extends this power-through-technology to further heights on tracks such as "Follow the Leader," where he raps that his rhymes "engrave" as deeply as "x-rays," referencing the power of his lyrics and their invisible and all-penetrating means of transmission. He continues, on the stunning track, to aver that he can take a rarely heard phrase and "flip it," making it a "daily word." This is a serious power, one that can all but incapacitate—or as he put it "freeze"—his listeners.

The increasing separation between artists and audiences enabled Rakim, it seems, to address the importance of technology in mediating these new kinds of relationships. These new relationships, increasingly privatized, though increasingly intense, allowed for a verbal complexity all but unknown to early hip hop MCs, those who kept live crowds moving from within live events. "My Melody" has a verbal complexity that demands close repeated listening, foregrounding an intricate word-play that could not, one would think, be absorbed in live performance (as when he plays off the letters in his name, "Rakim"). He raps that his melody is "in a code"—an acknowledgment of the lyrical density that entered the music during these years. This density is evinced, as well, when he refers to himself as an "architect," as he does in "Let the Rhythm Hit 'Em." These terms evoke complex images of musical and lyrical construction, ones with, as I will now explain, religious overtones.

Indeed, while KRS-One developed an explicit political agenda for rap, Rakim and others (e.g., King Sun and the Poor Righteous Teachers) touched more upon the spiritual—the politically charged spirituality of black-based Islam (Miyakawa, 2005). Rakim was and is a member of the Five Percent Nation of Islam. This Islamic sect, which claims direct lineage from former (and now deceased) Nation of Islam member Clarence 13X Smith, maintains that 10% of the world (the devils) control 85% (the masses), with the Five Percent Nation knowing the truth. The sect uses mathematics and scientific language to explain their belief that all black men are "born gods," as evinced by its vocabu-

lary, which includes terms like "Build," "Born," "Dropping Science," "Elevate," "Gods," "Knowledge," "Manifest," "Mathematics," and "Original Man." Many such references show up in Rakim's lyrics. He makes liberal use of terms like "knowledge" and "born" and refers to himself as a "scientist" and "architect." Rap, thus, became more lyrically involved than ever before with self-proclaimed artists like Rakim. Examples proliferate on tracks like "Follow the Leader," "Let the Rhythm Hit 'Em," "Paid in Full," and "Microphone Fiend."

This was a key moment of critical validation for hip hop—the moment when it moved from being "just" a party music to being a music with seeming depth and complexity. It was a moment when rap drew upon the deep-bodied sense of artistic craft so enmeshed in the academic imagination. The self-professed trappings of artistic and pedagogic complexity came hand-in-hand with a focus on the individual artist. I recall here Rakim rapping, "I start to think and then I sink into the paper, like I was ink/When I'm writing, I'm trapped in between the lines/I escape, when I finish the rhyme." This stress on language, on the textual, on the creative process, stood in some distinction to the earlier rap texts, which tended to be party oriented.

Rappers were no longer only entertainers but self-professed poets, artists, and intellectuals (in ways I will discuss below). We see a key parallel here with the move from swing to be-bop in jazz. As Amiri Baraka (LeRoi Jones) noted in his still-classic discussion of the shift, early swing was a dance music, a "functional" music propelled by the immediate demands and needs of ever-changing audiences. The birth of be-bop signaled a shift in music and style. Denser and more intricate arrangements became the norm, while symbols of seeming sophistication, the "goatee, beret, and window-pane glasses," all became part of evidencing the jazz artist's "fluency with some of the canons of formal Western nonconformity" (Jones, 1963, p. 201).

Unlike swing artists, be-bop artists turned their back on their role as "entertainers." A cool distance was effected by Charlie Parker, Miles Davis, and others. This was not a dance music first and foremost. Artists like Parker and Davis mined and reworked classic "standards" of the era, giving the music a self-conscious intellectual feel and dimension. According to Baraka, this was very much about moving from a "functional" art form to one that was more of a self-defined and self-directed "art" music. Indeed, Ralph Ellison, among others, would mourn this passing. He writes that, with bop, jazz "has become separated from the ritual form of the dance...the response of the audience is more intellectual...and thus its participation is less immediate" (2001, p. xxix). It was at precisely this moment that the field of "jazz criticism" exploded.

We see something like "hip hop criticism" emerging during the late 1980s as well—most especially with the launch of *The Source* magazine (Chang, 2005). *The Source* was started in 1988 by two Harvard University juniors—David Mays and Jon Shecter—out of their dormitories as a kind of low-grade newsletter. Soon after, the magazine moved its offices to New York City and took on a glossy format—complete with regular columns, commentaries, feature-length articles, and reviews. For many years, *The Source* was considered the "Bible of hip hop," with its reviews taking on a kind of canonical status for artists and consumers. With time, other magazines emerged, including *Vibe* in 1992 and *XXL* in 1997.

In sum, the artists discussed here explicitly pushed rap in more self-consciously artistic and educative directions. Lyrics became more complex, while epithets of "poet" and "artist" proliferated. All this came, it is important to note, as a parallel phenomenon to the emergence of a discourse about rap and its histories and traditions—a discourse that would have seemed anomalous early on. This developed as a nexus of interests and intensities.

### The Emergence of a Self-Defined Tradition

Critically, an awareness of the rapper's "place" in a historical continuum, with clear epochs and periods, seemed to emerge during this period. To return to an earlier discussion, tradition is never simply given but must be actively constructed and sustained in practice (Bauman, 1992a). KRS-One, thus, explicitly places himself in opposition to all those who preceded him on tracks like "Criminal Minded." (Note that he talks about listening to other MCs when he "was a kid.") With rap's emergence as a codified art form, it seems, artists began to make some effort to define their places in rap and its recorded history. Again, this was not a concern early on for those who saw it as a party music and for those who saw it as a kind of popular entertainment. The concern arose for those who began to see rap as an art form, one with educative imperatives, one with a perceived longevity within its recorded archives. Here, KRS-One acknowledges the "rap tradition" while claiming to transcend it or break out of it (he says he "busts more shots" than any of these MCs). KRS-One has since been instrumental in preserving "hip hop culture" and has even tried founding a "temple" for its study in New York City.

If rap had its first "anxiety of influence" around this time, it also had its first "anxiety of origin." KRS-One, in fact, engaged in an on-record feud over the borough of rap's origins beginning in 1986. KRS-One represented the South

Bronx, while the Juice Crew (a loose collection of MCs including Big Daddy Kane, Biz Markie, MC Shan, and Roxanne Shanté and producer Marley Marl) represented Brooklyn/Queens. The "battle" began when MC Shan released a single called "The Bridge," which was about—as the title might imply—the Queensboro Bridge, which connects Queens and Brooklyn. While the single did not explicitly state that these were the origins of hip hop, KRS-One responded with "South Bronx," which stated quite explicitly that the Bronx was where it all, in fact, began. Marley Marl and the Juice Crew responded, in turn, with "(South Bronx) Kill That Noise," to which Boogie Down Productions replied "The Bridge Is Over." There was a real desire to trace what came to be seen as lineage at this time, with stories and myths of surviving wild, violent jams and—more than anything—being there first.

KRS-One defined himself on "South Bronx" and on "Criminal Minded" by consciously rejecting the past (i.e., the music of 1983), while claiming validity by being bound in it (as in "South Bronx"). This seems to be the nature of an artist working out of an amassed body of material, attempting to find some semblance of an individual identity in and within a tradition. By the mid-1980s, rap was its own idiom—a self-contained art form. It was around this period, interestingly, that "rap" sections cropped up in record stores. Up until this point, these albums were typically kept under the "soul" or "R&B" sections of record stores and chains like Tower Records. Yet, with the increasing prevalence of explicitly rap-oriented albums, new rows, sections, and signs were deployed to accommodate them. The genre thus became explicitly defined, its boundaries increasingly policed. What goes where became a key question. Hence, with rap's self-acknowledged move to more pedagogical contexts came an interrogation of its history, origins, and place in and within other African-American music.

All of this, importantly, took place against the backdrop of hip hop's first wide crossover success. In many respects, hip hop artists anticipated key conversations around the role of popular culture and education. In particular, as hip hop became widely popular, it did not simply cater to dominant tastes. Rather, it became more complex, more pedagogical, and began to agonize over its own lineage as a self-contained art form. This impulse should serve as a key corrective to those who would "use" hip hop for functional ends in the classroom. Importantly, artists themselves were having complex conversations about the idiom and its place in the culture well before those of us in academe. Perhaps most importantly, it announced itself as a art form that would work through and struggle with the contradictions implied in "crossing over" to dominant culture—not flatten them out.

## Conclusions and Complications

In closing, when we focus on the kinds of discourses created *by* rappers *about* rap music, we begin to see the art form as a historically evolving and often highly contested idiom, one that confounds ready-made theoretical tools and explanatory frameworks. Specifically, when we treat "tradition" as a verb and not a noun, we see the idiom as complex and evolving, defining itself as pedagogical right at the moment anxieties about tradition and history emerged. We thus see here underexplored resources for thinking through what counts as "the pedagogical" for increasingly disenfranchised young people today. We see, as well, a broader kind of struggle over what counts as "the popular"—a dialogic, emergent struggle over the uncertain terrains of affiliation and identity.

Accordingly, we must at least gesture toward some key, concomitant complications here. Specifically, as I noted earlier, rap began as a performance-based art form, one engaged in particular times and places, one which blurred the line between those "on stage" and those "off stage." However, as rap moved toward a more complex and culturally meaningful vocal art, it left behind these kinds of artist-audience connections that marked the art form early on. As rap became a forum for the pedagogical, as lyrics and subject matter showed more depth and self-reflection, a self-conscious rift between the artist and the audience grew. Hence, the notion of the "poet" and the "educator" drawn on here came to imply a kind of solitude and separation, a kind of solitude and separation that KRS-One underscored when he drew a clear distinction between himself and his audience on "Criminal Minded." "*I* am the lyricist," he raps, while "*they* are the audience."

In addition, the conflict between KRS-One and the Juice Crew prefigured many of the more violent conflicts that would come to mark hip hop. While the so-called "beef" between KRS-One and the Juice Crew did not escalate, many other such conflicts did. In fact, so-called diss records became wildly popular over the next two decades. KRS-One was among the first artists to personalize these attacks, taking them away from the whole realm of lyrical "skills" to decidedly more touchy terrain. As he rapped on the single "The Bridge Is Over," "I finally figured it out, Magic's mouth is used for suckin'/Roxanne Shanté is only good for steady fuckin'/MC Shan and Marley Marl is really only bluffin'." As we see here, KRS-One takes on Mr. Magic, Roxanne Shanté, MC Shan, and Marley Marl—all associated with the Juice Crew—with a stream of homophobic and sexist assaults. While the single was something of an anomaly at the time, it is important to note that it set much of the tenor for future hip hop.

Ultimately, then, understanding this extraordinarily complex moment puts us in the middle of a web of contradictions. Understanding this particular nexus of contradictions, I argue, is crucial for beginning to understand rap's role in contemporary U.S. culture, for allowing us to see this art form in all of its complexity and all of its contingency and all of its possibility. This, again, is the space of pedagogy and performance *tout court*.

# II
# HIP HOP IN PRACTICE

# POPULAR CULTURE, CONSTRUCTIONS OF PLACE, AND THE LIVES OF URBAN YOUTH

Over the next three chapters, I shift focus from the production to the reception of popular culture texts, challenging rigid distinctions between the two along the way. As I will demonstrate, young people today are using contemporary media to define themselves and to map their daily lives in ways that often confound adults. These texts, discussed in the introduction and in the previous chapter, are circulating and are being picked up in many different and often entirely unpredictable ways. These texts are no longer—if they ever were—embedded in stable social systems that draw participants into coherent and predictable modes of reception (Thompson, 1990; Lash & Urry, 1994). Reception practices, as many now realize, cannot be assumed *a priori*, nor can their effects be prefigured. Indeed, though control of signs and sign systems is an increasingly important part of success in this global information age, we have very little sense of how young people actually use these texts to construct their identities, their unique subjectivities, and their social networks. The default response, quite often, is to assume that we can read relevant information off of texts themselves and use this information to explain the lives of various social actors. The default condition here is to assume high levels of predictability from text to subject, a problem with much work in cultural studies and education (Giroux, 1996).

It is a central proposition of this book that the specific links between individual biographies, local social networks, key institutions, and broad cultural

values as realized in popular texts must always be posed as empirical questions in situated contexts. They cannot be assumed. For example, the connection between popular texts and lived lives may be very weak (as one might imagine in certain totalitarian regimes in which state-imposed propaganda may be derided by many), or it may quite strong (as I found among many of my subjects). In addition, this picture might be more or less complicated by the presence and importance of local social networks and institutions. Friendship networks and their particular histories, especially as they play out in particular institutions, can radically shape the kinds of texts young people value and how they choose to talk about them in group contexts (Buckingham, 1993). Finally, individual actors with particular life courses and biographies, goals, and wills inextricably complicate this picture. Ultimately, one can never exhaust all meaning at the level of individual biography (Richards, 1999). All of this points to an emerging complexity in studies of popular texts and texts-in-performance, a complexity, I argue throughout, that can be appreciated only by way of situated studies in concrete contexts, with real subjects.

As I will demonstrate here, popular media forms made a whole host of constructs available to the young people at the community center where I conducted this research. These constructs were part of day-to-day life and conversation in ways fairly easy to predict. Yet, I did find some surprises here as I explored local friendship networks and individual biographies in situated institutional contexts. I argue here that the closer we get to young people's lives—their individual biographies, their valued friendship networks, and the institutions they traverse—the less predictable is the role of popular media. Specifically, this chapter focuses on two African-American teens, Rufus and Tony, and how they used key popular texts to construct a sense of place in the small city where this research was conducted. These two teens mobilized these texts in particular ways, both finding specific thematic links between and across them and using them to index their relationships with biological and extended family, in this city and "down South." These two young people reconfigured a Southern tradition of specific values and mores, one that provided a highly valued sense of stability in the face of an intensely precarious social, cultural, and material reality that each lived through in his own way.

This study thus assumes that places are created and maintained by active agents in particular ways, by and with particular kinds of cultural resources and with real consequences therein (Appadurai, 1996; Gupta & Ferguson, 1997). These constructions, I will stress, have fundamental implications for the kinds of selves that young people can inhabit, a point underscored by much recent

work in human geography, cultural studies, and youth culture. As Skelton and Valentine (1998) argue, young people must typically traverse places defined and policed by adults—for example, schools and shopping malls. Understanding how young people map their own lives here, how they create their own personal sense of place within and between these sites, is of crucial importance if we are to begin to develop the policies and institutions most relevant to and for their lives.

I begin by looking at this small city in historical and social context, arguing for a kind of qualified dynamism that can be located both in traditional patterns of black migration from the South and in the more contemporary "work of the imagination" (Appadurai, 1996, p. 9). I then look more specifically at rap music, noting how themes key for the realization of self in this community (e.g., "playing") emerged. Extending the discussion begun in the previous chapters, I situate these themes in terms of broader cultural discourses (e.g., the psychologization of public discourse), opening up questions about which kinds of forces helped make which kinds of "selves" available to and for young people. I then show how one group of young people lived through these discourses in fairly predictable ways. Finally, I look at Rufus and Tony, best friends, and how they mobilized these constructs vis-à-vis highly valued, local social networks. I explore how these constructs linked these two teens to real and claimed familial ties in town and down South. I look, as well, at the ways each teen lived through these constructs and how they enabled and constrained the teens' life courses.

## Setting and Participants

The site for this study was, as noted, a local community center (or "club") in a small Midwest city where I developed and ran a weekly program devoted to discussing African-American vernacular culture generally and hip hop or rap music specifically. I maintained the program and its curriculum for two and a half years. This program was offered as one of a handful of programs at a center that served more than 300 economically marginalized African-American children in the community. In this program, we discussed popular texts and figures—most often related to hip hop or rap music—in open-ended and nondirected ways. I typically brought in a number of prompts for discussion (e.g., copies of song lyrics) and gauged what my participants were most enthusiastic about discussing. I chose a new prompt whenever discussion seemed to wane. I usually began by asking participants to interpret or explain the meanings

of these texts, though these discussions almost always led us toward key events in their daily lives. The participants ranged in age from 10 to 17 and met in two separate groups (ages 10–12 and 13–17). These focus groups typically consisted of three to ten participants who attended many but not all sessions. The younger group tended to attract larger numbers than the older group. The younger group typically attracted more boys than girls, while the gender balance was more even in the older group. I also conducted one-on-one interview sessions with a number of older teens, including Rufus and Tony. These interviews were explicitly nondirective and more like informal conversations, designed to elicit the kind of detailed biographical information that might be excluded from more populated focus groups.

I came to this site as a researcher in 1995. However, my role changed considerably over time, in ways that helped me understand this site and its role in the community more clearly. Most specifically, as I was conducting research, I also began performing volunteer work in the fall of 1996, doing a range of tasks, including answering the phones and monitoring the main games room. Over the course of this year, I impressed some of the older staff members, including the unit director, and I was asked to become a regular staff member during the summer of 1997. There were about five staff members total. In this staff role, I developed and maintained educational and recreational programs for children in three age groups: 7–8, 9–10, and 11–12. I returned the following fall for two more years of volunteer work. Toward the end of the second year, I helped organize the activities of the teens and the newly opened teen center. My shifting position—as researcher, volunteer, and staff member—gave me greater purchase on the site itself, the community where the center is located, and the children and adolescents who peopled the club and participated in my program. All of these insights, as I worked these various hyphens, were central for this work (Fine, 1994).

Indeed, as a white researcher working in a nearly all-black setting, I was clearly marked as an outsider, someone who had entered into a formal, contractual relationship with the site and its members. I agreed to bring pizza to each meeting, and these young people agreed to provide me with valuable data. I did not share any responsibility for the club or for maintaining its rules. My relationship to and with these young people was clearly contained. As a volunteer and staff person, however, I was more aligned with the authority structure of the club, an institution that had a long history and privileged role in the local community. I was able, as the only white person who occupied such a position, to negotiate new kinds of relationships and trust with young people over this

period. (Discussion of the constraining dimensions and ethical problematics of occupying these new roles for someone also conducting research is beyond the scope of this chapter and is treated elsewhere [Dimitriadis, 1999b]).

As I became a fixture in the community and at the center, I had opportunities for more informal kinds of interactions with these young people, including Rufus and Tony. As the rare individual with a car, I was called on for trips to the supermarket, to the bank to cash checks, to the Laundromat, and the like. In addition, young people would drop by my home from time to time. While conducting this research, I lived only two miles or so from the club. My apartment was located right between the club and the local high school attended by many of my older participants. This accessibility and opportunity for informal interactions complemented the interviews and focus group sessions I conducted at the club. This situation reflected my growing role as a trusted, older figure in their lives.

## Space, Community, and Popular Culture in a Small "Hub" City

### Space and Community

The small Midwest city where this study was conducted has a population of more than 60,000. It is equally distant from a handful of major cities, including Chicago and Indianapolis, and readily accessible via a number of interstate highways from Southern cities, including Mississippi, Alabama, and Tennessee. In addition, the Amtrak railroad runs through this "hub" city, a line that connects Chicago and a number of key Southern towns and cities, including the ones mentioned above. However, because of the prohibitive costs of other forms of transportation, the Greyhound bus and car pooling remain the primary options. African Americans are the largest minority group here (nearly 20% of the total city population), though whites overwhelmingly dominate (at nearly 80%). The African-American population has traditionally been highly mobile and often transitory, coming from and going to this city for a variety of reasons. Individuals, as I will note, can often trace their complex family histories across the South and Midwest. These family ties are both biological and "claimed."

This is a starkly segregated town. The site of a major Midwest university, the town is divided, quite literally, by the railroad tracks. When I first met the unit director of the community center, he commented that while black kids

will often be rowdy and even destructive in their own neighborhoods, they are scared to "throw a piece of paper on the floor" in white parts of town. These divisions are psychological as well as physical, reinforced by the "common sense" of both blacks and whites. One key example: I repeatedly observed white people inform new white students of the "bad"—obviously black—parts of town upon their arrival. This kind of segregation resonates across this city in multiple ways and contexts. For example, the public school system was sued for its de facto policies of segregation around the time of this research.

In addition, there are strict class divisions in this town. The black community on campus exists in an essentially separate world from the black community in town. This was tragically reinforced during the time I conducted this research when two teens from the local community tried to enter an on-campus party at a multicultural fraternity house. When they were denied admission because of their gang-related clothing, one pulled a gun and fired into the house. An engineering student from Jamaica was killed in the incident and another student injured. This shooting reinforced for many the stark divisions among black people in this small city.

Economic promise (real or not) attracted many African Americans to the city. Until the 1970s, this was a manufacturing town, with a number of major factories. These jobs have largely disappeared, the victims of corporate downsizing. Young people still speak of these jobs as lucrative, however, and of the individuals lucky enough to have them as all-but-wealthy. I recall, in particular, one staff member in his early twenties who left a job at a large food company in 1997 to follow his professed dream of working with young people. Other staff members and children alike often noted that his taking the job at the center (which paid about $6 an hour) meant taking a serious pay cut, indicating a high degree of commitment.

Work on the railroad was another traditional economic incentive for people to move here. In fact, Tony's grandfather, Phil, whom I will say more about, came to the city to do railroad work. He eventually bought a small house, which indicated, for many, the relatively rewarding nature of this work. These jobs, of course, have disappeared completely. In fact, many of Phil's grandchildren, unable to secure such work, have lived in his house at various times when in need. For many, service-sector jobs in fast food (e.g., McDonald's) and mega department stores (e.g., Kmart), as well as manual labor at the university or local hotels, provide the most common alternative options. As a result, young people typically work jobs similar to those of their parents. Salaries here are typically minimum wage (or slightly above), $5.15 in July 1997, with little or no security or benefits.

Fear is another reason that African Americans have migrated to this city. Traditionally, many left the South fearing racism and racial terrorism. This fear is still a living memory for many, including the unit director, who often related stories of racism—both explicit and implicit—in the South. These fears of the South recurred at the site as a result of a proposed visit by the KKK. As I will note, many young people commented that the Klan is still active down South and also spoke of relatives who have experienced the Klan's violence. As one young person commented, "They came from Mississippi or Alabama... They be going around burning houses and stuff, putting people, black people, on crosses and burning the crosses."

Many have expressed a general fear of crime, a fear encouraged by popular media forms that often construct cities as irredeemably violent (McCarthy, 1998). Many children from larger cities have been sent here to avoid violence, especially the gang violence that became pronounced beginning in the 1980s. I recall one staff member in his early thirties who had left Chicago several years earlier, in the mid-1980s. When I asked why, he said, "Mom's thought it was about that time!" He was being recruited by a major gang. One young person who left Chicago to come to the town commented that he left because "my mamma thought this was a nice and quiet place." This young person, who briefly flirted with gangs in the city, commented: "While they gambled like on the street, I supposed to be sitting up, watching them... if you see police, they say, if you see police, tell us, there's like a little signal to make on the corner. They'll run, and then I'll be like another kid playing." When speaking about life in Chicago, he commented: "At twelve o'clock, mostly every night... on the West Side... those gangs gonna be shooting... just in the air. It woke me up in my sleep." In a similar vein, one young person commented: "In Memphis, if you wear a starter coat, they'll try to take it... I been there before and then I saw somebody, they was getting chased and they was like, 'help me, [they] trying to take my coat!' and then they just kept on running and then I had me on one, then I just took off. Zip around the corner." During this discussion, there was much debate concerning which cities were most dangerous. For these youths, this town provided, again, a good and safe alternative.

This city, thus, has an African-American population that migrated here for a variety of reasons, often to leave behind racism, find better jobs, or, more recently, to avoid the violence of larger cities. Following Clifford, Appadurai, and others, these patterns of migration can be linked to social and cultural shifts in media forms and technologies. Yet, this migration can also be linked

to a broader, diasporic migration of blacks from the South to the North, one enabled by a once-burgeoning railroad system (Stack, 1974).

Indeed, the South looms large in the collective imagination of these young people, who typically trace complex family histories to and across Southern cities, including Tennessee, Alabama, Arkansas, and especially Mississippi. Often these young people have come from Chicago, but it is usually "by way of" one of these Southern sites. An interesting interaction stands out here. One evening, a young girl came to the club and, as she signed in at the front desk, the unit director asked her where she was from. She responded "Chicago." He then asked, "By way of where?" To which she responded, "Just Chicago." Sensing she was trying to be evasive, he then asked, "Where are your parents from?" She laughed and then said, "Mississippi!" Many young people share histories of migration. During a discussion of family history, one young person noted, "I got people from…Atlanta, Chicago, Texas, Mississippi," to which another young person said, "Everybody from Mississippi." Still another said, "I know! That's where most people in town from." Indeed, such comments (e.g., "Everybody got family in Alabama!") were common.

Since family members are so spread out across the county, family reunions are often a way to convene and reinforce family ties. Such family reunions were a ubiquitous subject of conversation among club members. Homemade T-shirts announcing family reunions were common. These reunions, it is important to note, are often held in succeeding years in different locations across the South and Midwest. Unlike reunions that take place every year in one site, these are highly mobile, evidencing how populations are spread out, how familial identifications transcend geographic sites while indexing them. T-shirts often indicate the year of the reunion and, importantly, the particular site where these events are held, often by way of maps. These sit side-by-side with remembrances, prayers, and photos of beloved and often departed family members.

Importantly, "family" indicated claimed or chosen relations as well as biological relations for many young people. (Claimed relations, for example, often attend such reunions.) Typically, young people will choose to "claim" people who are not related to them by blood or will disclaim those who are. This dynamic is complicated by the fact that maternal lines of relation are much stronger to these young people than paternal lines. One can more easily choose not to claim a step-sibling by one's father than one can a step-sibling by one's mother. During a particularly telling conversation between two girls, for example, one, Keisha, commented: "I don't even like my own brother [kin on her father's side]. I barely claim him…he ain't gotta claim me either!" She

continued, "My sister Keia [also kin on her father's side], we claim each other. She cool." Thus, while blood relations were mobilized here to give warrant to Keisha's claim about her father, they served to index, ultimately, the fluidity of these familial ties.

These kinds of ubiquitous discussions indicated the contingencies around claiming family as well as the durability and strength of claimed ties. I often heard young people refer, in the possessive, to their "brothers," "sisters," and "aunts," only to find out later that these were claimed relatives. These notions of family were connected to shifting and dynamic notions of place as well as histories of migration. As such, family and community were mapped by young people in ways that often implicated particular, highly complex, and mobile notions of place.

## Place and Popular Culture

A sense of place is thus quite dynamic in this town, implicated in complex interpersonal connections and claimed family ties, often across geographic sites. I will look now more closely at the role of popular cultural texts here. Extending the previous chapter's discussion, I will trace some important tendencies in the historical evolution of rap music vis-à-vis the emergence of key themes and constructs, including that of "place." I then explore how these themes were picked up by young people in this town, often in fairly monolithic ways. In the following section, however, I shift focus and narrow in on the lives of two teens. Here, I show these teens powerfully drawing together and co-articulating these themes, using them to recreate stable notions of place and of community.

Taste in rap music is very much connected to notions of place. Whenever I asked young people what their favorite kind of rap was, they almost always answered "East Coast" or "West Coast" or "the South" or some combination of the above. The personalities of key iconic figures, such as Master P, Biggie Smalls, and Tupac Shakur, were co-constituted through their implication in particular places. Thus, favoring Tupac Shakur is tantamount to favoring West Coast rap, as favoring Biggie Smalls is equivalent to favoring East Coast rap.

Sometimes these constructions were stable, with individual geographic areas and discursive constructs evoked in monolithic ways. For example, the two teens who are the centerpiece of this study used Southern rap music to reconstruct a sense of community and shared Southern values in this city. In any kind of discussion about music, they typically stressed that they favored Southern artists. When speaking of other artists they liked, these teens typically

said that they "sound Southern." The South is thus of primary importance here. It is a discursive construct through which these teens filtered many other popular themes.

Sometimes these constructions were more fluid. For example, one white teen who lived for a time in Chicago noted that "Chicago rap" was among his favorites, noting especially "underground" artists whose albums and recordings (as he perceived it) could be purchased only in Chicago. Yet, this same teen pointed to the music of the West Coast as well, linking the two explicitly. This teen referred often to his favorite artists as "Chicago and West Coast," often with a nod to the South.

To fully understand the importance of place, and why place has emerged as such a relevant construct for thinking and talking about rap, one must appreciate hip hop in historical context. Hip hop music, as I noted in the previous chapters, was originally a performance-oriented music, situated in particular times and places and inextricably connected to other art forms, including breakdancing and graffiti music. During the early 1980s, however, with the rise of Run-D.M.C. and related Def Jam artists, rap vocals were delinked from this complex set of practices. Narratives soon became most important, with clear choruses and themes. Hip hop became less of a situated and performance-based music and more of an art form consumed and disseminated in myriad, less localized contexts. The music no longer indexed live events but was disseminated by way of self-contained texts. Rap became a popular American art form.

Not long after that point, rap experienced its first "anxiety of place," and, indeed, place would emerge in time as one of the most dominant themes in the music. This dynamic needs to be located within broader historical contexts as well as within the idiom itself. As many cultural critics, especially those drawing on constructs from geography, have pointed out, capitalism (and global capitalism in particular) has tended—paradoxically—both to erase and to stress the particulars of place (Harvey, 1990). The typical example is of small localities that must now foreground difference (e.g., tourist attractions) to single themselves out in a broadly homogeneous global culture. Thus, as an increasing number of texts came to the marketplace, rap artists had to distinguish their work in particular ways, such as stressing the local.

This move to the local can also be located in broader cultural imperatives. Beginning during the late 1960s, there was a historic move to identity politics in the wake of the decline of the civil rights movement (Shattuc, 1997). Broader notions of shared community gave way to more local constructions of identity and community. This is evidenced, most clearly for my work, in the demise

of groups like the Black Panthers and the Student Nonviolent Coordinating Committee (SNCC) and in the rise of more locally constructed "gangs" such as the Crips and Bloods (Perkins, 1987). Emblematic of this shift is the opening scene from the 1991 film *Boyz N the Hood*. The main character, Tre, is giving a presentation to his grade-school class about Thanksgiving and comments that everyone in the world originated from Africa because that is where the first human remains were found. Another youth in the class, clearly more aligned with gang culture than the Afrocentric discourses Tre draws on, comments, "I ain't from Africa—I'm from Crenshaw Mafia." This is a reference to a Los Angeles street the Bloods claim.

One can also locate this stress on place within the hip hop idiom itself. Specifically, the first anxiety over place in rap centered on a "borough war" between MC Shan and KRS-One. MC Shan released a single called "The Bridge," which referred to the Brooklyn/Queens Bridge and told tales of hip hop's earliest years. In turn, KRS-One, feeling that MC Shan did not properly respect the Bronx, where he felt rap had truly begun, released "South Bronx." Both singles were released in 1986, the year after Run-D.M.C. released rap's first platinum-selling album. Place thus became very much a part of the music—a site of intense anxiety—as it grew in popularity and scope.

Another conflict over place, less specific in geographic scope but broader in its implications for the music, broke out a decade later. This conflict, in contrast to rap's earliest "battles," foregrounded the lives and biographies of iconic personalities, including (most especially) Tupac Shakur, who represented the West Coast–based Death Row Records, and Biggie Smalls, who represented the East Coast–based Bad Boy Records. Much of this conflict revolved around off-the-record personal conflicts. Tupac thus claimed, in the single "Hit 'Em Up" and elsewhere, that he and Biggie had been friends but that Biggie had stolen his style of music. He did not criticize Biggie's music as much as the "fact" that Biggie did not live the life he rapped about but instead imitated Tupac's. This conflict has been explored elsewhere (Kamberelis & Dimitriadis, 1999) and will be treated in more detail in chapter 5.

This conflict gelled together regional differences in music that had been a part of the idiom since the mid-1980s (Cross, 1993). Part of the reason this conflict became such a large and ubiquitous component of the music and the culture surrounding it was that it drew on conversationalized discourses widely available in dominant culture as a whole—for example in talk shows or newscasts, which have come to stress personal biography and narrative (Fairclough, 1995). As noted elsewhere, the internal lives of these characters and their motivations

and biographies became most important, eliding other kinds of structural and political considerations (Kamberelis & Dimitriadis, 1999). This discourse conjured up "the real" for many young people, allowing and encouraging them to psychologize the violent conflict between the two camps.

These psychologized notions of self enabled a whole host of themes to come to the forefront of rap music, including "playing," "player-hating," and anxieties around "respect," especially as linked to the contingencies of local friendship networks. Thus, being a "player"—being able to manipulate the opposite sex for sexual and economic capital—was a part of both Biggie's and Tupac's music, as was "player-hating." These themes are, of course, entirely a part of the kind of personal rivalries that became so pronounced in the music, beginning around this time, with the ways the music came more and more to stress personal narratives detailing complex life stories.

Playing was a construct that many teens—boys as well as girls—used to talk about romantic relationships, in which manipulation for sex and money and affection was the seeming ultimate ideal and hurt and loss were the risk. Though not necessarily linked to physical invulnerability (girls, for example, were often better players than boys), playing was more about the ability to sustain and maintain mental and emotional distance. Many of these teens were fans of music that highlighted this lifestyle, and many—both boys and girls—attempted to reproduce it in their own lives. For example, one girl from Chicago was noted and highly respected—by both boys and girls—for her ability to exchange affection for material items. As one awestruck teen noted, she even had her boyfriends "kicking it" (or hanging out) with each other while they provided her with clothes and money. Her relationships, however, were not physical. As another teen qualified: "She's not a whore or anything, because, you know, she don't be kissing all of them. She just get money from all of them. Just make them feel like they're important." This kind of lifestyle is entirely common, and many girls spoke often of their numerous boyfriends. However, most of these teens also stressed that they would leave behind the practice of playing for a committed relationship, though these often imply a great deal of interpersonal risk. These, it seems, are the two options, an issue I will explore later.

Concurrently, the idea of "player-hating" has become very popular both in music and in the everyday discourse of teens. For example, during one session a teen turned on the Master P song "Haters" and sang along: "Look at all these haters...Stop all this hating, I can't take it no more, just trying to get mine, you best get yours, so what you hating for?" When asked what player-hating

is, he responded: "Say, you know what I'm saying, you going out with one girl, right?...Then there's another girl that, oh, you wanna get with and then you go get with her. Well...your woman that you was first going out with, goes and tells the other woman that you going out with another woman. That's what player-hating is." This teen then related a number of cases in which his friends had "player-hated" on him. This notion of playing and player-hating is very much a part of popular culture, in the work of Master P, Mase, Puff Daddy, and others. It is indicative of a kind of distrust that is evident in all areas of teens lives, in the notion that "self" comes first and one can really trust only oneself. It indicates the degree to which friendship and trust are paramount in the lives of these young people, yet, in turn, how fragile these constructs truly can be.

In a key example, during one focus group session, a teen asked to play the song "Ride 4 You" from Master P's 1997 soundtrack album *I'm Bout It* and proceeded to play it a number of times, singing along with it, as did the rest of the group. This song, though it was not commercially released as a single, was clearly a favorite among group members. "Ride 4 You" is about "riding out" or helping out one's friends in potentially violent situations. During the discussion, the teens (who were all friends) related a story about being attacked by another group of teens, noting one young person ran away from the group when it happened. When I asked why it wasn't okay for this girl to look out for herself, another noted, "That's bogus, they shouldn't of came in the first place if they, just run for their self...if it's your real friend, you ain't gonna leave your friend." While friendship was prized by these teens, it was a constant source of anxiety and tension. "Friendship" was informed and cross-cut by the widely accepted notion that one can trust only oneself. That one can trust only oneself is evidenced by ubiquitous comments such as "I don't have friends—only associates."

The question of trust is central. Many teens claimed to trust only themselves and their immediate family. Intimate relationships were to be avoided. When asked what friendship is, one teen commented, "Somebody who won't leave you when you're in trouble." Trust is too serious an emotion to play with. As one teen commented: "You can't trust nobody in this world. I mean, once you let down your guard to somebody—bam!—they just creep up behind you." This same teen further commented: "Really, I trust myself, right now. I mean, I got associates and stuff like that. But I really trust myself. I probably kid around with folks, talk to them. I call them my friends but they really my associates."

The notion that one has associates and not friends was reiterated numerous times in discussion. In the end, teens said that it is difficult to trust anyone and

that trust is earned in precarious ways—like standing by someone when he or she is in physical danger. Even gangs, often portrayed as a crystallization of the familial ethic, were eschewed here. As one young person put it: "If you were in the hospital or something, your gang wouldn't be there for you. Your family would."

These constructs cut across East Coast, West Coast, and Southern rap, as I will note, pointing to a paradox in the music itself. As the music has grown in scope and reach, similar themes have registered across different geographic areas in very powerful ways. Note, again, that Tupac derided Biggie for imitating his lifestyle, not for the life he proclaimed to live. However, simultaneously, the music has proliferated in powerful ways into individual and often brutally antagonistic scenes in different parts of the country. Part of this move to more localized rap scenes has to do with changing modes of production and distribution. Like many arms of media culture, rap became increasingly marked by centralized distribution and decentralized production deals during the late 1990s, a point I would like to explore now (Morley & Robins, 1995).

Many international, highly mobile entertainment conglomerates—for example, Sony and Warner—now make distribution deals with local producers who head independent record labels such as Suave House. This arrangement has been enabled by a number of sociocultural currents, including the rise of entertainment chains (e.g., Virgin Records, which deals with only the six major distribution companies), as well as by the failure of these companies to produce and market rap artists with local "street" currency. These conglomerates thus find it expedient to make distribution deals with local record companies that have already worked with successful independent artists.

The industry had, up until this point, a different *modus operandi*. In general, talent scouts or A&R people would "discover" individual artists, sign them to the record label, and then produce their music and promote their careers. The industry no longer thrives on iconic figures alone, nor does it assume the risk of developing long-term careers. Though individual artists and iconic figures such as Master P are stressed, they are linked to local scenes and large "crews" (an informal social network) from particular neighborhoods, as I noted in chapter 1. Artists from the same label will almost always rap on each other's albums— tracks with three or more rappers are the norm today—and artists will claim on-record explicit allegiances to their record labels and neighborhoods. This is nowhere more evident than in the career of Master P and this story of his record label No Limit Records. Master P has assembled a self-proclaimed "No Limit Family," including rappers Silk, C-Murder, Mystical, Mia X, Fiend, and Snoop

Dogg. P and his in-house production crew, Beats by the Pound, produce all of these artists in their private studio and have negotiated a profitable distribution deal with Priority Records that allows them to keep a majority of their profits. Master P stresses the role of family on all No Limit recordings, often deploying Mafia-like imagery on his tracks, as underscored by Master P's 1998 album *MP Da Last Don*. In summary, as Morley and Robins (1995) have noted, the rise of multinational, vertically integrated entertainment conglomerates has produced, paradoxically, a more localized kind of entertainment, providing models of friendship and association to which many teens are gravitating.

Rap has also tended to articulate very particular notions of space and place, creating virtual links between disparate sites, ones that work to co-articulate key themes in the music. Thus, rapper Master P—a Southern rap artist from New Orleans—has released albums featuring artists from the West Coast. A late 1990s collection that brought together artists from the West Coast and the South was titled *West Coast Bad Boyz*. Other collections, such as E-40's *Southwest Riders*, feature artists from the South, West Coast, and Midwest.

Young people often made similar "common-sense" connections. For example, in one discussion, a young person commented that the Midwest and the South have always "got along" with each other, noting similarities in their music and ethic. In another example, John, a white teen, made a mix tape entitled *Westside Playa #1*. It contained songs by Master P, 666 Mafia, Biggie Smalls, Tupac Shakur, Bone Thugs-n-Harmony, and Twista. Thus, Southern artists (Master P), artists from the West Coast (Tupac) and the East Coast (Biggie Smalls), and Midwest artists (Bone Thugs-n-Harmony and Twista) rested comfortably together. Yet, the title marked it as explicitly "westside."

Interestingly, the term "westside" was used to signify California, the West Side of Chicago, and the west side of this town. All three references contain the traces or resonances of gangs and gang-related activity, central themes in the music. For example, many rap artists from the West Coast—that is, California— began the practice of "throwing up" a "westside" hand sign, much like the one that gang members use. The West Side of Chicago, in addition, is known for its heavy gang-related activity, as is the west side of this city, and both are marked by the presence of the Gangster Disciples or Folks Nation street organization, a factor in the "common-sense" linking of these places.

The term "westside" referenced all these at once for teens, and often indicated that people would settle personal conflicts violently. An example stands out here. I was working at the front desk one night, signing in young people, when the unit director and a young teen started joking with each other. The

teen quickly and deftly grabbed a pair of scissors and held them up. The unit director laughed and said: "See, she went right for the scissors! You can tell she's westside!" These constructs are thus open, multiple, and polyvocal. Being "westside" implies a specific set of values, values linked to a sense of place but not bound by its dictates.

In summary, we can see that the themes and constructs of much contemporary rap music were picked up wholly by young people who, for example, used the defining construct of "place" to talk about the music. In addition, they drew on rap's most dominant themes (e.g., being a player or valuing the local) in multiple ways in their daily lives. Thus it seems one can assume or predict much as we move from text to lived lives here. Yet, I did not observe a clear and systematic connection between place, genre of music, and key themes, nor did I observe a grounding of key values in particular geographic regions, though these values were often broadly associated with them. Instead, I found something very different when I began to explore one local social network and the individual biographies of two teens. Here, I began to see the co-articulation of these themes in specific and often defining ways that mediated specific social relations and life courses. I would like to look now at how the social networks enabled and sustained by these two teens allowed for a very specific articulation of place in this town. These teens used these texts, as I will note, to solidify their mutual friendship and to index key relationships both biological and claimed, linking them to their local friendship network or "clique" in this small city.

## "In the Clique": Two Teens Construct a Sense of the South

I will focus the rest of this chapter on two teens, their particular social network, and their particular constructions of place. I will highlight the themes they used to construct this worldview around community, respect, and playing—themes readily available and entirely valued by many young people, as noted above. The teens discursively linked these themes in particular ways, connecting them to family and friends, as well as to their Southern home town. These teens reconfigured a stable Southern tradition in this city by using, in part, Southern rap, a popular art form. Ultimately, as I will argue, the teens used these texts to help create a sense of stability for themselves in the face of a profoundly uncertain future.

These young people created a kind of "traditionalized" discourse about Southern rap, one entirely linked to day-to-day survival. Like generations before them in the North, these young people used available discursive resources to recreate the sense of a caring and stable community, one that mitigated a profoundly precarious social, material, and cultural reality. Yet, the imperative of daily survival often cut across and reconfigured this sense of community in important ways. These two young people used these resources—resources marked as Southern—in often paradoxical, highly individualized ways, which ultimately put them at cross purposes to each other.

The two teens in this study, Rufus and Tony, are 17- and 18-year-old African Americans (respectively) who attended the Midwest community center where I conducted this research. While similar in many ways, these teens have, until recently, followed very different life courses. Rufus has stayed clear of trouble, forming close relationships with the club and its staff members. While he has not done particularly well in school, he has participated in many extracurricular activities such as football and has done well in them. A well-liked teen, Rufus has received a number of awards at the club, including "Youth of the Year," as well as at school. Tony, however, has had a considerably more conflict-ridden life. As he stressed to me a number of times, he has had numerous problems at school with his teachers and with the law throughout his life. He spent nearly all his teen years on probation and was involved with gangs from age 13.

The teens, however, are close friends—they call each other "cousins" even though they are not related by blood—and come from the same home town in Mississippi. Tony has a large family in this Midwest city, including numerous aunts and, most especially, cousins. Rufus, significantly, referred to all of Tony's cousins as his own. They are all roughly the same age and have been Rufus's primary group of friends for his entire life. This group, numbering roughly six, share a long history; they even lived together in the same house for a time growing up. This house, recently torn down in a city-wide renovation project, was at the center of their early lives, serving as a kind of home base for the group. When Rufus's mother moved up to this town from the South, she stayed in this house with Rufus until she got settled in her own home with the help of one of Tony's aunts—Rufus's godmother—who got her a job. This house was a first stop on the trip from Mississippi for many.

These claimed familial ties were crucial for both teens, as was their friendship generally. Tony looked up to Rufus as a person who could "kick it" or hang out with different groups of people without getting into the kind of trouble he often found himself in. In this Rufus is singular, as other members of the clique

had trouble with the law and were also involved, in varying degrees, with gangs. He was also a sympathetic ear for Tony, who commented that Rufus was "like a counselor" to him, helping him through some particularly hard times. Finally—and perhaps most significantly—Rufus was a living connection to a Southern neighborhood and ethic that Tony prized above all else. In turn, Tony and his family provided Rufus, whose only blood relative in town is his mother, with a family of his own away from his home down South. He noted: "Like up here, I really don't have no family. I just call Tony and them my cousins 'cause they the closest thing." This large familial network was very important to Rufus, providing him with a sense of solidarity as well as informal protection in the neighborhood.

Family networks are often mobilized by youth, from a very young age, to deal with interpersonal conflicts. As I have observed at the club on many occasions, young people will almost immediately call on family members to help them deal with interpersonal and potentially violent conflicts. Someone with a large family is privileged in many respects, while someone with a small family is often at a disadvantage. In fact, many parents tell their children that if their siblings or relatives are in a fight, they are morally obliged—if not explicitly required—to help them out. Children were often at cross-purposes here. They would be suspended at the club if they were caught fighting, but in trouble with their mother or father or grandparents if they did not fight. Many staff at the club acknowledged that, growing up, they were told similar things by their own parents.

This kind of protection played a crucial role in Tony's life as well. For Tony, the clique provided a network that allowed him to decrease his involvement in his gang at the point in his life when he wanted to turn things around for himself. Gangs purportedly offer a ready-made family for young people who will stick up for each other no matter what. In reality, many young people talk about how difficult it is to trust anyone in one's own gang and how gang members, typically very self-centered and self-directed people, are often the first to turn on each other when there is trouble (Jankowski, 1991). As Tony got older and decided to extricate himself from his gang, the clique provided him protection and also provided him with a tightly knit peer group, most of whom also happened to be in gangs. Family ties, however, were most important here.

Indeed, both teens stressed that these familial ties came before other kinds of allegiances, including potential gang allegiances. As Tony noted, "No matter what this gang and this gang is, you gonna draw together [i.e., look out for one another]." Rufus offered another example, referencing Midwest gang rivalries

(Gangster Disciples and Vice Lords) as well as West Coast ones (Bloods and Crips): "Two common ones, GD and Vice Lord or Blood or Crip. That's a clique right there, those four would be a clique. They would clique together. It's a set thing, if they was from the neighborhood, your neighborhood comes before your gang."

Both teens linked the idea of the clique to valued notions of the local. While they both stressed that the clique is not a gang and that they do not claim territory as does a gang, the clique shared a memory of growing up together in this neighborhood. Both Rufus and Tony were very clear about the specific streets and avenues that defined where their neighborhood began and ended. Staying loyal to this neighborhood was important to both. This was realized in various ways, including cleaning up litter, helping older people with chores, and physically protecting their neighborhood from outsiders, including drug dealers.

Both teens marked this kind of local pride as distinctly Southern and linked it to elder figures in their lives. For example, the unit director of this center, Johnny, grew up right outside of the same Mississippi town that these two teens were from; both teens prized and often mentioned this fact. Johnny was, in almost every respect, a neighborhood hero, and it would be hard to overstate his importance in their lives. As both Rufus and Tony observed, Johnny made an extraordinary amount of money by community standards. However, he maintained his home in the neighborhood (he lived a block away from each) as well as all of his old allegiances and friendship networks. Tony noted:

> He got all this money, but he wish to fix him up a fancy house in the middle of the ghetto, you know what I'm saying? That's what I really like about Johnny, 'cause he ain't trying, 'cause like most black people...when they get the money to they head, they try to get away and get the biggest fanciest house, the fanciest cars.

"Moving up," thus, was not equated with "moving out" for Johnny. However, this ethic—which both Rufus and Tony explicitly validated—was not shared by everyone from the South. During this same discussion, they mentioned another family, the Johnsons, in contrast. Tony reflected:

> The Johnsons and them, they went through a rough time in the South also. That's the way I see it, and then, so now they got all this money so they let it go to they heads, saying they don't want to live the way they used to live. But Johnny, on the other hand, he was born and raised in the South and he stuck with the South. He still visit the South till this day.

Thus, the Johnsons equate success with rupturing old ties (i.e., saying they don't want to live the way they used to), while Johnny, in explicit contrast, has "stuck with the South," implying values of selflessness and community that these teens explicitly linked to a shared, lived memory of their home town.

These values were crucial for both Rufus and Tony. In fact, Rufus, who similarly embodied them, was the recipient of much positive attention at the center at the behest of Johnny, resulting in a number of local awards. He was featured in a series of newspaper articles about the club and was on television a number of times. Unlike individuals who were criticized for letting such attention "go to their heads" (i.e., separating themselves from the group), Rufus characteristically downplayed much of the attention focused on him, further evidencing this egalitarian ethic. In fact, Rufus was quick to point out that he was just a club member like any other and encouraged younger kids to try to get the awards and attention that he received. During one session, when I showed him a newspaper article in which he was featured, he indicated that he hadn't read it. His only comment was that it should have featured other club members more prominently. During this same discussion, he commented, "I'm getting tired of being graded better or lesser than the next man," noting that this kind of "grading" takes place in school and out of school by both teachers and peers.

This is an egalitarian ethic, self-consciously rooted in a sense of the South and mediated by a number of important personal relationships as well as by key cultural texts. Indeed, as both teens stressed, the South was a site where such communal values were prized, a place that forced people, due to rampant racism, to stick together and look out for one another. As Rufus noted, people in the South have "been through a lot" together, and this has prompted them to maintain a familial ethic. Both teens shared this "living memory" of racism in the South and (in turn) of the ways that communities had to come together to face it. One key example: Both related stories of communal discipline while growing up in their Southern home town. Neighbors outside the family had an obligation to discipline other people's children, and numerous "whoopings" were the norm for transgression. Similarly, Rufus and Tony both took it upon themselves to discipline children in the neighborhood, just as they were disciplined. This, it seems, was "acting Southern." Of course, the implicit assumption here was that these transgressions carried higher potential consequences in a racist criminal justice system, where these children would wind up, if they were not "checked" in the community early on.

Indeed, this egalitarian Southern ethic is one of the traditional survival practices that this community and other African-American communities have

had to maintain in the face of intense poverty and racism. This is a point that Carol Stack (1974) makes in her classic ethnography *All Our Kin*, in which she notes that material and social exchanges and obligations between families and extended kin are very much "a resilient response to the social-economic conditions of poverty, the inexorable unemployment of black women and men, and the access to scarce economic resources of a mother and her children as AFDC [Aid to Families with Dependent Children] recipients" (p. 124). Again, this sense of extended community was very much tied to the imperatives of material and social survival.

Johnny was one of a number of key figures who embodied the ideals these teens posited as distinctly Southern. Another was Tony's maternal grandfather, Phil, who was a particularly strong presence in Tony's and Rufus's lives and in the neighborhood in general. As Tony put it, "Basically, he's the grandfather of everybody in this neighborhood." When I first met Rufus, he referred routinely to this man as his grandfather, though it later emerged that they were not related by blood. Like many African-American grandparents, Phil opened his house up to many relatives in need, including several of his grandchildren, and even to Rufus, who considered Phil his *de facto* grandparent. In addition, Phil owned a car and routinely drove Rufus and his mother, as well as Tony's mother and siblings, to perform myriad day-to-day tasks, including the always important job of getting groceries as cheaply as possible. Like Johnny, Phil was someone who had lived in the community for many years and was always there to help out others when they were in need. It was Phil who housed Rufus and his mother when they first made the trip up from the South.

Both Johnny and Phil thus gave themselves over to the community in selfless ways—again, a value that was marked by these teens as distinctly Southern. Just as important to the teens, both Johnny and Phil embodied ideals of physical and emotional toughness and invulnerability. Both maintained a sense of individual respect at all costs. Johnny, as unit director of the club, had to settle many conflicts and fights between teens. A physically imposing man who lifted weights at the club with many of the youth, Johnny was not averse to physically intervening between combatants; indeed, he marked this as a source of pride. Johnny worked hard to earn the respect of younger club members, and a large factor in that was his physical presence. He was highly respected by many young people in town, including many gang members and leaders, who tended to keep their conflicts away from the club at his behest. However, more important than his physical prowess was his ability to settle conflicts without fighting. When Johnny, after nearly two decades, left his job,

he was replaced by a younger man, a former football player who weighed more than 300 pounds. Johnny commented to me that his size would not necessarily help him with trouble-making teens. Maintaining control was largely a mental endeavor, effected by way of roots in the community as well as by the ability to generate a more intangible kind of respect.

Though nearly 30 years older than Johnny and suffering from diabetes, Phil had a strength and toughness noted often by Rufus and Tony. Phil was unafraid of anyone and reportedly used to keep an rifle in the trunk of his car against any eventuality. He was also rumored to have loaned out resources in the not-so-distant past and to be able to effectively demand repayment as well. Tony's grandfather, they said, demanded respect and got it from everyone, including those younger. Tony elaborated, "He got a belt for every child in the neighborhood that don't call him granddaddy." Both teens stressed how distinctly valued this kind of respect and autonomy was in the South. Rufus noted that in the South, "You gotta give grown folks they respect." To which Tony added, "It's all about respect...'cause down South this how it is...you gotta show that respect."

A similar kind of autonomy and invulnerability was at work, and explicitly valorized by both teens, in romantic relationships. Playing, discussed previously, meant different things to different young people. For Rufus and Tony, playing meant flirting with different girls at the same time, rarely committing to any one, always having another relationship possibility in case a current one fails. Though the term "pimping" was often used interchangeably here, these practices seemed far more egalitarian than the term might imply. They never involved coercive mental or physical manipulation for sex, an act that was treated as a very serious social, physical, and psychological commitment for the teens I worked with—girls as well as boys. In fact, talk about playing and pimping, I found, was a way to mitigate the very real personal risk that intimate relationships always seemed to imply for these young people.

Key here for Rufus and Tony were elder figures in both their lives, especially family members. Indeed, both Rufus and Tony drew on specifically Southern familial and interpersonal ties to inform their discussions of playing. As Tony noted, "I think being a player runs in your blood...I think it's hereditary." Rufus concurred, saying that he had an uncle "down South" who was a player and also a cousin who should be a player but wasn't. He remarked: "Sam, he was the son of a player. Therefore he a player. He should be a player now. But Sam, he ain't like that. He a happily married man." The son thus was an exception that proved the rule—playing runs in one's family. Even Phil, according to

both, was a "player." Tony noted: "I don't care what nobody says…he the truest player…I don't care what nobody say. I know it for a fact." Playing thus was an ideal marked by both as distinctly familial and distinctly Southern.

Thus, these youths have constructed and sustained a particular notion of the South, one mediated and realized by key figures in their lives. I want to suggest here that the themes that the teens made use of in their construction of the South were marked by both as unique to Southern rap. Indeed, although these themes were available in rap in general, these teens posited Southern rap as distinct here. Importantly, both posited Southern rap as an alternative to investing in the highly violent dichotomy between the East Coast and the West Coast mentioned above. For example, Tony commented, "The South is cool with everybody," noting that artists from the South rarely "diss" other artists on record like those from the East Coast and the West Coast do. While discussing the East/West conflict, he commented that Tupac "should have took his ass" to the South instead of involving himself in the rivalries. He repeatedly noted that "the South on [is interested in] pimping, playing, and making money"—not petty conflicts. Southern rap was a key resource through which their connections to the South and to each other and family members—including the clique—were enabled and sustained, though in entirely unique ways. In fact, both, I argue, used this popular form as a way to access and make new and relevant this constructed tradition—a tradition that has helped African-American communities survive in the past and in the present.

During one of my earliest discussions with Rufus about rap, he noted that his favorite rap artists were 666 Mafia, Kingpin Skinny Pimp, and others associated with the Prophet Posse record label. He also said he liked Eightball and MJG, Tela, and others on the Suave House record label. Both are Memphis-based companies. During a later discussion, Tony said that he liked all of these groups, but added Master P and related artists on No Limit Records, based in Louisiana. Both teens thus spoke more of record labels and localized (here, explicitly Southern) sounds than of individual artists, deeming Suave House, No Limit, and Prophet Posse their favorites. Both Rufus and Tony self-consciously identified with the perceived egalitarian ethic these Southern rap artists used with each other and within their neighborhoods. During an early discussion, Rufus commented on the importance of local Southern crews:

> Really down there that's what it's based on. If you from my hood, if you in a different gang, it don't matter, 'cause you from my hood. Like if you was a—I'm gonna use the Bloods and Crips—if you was a Blood and I'm a Crip, but you was born in my neighborhood, we still boys…so it's just like a clique thing.

Thus, one's neighborhood and local allegiances were more important than gang allegiances, which can span (at least in theory) beyond the local. (e.g., the rival Bloods and Crips gangs are represented—often symbolically—throughout California and the Midwest, while Chicago gangs such as the Vice Lords and the Gangster Disciples have proliferated in the Midwest.) Rufus went on to note that the artists who are loyal to their clique will help one another out when they need help. Notably, artists who get famous have an obligation to put other rappers on their records to promote fledgling careers.

However, as Rufus noted, some artists don't sustain this egalitarian ethic and are the focus of negative criticism. During an early discussion, Rufus brought up a conflict between rapper Player Fly (who has received little public attention) and his former group-mates in 666 Mafia (who have received more). He noted that 666 Mafia did not help him out once they got famous: "Player Fly was once with them, right? So uh, I guess they got up, and they made so much money, since they on a worldwide tip. Player Fly still underground. But yet, I guess he said they forgot all about him. They don't even know, remember they neighborhood." Rufus thus saw certain kinds of allegiances in the "crew system" of Southern rap and prized them. These values included staying close to one's neighborhood and helping out others from the neighborhood when possible—exactly the same ideals that registered in their construction of the South. When discussing a favorite cut, "Serious," from a compilation entitled *Young Southern Players*, he noted: "I relate to that one because he's saying how things were in his neighborhood and how he gonna stick with his neighborhood. The neighborhood makes the person, stuff like that. I felt that, 'cause I love my neighborhood. All my friends and stuff."

The importance of extended friendship networks and familial ties came up numerous times in our discussions, both formal and informal, and was explicitly linked to the vicissitudes and uncertainty of a cruel world. As Rufus noted: "You can't stand alone in this society. You gonna need somebody. If I made it big, and Tony went the low route or even it's the other way around, and Tony went big, I say, 'Tony, man, look, I need some help.' 'OK, man, you my boy you help me out...I do the same for him.'" Thus, the world is rough, and having friends who can watch your back is crucial. Tony mirrored Rufus's sentiments about friendship and community. But he added the crucial dimension of "respect," which played so pivotal a role in his life. (While Rufus claimed respect was important to him as well, it had not defined his life course in quite the same way.) When I asked Tony whether he agreed with Rufus about "standing alone," he responded, "Most definitely, you got to have somebody look out for you at all times. Like I

said, society rough out there now." He continued, drawing on Southern rap to inform his conviction, "Like Eightball said, 'I trust no man, 'cause man will put you down every time.'" When I asked whether he trusted people in the clique, he responded: "Can't trust nobody. But like I said, I got respect for my boys. Like I said, when it comes down to it, I'ma ride out with them before I ride out with anybody." This point is crucial—both the egalitarian clique ethic and the kind of radical autonomy indexed by "respect" were implicated in personal survival, as ways to defend against a world that's "rough out there now."

Tony, in particular, tended to stress throughout his life a kind of "invulnerable self" as a means of self-preservation. Tony had a clear sense of right and wrong and always felt the need to speak up for himself if he thought a wrong had been perpetrated, often to the point of physical confrontation. Indeed, when, as he perceives it, people do not show him respect, he "snaps." When I asked him for an example, he noted:

> Like when we in class and the teacher make a mistake and then I try to correct her, even though I'm raising my hand or something and then she gets a little attitude or whatever. I don't appreciate that...Got kicked out of class for correcting a teacher...Basically, the dean gave me an hour detention and I snapped, 'cause I felt I shouldn't get no detention for trying to correct a teacher.

In fact, nearly every major incident in which Tony got into trouble with the school or the police (e.g., when he was accused of attacking his boss at McDonald's over nonpayment of wages) was over his "snapping" at another person when he felt he was not accorded respect. As he noted: "I hate when people call me wrong when I knows I'm right. So then I snaps from there." As he perceived it, snapping was the first step to a more physical confrontation.

In contrast to Rufus, I argue, Tony's stress on "respect" was enabled by his large familial network of kin in this city—ties that are, in the end, stronger than claimed ones, a fact that came up in numerous painful discussions. Someone was always there, it seemed, to help Tony if he got into trouble. For example, as mentioned earlier, when he chose to leave his gang, his clique—which also included numerous gang members—was there for him.

This kind of respect, and the feelings of self-preservation and invulnerability that often underlie it, was also very much a part of romantic relationships, which were similarly fraught. Indeed, romantic relationships were a constant source of discussion and anxiety, as they implied a loss of self that was frightening for both teens. In the face of this uncertainty and contingency, these young people drew on an ethic of invulnerability and mutual manipulation. As Tony noted,

"To be a player, you can never like your females...well, you can like them but you should never fall for them." The problem, of course, is that the one female you "fall for" might be playing you. As Tony noted later: "You should never let a female be your main attraction...over the rest of your females. 'Cause then, that one female'll use your game [i.e., of playing] to go against you...play you at your own game. Then she'll be the player and you'll be one of her hoes."

Here as well, both Tony and Rufus noted that they learned a lot about playing from rap music. As Tony said, "Rap music, they tell you how to pimp and play [women]." When asked for examples, Rufus cited the songs "Sho Nuff" and "Space Age Pimpin." These teach you, in his words, to "get you a ride [i.e., car], take her wherever she want to be," both metaphorically and literally. Tony in turn noted that the song "'Lay It Down'...tell you how to play females...basically telling you how to keep your game [of playing] down." "Space Age Pimpin" and "Lay It Down" are both by the rap group Eightball and MJG, while "Sho Nuff" is by Tela, who is on the same rap label, Suave House. The artists on this label are marked by their emphasis on playing and its attendant attitudes toward women and conspicuous consumption. Eightball and MJG's most popular album is entitled *On Top of the World* and features tracks like "Pimp in My Own Rhyme" and "Space Age Pimpin." It is important to note that East Coast rap—especially the work of Biggie Smalls—stresses many of these same ideals. However, to inform these discussions the teens continually drew on the explicitly marked genre of Southern rap, one which indexed a highly valued social network including key Southern traditions and family relations.

In addition, the films of Dolemite (or Rudy Ray Moore) were repeatedly mentioned as favorites, films that they were able to "learn" from. Released in the 1970s, though now circulating widely on video, these include *Avenging Disco Godfather* and *Petie Wheatstraw*. Rudy Ray Moore is famous for his deep Southern accent and his characters, like Petie Wheatstraw, that draw on traditional Southern folklore. In fact, it is worth mentioning here that "Peter Wheatstraw...the Devil's only son-in-law" reminded the narrator in Ellison's *Invisible Man* of his roots back home in the South, with his blues singing, "*She's got feet like a monkeeee*" (Ellison, 1947, pp. 176–177).

In summary, this interpersonal ethic was entirely linked by both teens to a Southern-influenced worldview mediated by memory, popular cultural texts, and key agents. The South—and Southern rap—provided both with stability and feelings of invulnerability in the face of intense anxiety. Both found this stability in rap and in the intergenerational ties it indexed. These constructs allowed the teens to live locally validated lives while linking them

both to a Southern heritage that mediated a whole series of valued familial and interpersonal networks that have been particularly important for both Rufus and Tony.

Yet, it is crucial to note that while these teens made use of a Southern tradition to mediate ever-present feelings of anxiety and uncertainty, this tradition was, in practice, also shot through with tension. Conflicts within the clique, for example, were numerous. Tony was constantly having big and small physical and verbal fights with his cousins over things such as sneakers borrowed without permission and jokes that cut too deep. Rufus, in addition, said that members of his clique were often his main antagonists growing up, noting that they had many fights among themselves. As Rufus stressed many times, members of his clique knew his strengths as well as his weaknesses, making them particularly good allies and particularly bad foes. Respect among these peers must be constantly negotiated and renegotiated. It is never simply "given."

In addition, the monolithic sense of respect that is seemingly and unconditionally given to older people down South was simply not apparent in this city. Key relationships were mediated by the forces of institutional authority and social positioning—some of which were stronger than others. Teachers, who represent a system many young people find culturally and personally alienating, must earn this respect in specific ways that are precariously sustained. For example, both teens spoke of teachers they respected who were not intimidated by students and did not defer to others. They were clearly exceptions. Family members, especially kin by their mothers, were more likely to be respected unconditionally. In many respects, Tony's maternal grandfather, Phil, was linked to a Southern tradition that both teens associated with a strong sense of self and respect. This kind of respect was different from the kind accorded to teachers, for example. It was more likely to be given unconditionally. Yet, even familial respect had to be maintained. Tony commented to me that he had a hard time respecting his father because his father had all but abandoned him. More importantly, he also commented that he would even fight his maternal grandfather, Phil, if he ever hit his mother. However, this seems the most far-fetched example, as his grandfather indexed a monolithic and idealized sense of the South, linked to a seemingly stable line of relatives.

Finally, the notion of playing, which both teens marked as an ideal and as linked to familial ties and lines, was similarly unstable. Tony was quick to point out, for example, that one can give up this "game" of playing if one finds a romantic partner who is truly trustworthy. Concerning one girl with whom he wanted to have a committed relationship, he noted: "I ain't really tripping

off [trying to manipulate] her...I respect [her] because of the way she treated my mom." This girl asked to take Tony's mom out for dinner, and he thought this was an act of "respect" and enough of a reason to not play her. As he noted on a number of occasions, she made him want to "settle down" and give up his "other females" as well as the practice of playing and the sense of self it implies. Yet, even here Tony noted, almost as an aside, that he did not want this young woman to meet his mom because she might glean embarrassing information about him. These constructs were therefore flexible but also highly durable. While social networks, including romantic ones, were valued, they implied a loss of self that could be frightening. In effect, their fragility was at the heart of Tony's anxieties about self and one's precarious relationships with others.

I have thus shown how these two young people produced and maintained a certain kind of local ethic in this Midwest city, using the themes available in Southern rap. These themes were valued by all young people, but these youth used them in specific ways to index an idealized notion of the South. This empirical insight resonates with contemporary currents in anthropology that stress that "culture" is not coherent or static but is instead a rough assemblage of discourses that individuals mobilize in specific ways and not others. In fact, the themes and constructs these young people picked up from popular culture and connected to the South (e.g., friendship, respect, and playing) were intimately connected to day-to-day survival and, as such, coexisted in often intensely precarious ways. One recalls here the many conflicts over personal respect in the "clique."

These teens, however, found some kind of broad and necessary cultural continuity by making use of these popular resources. This finding is worth stressing, coming up, as it does, against popular discourses about the loss of history and tradition in African-American communities, most especially because of the perceived effects of rap music. Indeed, critics such as Farah Jasmine Griffin (1995) have argued how a seemingly communal sense of the South has been symbolically recreated in the North by the first migrations of African Americans, often as a survival tactic. Many have argued, in turn, that this kind of community has been lost to an out-of-control generation of black youth—most often symbolized by and through rap music (a phenomenon I will explore more fully in the next chapter). Yet, we see here that these teens attempted to create a kind of cultural continuity through these same popular resources—an insight that simply could not be prefigured by textual analysis of rap lyrics alone. The lives of these teens were thus both continuous and discontinuous with the past, as tradition must be created and recreated in the present (Bauman, 1992a).

As such, it is important to consider the particular contemporary forces that have enabled these kinds of constructions: the flows of money, ideas, people, technology, and identities that have allowed these forces to become salient for these teens at this historical moment (Appadurai, 1996). Significantly, this sense of the local has been enabled and encouraged by a certain kind of "tribalization" in rap music. Multinational conglomerates, as noted, now cull producers and groups of artists from local, independent record labels, forming broad-based distribution deals that result, paradoxically, in a plethora of local music scenes.

One such scene, Memphis rap, provided these teens with the resources to live through these Southern values in a distant geographic space, to index a valued sense of community. However, just as this worldview was not shared among their peers, both Rufus and Tony lived through these resources and discourses in unique ways that had real consequences for them. In fact, Rufus and Tony, though united very deeply, saw themselves and were perceived by others as having followed significantly different life courses up until very recently.

The tensions that exist in their complex and contradictory notions of the South were key here. Drawing on communal resources and constructions of the South, Rufus was entirely willing to place himself in the background, to avoid conflict and maintain a kind of "conciliatory" role. In fact, Tony suggested that Rufus was like a counselor to him. He was an extremely good listener and highly supportive, someone willing to give himself over to others, including the community. Rufus, out of necessity, had to expand his circle of extended kin, and perhaps thus maintained a nonconfrontational and conciliatory personality. This was a survival tactic for Rufus, one he found indexed in Southern rap and in its constructions of community.

Tony, however, was more willing to fight for certain kinds of social and cultural capital, risking his own "self" both literally and metaphorically. Tony's more confrontational personality was, I argue, enabled by local kin ties that were considerably stronger for him than Rufus's local kin ties. While these ties had always to be sustained and maintained, they were more likely to be "given" unconditionally to Tony. Yet, Tony, in his effort to turn his life around, came to be more self-reflective over the years I knew him, using these Southern cultural resources differently. Indeed, while respect and playing were both important for Tony, he came to stress "playing" first and foremost. Recall his comment that rappers in the South were more interested in "pimping, playing, and making money" than in conflict (although conflict was no less important to Southern rap than it was to any other kind of rap). These constructions of the South, as

I have argued throughout, were intrinsic to survival, and survival—including staying out of jail, finishing school, and getting a trade—came to rely more on mental dexterity than physical confrontations for Tony.

## Conclusions

In conclusion, both teens managed to create a certain kind of "place" for themselves out of the dominant "spaces" offered in this small city (de Certeau, 1984). These processes were exceedingly important for both teens and give us insight into the ways that young people can mobilize texts—here, rap music—in unpredictable ways over complex life courses in particular social networks. As such, this work goes some way in engaging questions posed by those in human geography and cultural studies (Skelton & Valentine, 1998).

It also, perhaps, gives some insight into the ever-growing popularity of Southern rap. When I conducted this study, Southern rap was still a relatively underground movement. While groups such as 666 Mafia had begun to achieve some notoriety, it was nothing like the widespread appeal they would have in later years. In fact, 666 Mafia soon changed its name to Three 6 Mafia, to shed imagery associated both with the satanic (666 is often the sign of the Devil) and gangs (where the number 6 is often associated with the Folks Nation). They have gone on to record several successful, major-label albums (e.g., *Da Unbreakables*, 2003; *Most Known Unknown*, 2005; *Last 2 Walk*, 2008), straight-to-DVD movies (e.g., *Choices*, 2001; *Choices II*, 2005; *Clean Up Men*, 2005), and television shows (e.g., *Adventures in Hollyhood*, 2007). But perhaps their biggest "crossover" success came with the film *Hustle & Flow* (2005).

Three 6 Mafia's song "It's Hard Out Here for a Pimp" was featured on the film's soundtrack and became the first hip hop song by an African-American group to win an Academy Award. The film and the song reflected many of the themes marked by Rufus and Tony as key in Southern rap—respect, family, community, and struggle. In fact, a subplot of the film involves the main character's efforts to get his demo tape noticed by a now-famous rapper named Skinny Black. Trying to get out of the "pimp game," the main character DJay records a demo and tries to get Skinny Black to hear it, upon his return to Memphis for a Fourth of July party. We see here the tensions around community noted above—in particular, the notion that Skinny Black forgot about everyday street life in Memphis once he got famous, as well as the need for DJay to maintain a sense of personal respect. It's a familiar set of tensions—one evoked by Rufus

and Tony as well as the characters in this film. It's a set of tensions that, it seems, have captured the national imagination as Southern rap has taken center stage.

In addition, this study gives us insight into how tradition is mediated in the present, how tradition is "performed" or made real in the face of intense anxiety. In a sense, following Bauman, these young people have made Southern rap a traditional discourse, one that reaches across generations and provides key social support in the face of flux. As Bauman has argued, tradition should be considered not a noun but a verb, a process by which people create a sense of historical stability for themselves, linking contemporary concerns to the certainties of the past. He writes:

> Tradition, long considered a criterial attribute of folklore, is coming to be seen less as an inherent quality of old and persistent items or genres passed on from generation to generation, and more as a symbolic construction by which people in the present establish connections with a meaningful past and endow particular cultural forms with value and authority. (1992a, p. 128)

In closing, understanding these processes, how young people navigate their way between the various and often highly disjunctive influences operating in their lives, is crucial if educators are to forge more locally relevant policies, institutions, and curricula for often intensely marginalized young people. Indeed such work might help us to consider more clearly questions of multicultural curriculum development in school settings, helping us understand in less prefigured ways the affective investments marginalized young people have (or perhaps might have) in particular texts, popular and otherwise, as well as potential links between and across them. Such work—less sutured in its assumptions about the connections between texts and lived experience—would do justice to the complex lives of young people like Tony and Rufus, young people who must, as I have shown throughout, search for and sustain community, as Tupac Shakur rapped, "against all odds."

## · 4 ·

# MOBILIZING HISTORY AT A LOCAL COMMUNITY CENTER: POPULAR MEDIA AND THE CONSTRUCTION OF GENERATIONAL IDENTITY AMONG AFRICAN-AMERICAN YOUTH

As I demonstrated in the previous chapter, two of my key participants, Tony and Rufus, took the resources available in popular culture and used them to recreate privileged notions of the South, ones that provided them both individually and together with a desperately needed sense of social stability in this small city. Both confounded the popular notion that tradition has been lost to young African Americans today; they showed, rather, how such tradition is mediated and recreated by active agents to deal with contemporary concerns. In this chapter, I take up similar questions, though I turn to questions of generational identity. I look at how such knowledge is mediated across generations, both to construct a sense of "blackness" rooted in history and to deal with often pro-foundly dangerous contemporary contingencies. I turn, as well, to black popular film. As I argued in chapter 1, hip hop texts are linked in constitutive ways, with film having emerged, alongside music, as a central resource for young people and the imaginative worlds they inhabit. For many young people, the visual and the aural are linked in ways difficult for older people to understand fully.

Specifically, in this chapter, I look at how generational identity is mediated both in school and (more especially) out of school for young people, how young people choose to mobilize such knowledge, and the consequences they face as a consequence. Focusing on the film *Panther* (1995), I look closely at which popular filmic texts young people resonate with as well as how they pick them

up and use them to deal with historical contingencies, here a proposed march in town by the KKK. How these youth inhabit particular discourses, I want to emphasize and will demonstrate, has very real consequences for their developing selves and life courses. Throughout, I will remain sensitive to the ways young people connect these filmic texts to other popular resources in often unpredictable ways.

# Popular Culture, Popular History, and the Work of Audiences

## History and Generation Gaps Among Young African Americans

I begin with a broad-based look at history and generation gaps among African Americans today. Indeed, much recent work on race—both popular and academic—has stressed the (supposed) generation gaps emerging for African Americans. A 1997 cover story in *Newsweek*, "Black Like Who?," carries the very telling subtitle "Black families in the '90s are divided, as whites were in the '60s. And hip-hop is their Vietnam" (Leland & Samuels, 1997, p. 54). The article thus implies, as a point of departure, that black Americans have an autonomous and contentious "youth culture" much like one that became pronounced for whites during the 1950s and especially 1960s. This is an important supposition, for, as many have noted, the concept of "youth" was one generated out of white middle-class values and mores, at a point of relative prosperity in the United States (during the 1950s), when white teens could literally afford to spend time on leisurely cultural and political activity (Jenkins, 1998). Youth became a privileged in-between stage, a buffer zone between the seeming innocence of childhood and the rigors of adulthood. In addition, popular entertainment industries helped co-constitute this category of youth by marketing niche products such as rock and roll.

This kind of prosperity has not traditionally been afforded to African Americans, whose cultural productions (e.g., blues, jazz, and soul) were not so specifically and antagonistically constructed as a part of a youth culture within a broader trajectory of black arts. A clearer sense of cultural continuity, rooted in oppression, marked this music and culture, a point underscored in the work of numerous cultural critics, including LeRoi Jones (1963) and Charles Keil (1966). Thus, *Newsweek's* implicit claim that a similar kind of

privilege was available for African Americans in the mid-1990s is important and provocative.

If we take the discursive construction of generational identity as a starting point (Coupland & Nussbaum, 1993), it is necessary to investigate a whole host of popular and academic discourses to understand how a seemingly autonomous African-American "youth culture," the so-called hip hop generation, is being constructed in the popular imagination today. Clearly, the work of "media cultures" is crucial here, as Henry Giroux (1996) notes in *Fugitive Cultures*. The popular notion that young African Americans (specifically, men) are out of control and without traditional notions of community and solidarity is elaborated by films such as *Menace II Society* (1993), *Boyz N the Hood* (1991), and *Juice* (1992). These films have been instrumental in constructing images of black youth as "nihilistic," as lacking the support systems of previous generations. A lesser known but even more blatant example is the film *Original Gangstas* (1996), which tells the story of former gang members (all played by stars of "blaxsploitation" films like *Shaft* [1971] and *Foxy Brown* [1974]) reclaiming their neighborhood from their progeny—young, out-of-control gang members with no social vision.

All these films circulate in the discursive space opened up by rap music beginning in the early 1980s. Rap music, as I noted in the first chapter, became increasingly popular during this period, especially with the rise of gangsta rap, a genre of music that narrated first-person, often three-part stories about criminal exploits. The gang culture of LA loomed large in this music and was the source of much public anxiety over this art form. One key example: Organized boycotts, often prompted by older African-American activists such as C. Delores Tucker, became common. Yet the music was commercially successful, helping to spawn this film genre, a genre that stressed similar reality-based stories and often featured actors who had been successful gangsta rappers (e.g., Ice Cube, Tupac Shakur, Ice-T, and MC Eiht).

The panic over an out-of-control generation of black youth has been supported and buttressed by much academic work. Most important here is the work of Cornel West. In a series of influential commentaries, West has argued that young people today are marked by a sense of nihilism, one enabled by the lack of once-pervasive cultural and institutional support systems. West defines "nihilism" as "the lived experience of coping with a life of horrifying meaninglessness, hopelessness, and (most important) lovelessness" (1993, p. 14). While this nihilism is not new to black America, the lack of traditional support systems and the rise of predatory market culture (which clearly informs much black popular culture) are, he argues, very new.

Mitchell Duneier's work echoes many of these themes. Duneier's book *Slim's Table* documents the lives of older African-American men at a Chicago diner (Valois), men who spend a large part of the text bemoaning the young. These older men hold self-described values of hard work and honesty, and think younger African Americans have eschewed these values in destructive ways. These young people do not have a living memory of racism and the kinds of values it helps to build, something that can be said of the middle class as well. Duneier writes:

> No doubt many of the characteristics of the younger generation disdained by the black regulars can be found in members of their own age group as well. But the regulars rarely refer to their own generation, except as a homogeneous group above reproach. Their resentment is directed chiefly at middle-class blacks and younger poor blacks, the groups guilty, as they see it, of flashiness, wastefulness, and laziness. (1992, p. 70)

The notion that younger generations do not have a tradition of history rooted in oppression is a common theme in dominant representations of young African Americans. The hip hop generation, many note, is radically and dangerously different from the generations that have come before it, a notion underscored by Michael Dyson, who writes that some young people today maintain violent rule over their communities, helping to constitute a kind of "juvenocracy" (1996, pp. 140–141). This is a generation of youth, many argue, without the overarching narratives of racial solidarity and hope for emancipation. The seeming nihilism of the film *Menace II Society* is instructive here.

These arguments are underscored by recent academic debates, specifically vis-à-vis modernism and postmodernism. While many have argued that contemporary shifts in global cultural and economic relations have sped up processes rooted in modern industrial life, others have marked a more decisive shift (Harvey, 1990; Jameson & Miyoshi, 1999). Indeed, many (though not all) postmodernists tend to stress the ways that cultural and economic forces have necessitated a sharp break with the modern past. Deep structures—of whatever variant—have been replaced by radically new, surface constructions, ones wholly implicated in new media cultures (Jencks, 1996). This postmodern generation is without history; it is a generation that cannot rely on the historical constructions of past. History—including racial history—has been emptied of value, especially for the young. As a number of critical education theorists note, the implications for education and the transmission of knowledge are profound here, as these kinds of racial narratives have traditionally informed educational practice and reform.

As many of these critics argue, popular culture is performing pedagogical roles and functions for many young people in myriad local contexts today, if only by default. Specifically, for my purposes, history is being mediated to young people today in popular cultural form as icons such as Malcolm X and the Black Panthers have become fodder for both rap groups and black filmmakers like Spike Lee. Indeed, in the wake of hip hop's success and the success of the new black cinema, many young filmmakers have attempted to treat topics relevant to black history. These include Spike Lee's *Malcolm X* (1992), Mario Van Peebles's *Panther* (1995), and John Singleton's *Rosewood* (1997).

These films have been sites of much debate and public anxiety over history and who has the right to tell it and how. The case of *Malcolm X*, the life story of Malcolm X, is telling. (For a full discussion of this movie and its history, see Lee, 1992.) Spike Lee originally decided to direct the film when he found out that a white director had been slated for the project. Explicitly arguing that X's story needed to be told by a black filmmaker, he managed to take it over. However, these anxieties around race were soon eclipsed by different kinds of anxieties, including those over popular cultural form. While black celebrities like Oprah Winfrey and Bill Cosby were vocal supporters of Spike Lee's efforts to popularize the life of Malcolm X, others, such as noted poet and critic Amiri Baraka (formerly LeRoi Jones), saw a more insidious effort to co-opt and commercialize his legacy. Many pointed to the disturbing proliferation of "X" hats around New York City at the time of the film's release and to other blatantly commercial endeavors. Again, at stake was the historical legacy of Malcolm X and the dangers of popular mediation. Was this film opening him up to new audiences, making his vision and work important for a whole new generation of African Americans? Clearly, many answered "yes" and embraced, in typical postmodern fashion, the proliferation of Malcolm X in popular cultural forms such as rap. Others answered "no"—that the legacy of Malcolm X could only be cheapened and degraded by popular media cultures. If he was being made available to the masses, it was only in diluted and ultimately vacuous form.

Similar debates raged around the film *Panther*. Director Mario Van Peebles (1995) discusses his efforts to direct this film and the ways in which studios responded in the book *Panther: A Pictorial History of the Black Panthers and the Story Behind the Film*. He notes how one studio wanted a white main character to serve as the centerpiece of the film, a Tom Cruise–like figure who would organize and mobilize the political activity of the Black Panthers from behind the scenes (p. 136). While Van Peebles managed to wrest control of the film and its vision from such insidious forces, other tensions and anxieties soon sprang up. While Panthers

like David Hillard appreciated the ways the film documented underrepresented aspects of the Panthers such as their free breakfast program, others like Bobby Seale rejected and criticized the film for distorting many key facts in the group's history (p. 174). Films like *Malcolm X* and *Panther* thus exist at a key and problematic cultural nexus; they are texts linked to an emerging media culture instrumental in forging supposed rifts in the cultural continuity between older and young blacks; they are, as well, the films that many young people turn to in lieu of traditional modernist educational practices, even avowedly multicultural ones.

*Panther*'s history is worth looking at in some more detail. *Panther* was directed by Mario Van Peebles, son of Melvin Van Peebles. Mario Van Peebles was the noted director of *New Jack City* (1991), which was considered a watershed in the new black cinema. The film told the story of the crack explosion in the 1980s, detailing the efforts of a massive drug operation fronted by the gang CMB (Cash Money Boys) in a major (unnamed) metropolitan city. The film featured rapper Ice-T, at the height of his music career, as an undercover cop. *New Jack City* was the highest-grossing film of the year for Warner Brothers and encouraged studio funding for a number of other black films.

Van Peebles was clearly following in his father's footsteps. In fact, Melvin Van Peebles directed what many consider the "first" blaxploitation film, *Sweet Sweetback's Baadasssss Song* (1971). The film is about a young man who grows up in a brothel, performing live sex acts for voyeuristic white crowds. However, at one point he witnesses a black man being beaten by the police and assaults the officers, killing both. This act of defiance marks the beginning of his life as an outlaw. "Sweetback" then becomes a kind of folk hero, on the run from the police and lauded by the black community.

This film was very much connected with the black nationalist spirit gelling in the country at the time. In fact, Huey Newton, the head of the Black Panthers, made the film required viewing for all Panthers around the country, devoting the cover of the party's newspaper to a "revolutionary analysis" of it. Melvin Van Peebles, interestingly, wrote *Panther: A Novel* (1995), on which his son's film is based. Indeed, the film *Panther*, released more than 20 years after *Sweet Sweetback*, rode the crest of the wave of contemporary black cinema (and concurrently, rap music) which in turn was fueled by many of the themes given voice in blaxploitation films like *Sweet Sweetback's Baadasssss Song*, *Superfly* (1972), and *Shaft*. Mario Van Peebles sums up the historical complexity:

> Interesting that almost twenty years to the month after *Sweetback* became the top-grossing independent hit of 1971, my directorial debut, *New Jack City*, became the

most profitable movie for Warner Brothers in 1991. I was one of the young directors to profit directly from the earlier black wave of cinema that my father helped start. So here was Van Peebles' kid after twenty years pulling him back into the cinematic mix with *Panther*. And here were the Panthers, who wrote about us, now having part of their story told by us in one of the most powerful media of the twentieth century, film. (1995, p. 159)

These links across genres and history are crucial. *Panther* was part of an emerging popular aesthetic with which many young people deeply identified. A number of participants in my study made many similar links, in ways I will note.

*Panther* is a complex text. It features a blending of historical footage with the film narrative, blurring the line between what was real and what was fictitious. As Van Peebles points out, the film was also at pains to recreate classic historical images (e.g., the photo of Newton on the wicker chair, holding the spear and rifle) in the filmic text. *Panther* features a lot of action and stylized violence; the film's narrative revolves around the life of a fictitious character named Judge, a student who becomes a double agent for the Panthers. The idea, Van Peebles stressed, was to avoid telling an iconic history of "great men" like Newton because such efforts always result in attempts at character assassination. Judge thus becomes the conduit for telling the stories of others, including Huey Newton and Bobby Seale. The key events in the lives of both men and of the organization (e.g., the march on the United States Capitol in Washington and Newton's imprisonment) were all told as well. The film, finally, contains a controversial subplot: the U.S. government, under orders from J. Edgar Hoover, releasing heroin into Oakland to defuse the power base of the Panthers in the black community.

Thus, the question of cultural continuity among young African Americans is central to this discussion. As I indicated above, these texts have been sites of struggle and anxiety over identity, and we can learn much from performing textual analyses of them. For example, *Malcolm X* is a personality-driven film that foregrounds Malcolm X's individual and often complex internal struggles, drawing attention away from broader social and cultural questions about the black nationalist movement as a whole. But *Panther*, as noted, takes great pains not to make the film the story of Huey Newton or any other individual and talks more broadly about the organization and its place in the struggles of black people as a whole. Following Douglas Kellner (1995), one might posit that the film *Malcolm X* is more clearly aligned with dominant Hollywood conventions, while *Panther* is, as Denzin notes, a "film that explicitly resist[s] assimilationist ideologies" (1998, p. 53). Yet, as I argue throughout this book, while we can

learn much by these kinds of readings, they do not exhaust meaning at the level of social networks or at the level of personal biography. Ultimately, as I have stressed, the connections between texts, lived lives, and institutions are empirical questions that often yield unpredictable results.

In summary, I am interested in the ways that racial history is mediated to young people, as well as the kinds of historical texts these young people pick up on, how they use them, and how they inform the ways they think about history and racial struggle. Current work in audience studies and cultural studies proves helpful, in qualified ways, for looking at such questions. I look now at some contemporary work in cultural studies, noting relevant constructs as well as key elisions, before offering my own contingent synthesis, one most helpful to exploring these questions and issues.

## Cultural Studies and Audience Studies

Cultural studies—typically associated with the work of early scholars at the Birmingham School in England—offers a useful starting point to explore these issues. As many have noted, scholars and researchers in this tradition looked closely at the everyday cultural practices of ordinary people, including popular culture, investigating how they might inform a progressive political agenda (Grossberg et al., 1992). To use Raymond Williams's oft-quoted and memorable phrase, these early practitioners were drawn together by the belief that "culture is ordinary," that it did not reside solely in the realm of "high art." This work had a mooring in class and class-based politics; it looked at the working class as an emergent phenomenon, constructed and reconstructed through material practices. Following Stuart Hall, these early theorists broke with traditional Marxists over the idea that Marxism was a structural teleological category. While Marxism was central to cultural studies, it was a "Marxism without guarantees" (Morley & Chen, 1996). As Williams stressed throughout his work, culture can be found only in the material practices of everyday people.

Cultural studies, in an effort to locate these everyday material practices, came to stress "audience studies," or empirical studies of how particular audiences pick up or use texts in everyday life (Ferguson & Golding, 1997). These context-dependent studies have spanned life settings and specific genres, including romance novels (Radway, 1984), women's television shows (Press, 1991), and specific shows like *Nationwide* (Morley, 1980) and *Dallas* (Liebes & Katz, 1990).

This research has been helpful for understanding more clearly the work of active agents and how they enable particular kinds of textual readings and formations. Yet this work has often uncritically celebrated these readings without looking more closely at how particular meanings might be and actually are constrained. For example, Curran (1996) has argued that contemporary work in cultural studies and media studies is marked by a "new revisionism," one which stresses, in typical liberal-pluralist fashion, the work that audiences perform and downplays the ways meaning is constrained by larger questions of political economy. Drawing on these notions, David Morley writes:

> Recent reception studies which document audience autonomy and offer optimistic/ redemptive readings of mainstream media texts have been, wrongly, taken to represent not simply a challenge to a simple-minded effects or dominant ideology model, but rather as, in themselves, documenting the total absence of media influence, in the "semiotic democracy" of postmodern pluralism. (1997, p. 125)

Questions of power, of political economy and the ways that audience choices are constrained, are thus elided. The audience is considered autonomous, free to make of texts what it will. The audience is merely celebrated in such an approach. This is a serious omission, for, as Morley so starkly notes, "The power of viewers to reinterpret meanings is hardly equivalent to the discursive power of centralized media institutions to construct the texts which the viewer then interprets" (1997, p. 125).

What is needed, it seems, is a kind of reconstructed audience studies, one that stresses the work of active agents but also stresses how the meanings people create here are circumscribed by forces beyond their control. The rest of this chapter will draw together these issues, exploring the kind of historical knowledges popular culture is making available for cultural consumption as well as how young people are enabled and constrained by such knowledges. I will explore the ways that young people forge historical consciousness through their interaction with and talk about popular cultural artifacts. Specifically, the rest of this chapter is devoted to a study of how my young subjects responded to the popular film about the Black Panther Party for Self-Defense, *Panther*. Among the interesting findings here, as I noted in the introduction, is their gravitation toward invulnerable characters and violent and action-filled scenes, as well as how they used this film in responding to a proposed KKK rally in town. I will begin by looking at how history was mediated in school to young people, to understand more clearly the kinds of discourses available to them in this often explicitly validated setting. Understanding this local history will be crucial for

understanding broader questions about history and how these young people "performed" particular notions of history in their daily lives to deal with this profoundly unsettling local event.

## Constructing Racial Selves through Group Interaction

### *History in School*

The participants in this study spoke in almost wholly negative terms about how "history"—traditionally conceived—was taught in schools. Most young people noted that the life and work of Martin Luther King Jr. was stressed too exclusively and that black history was relegated to one month of the year—the shortest month. This antipathy to the ways black history was taught in school was expressed often and in many ways. For example, one young person stressed that the Black Panthers and Malcolm X were ignored in school in favor of King: "We talking about Martin Luther King but not Malcolm X ... Everybody know about Martin Luther King Jr." Another teen noted that all they talk about in school is "Dr. Martin Luther King famous speech, 'I Had a Dream.' We learned that back in second grade. Why you still teaching us that? Why don't you teach us something else, that's more important?" This teen also commented, "They won't teach you about nothing that Martin Luther King did except that yes, he was a famous black African American." He continued: "In a school district, they'll take one month and learn a little bit about African-American history. All the famous people ... the same thing over and over and over every single year."

It seems, then, as if individual icons who are explicitly nonviolent were stressed first and foremost in school settings. As one young person said, teachers talk about "people that was famous, that's all ... they talk about Bill Cosby ... um ... mostly she always be talking about Martin Luther King Jr. and Robert Clemente ... not the ones that's violent." As mentioned above, the life of Martin Luther King Jr. has come to stand for nonviolence itself, and he is often stressed to the exclusion of other figures, indexing black history completely. The construction of King as supremely emblematic of "blackness" itself, in addition, often rubs up against and can contradict, at least in part, more local notions of what counts as black. For example, this same young person commented that rapper Snoop Doggy Dogg was "problack" in the video "Gangsta Party" " 'cause

he, it was like, he did all that kind of black stuff. He was drinking, riding in the cars, sagging, all that stuff." Sagging is a way of wearing one's pants low and is often associated with prisoners and gang members. It is surely not a symbol of passive resistance or of nonviolence.

In addition to disliking how black history was taught, many young people resented how other groups were taught in contrast (for a discussion of resentment, see McCarthy & Dimitriadis, 1998). For example, many young people said that they did not like the way they were forced to focus on the Jewish Holocaust. One teen was not allowed to take a test on the Holocaust: "My grandmom won't let me take the, um, the Holocaust test...She just thought they [the Nazis] were some crazy white people...We making, um, a Holocaust museum, I can't participate in that. She won't let me do it...'cause she said if they can teach that, they can teach us something about Africa too and they really, they don't...During black history we don't do nothing." Another teen reiterated about this museum, "They made us go through it and a whole bunch of people didn't want to, but if we didn't go through it, then we got in trouble."

Thus, young people spoke both about the exclusive focus on King and about how he was taught, including in relation to events and figures key for other groups. Many indicated, following the above, that King was merely inserted into an already existing, uninspiring curriculum, his presence strictly "pro forma," to satisfy the demands of Black History Month. Nothing as participatory or as engaging as building and physically going through a museum was stressed. If anything, this use of King during Black History Month seemed to evoke deep feelings of anxiety, especially vis-à-vis their teacher's exclusive stress on King's philosophy of nonviolence. Their responses echo and underscore the work of many critical theorists of curriculum who stress the ways that multicultural education serves to reproduce a liberal-pluralist model of education, the ways such icons are uncritically added as a footnote to history (Beyer & Apple, 1998).

While many young people expressed dissatisfaction with the almost exclusive stress on King in schools as well as how he is taught, they also had a deep respect for the man. As former Black Panther Kathleen Cleaver (1998) noted recently, the popular appropriation of King to index an ideally nonviolent and passive black population often belies the respect and admiration many feel for him in other, more locally validated settings. Indeed, during Black History Month, the club where this research was conducted held a speech-making competition/celebration and young people were given the opportunity to deliver a range of speeches about black history and culture. I was in charge of much of the event and photocopied a range of speeches and poems, including those of

Huey Newton, Malcolm X, Langston Hughes, and Martin Luther King Jr. The young people, however, gravitated almost exclusively and with much enthusiasm to the speeches of King. Even the young person referred to above, the one who talked about how "everyone know about Martin Luther King Jr.," immediately went for the King speeches. This same young person, on the day of the competition, brought in a number of photos of his family's trip to the site of King's assassination. These included photographs of the jacket King was wearing when he was shot and photos of the hotel. He displayed these pictures proudly and suggested passing them to the assembled crowd. This young person also brought in a sheet of paper with the words of the speech "I Have a Dream" printed out, decorated on a blue background. Apparently, this text hung on a wall in his home. Indeed, many young people have similar photos and plaques in their homes, with lithographs of King as well as printed text from his speeches. These texts are plainly very important to many of these young people and their families.

Importantly, this competition, unlike other events at the club, was very well attended by the families of the participants. Many parents and relatives came to this event, taking time out of demanding work schedules. The competition gave these young people a chance to perform King's speeches in front of a validated audience of family and friends and people from the community. A kind of enthusiasm was generated, an enthusiasm lacking in their relationship with King as taught in school. It seems, thus, that the antipathy is raised not by King himself but by how he was taught in school, including how he was counterposed to other subjugated populations. While, of course, these young people did not verbalize it as such, they seemed to resist the ways King is used as a symbol for all black history, representing all that is nonviolent and passive. This is especially problematic in school, which is an institution many young people already see as hostile and alien (Davidson, 1996).

Many of the links that young people made with King were by way of their extended and immediate family. Again, many family members came to this event, and photos of King often adorned the home space. Links with King and even others like Malcolm X were often links with familial networks. However, this black history, the history of King, X, and others, seemed, in large measure, outside the constellation of popular texts in which these young people were invested.

As noted, the main methodological tool for my research was weekly discussion groups around rap music. During these focus groups, I attempted to make links between rap and other historical texts and events. For example,

over the course of a few sessions, I showed the film *Malcolm X* and attempted to generate discussion about his life in comparison with the life of Martin Luther King Jr. Though the links with rap seemed self-evident to me, during one discussion a young person asked, "What does this have to do with rap?" Another young person answered, "Well, right now, we're talking about Black History Month." When I asked whether rap had anything to do with Black History Month, they all answered "no." One commented, "At first we was talking about rap, about Tupac and Biggie." I then asked about *Rosewood*, which we had also seen, a film about an all-black community in the South in the 1920s that was destroyed by white racists. *Rosewood*, they said, has something to do with rap—more than *Malcolm X*, which, one noted, was about a "black leader" and as such seemed more "school-like" than "rap-like" (thus echoing the earlier discussion).

Young people expressed more or less interest for the historical films I introduced, including *Malcolm X*, *Rosewood*, and *Panther*. The level of enthusiasm seemed to increase roughly in that order, with *Panther* garnering by far the most enthusiasm and *Malcolm X* the least. As I will demonstrate, young people made more intertextual links with *Panther* and the other popular media forms they are invested in. This accounts in large measure, I argue, for the enthusiasm afforded the film.

I first decided to show clips of *Panther* to my discussion group after one young person expressed an interest in the film. However, the overwhelming consensus among the group was that I should show the whole film. I then devoted a series of sessions to the film, with discussion afterwards. The group's enthusiasm was unabated. At their request, I then showed an episode of the PBS documentary *Eyes on the Prize* which discussed the Panthers, to considerably less enthusiasm, as I will note.

## Panther *and the Local Construction of Racial Consciousness*

The group reaction to the film *Panther* can be delineated as follows. First, the participants all made intertextual links between this film and other films that featured the same actors; second, they made connections between the Panthers and their own informal cliques; third, they drew together, as a group, around the most violent scenes, especially those featuring guns; fourth, and in turn, they tended to carry out their own agendas (like talking and teasing each other) during scenes that featured talking; and finally, these young people focused,

thematically, on the film's antipolice subtext, making connections with their own lives and experiences. These viewing practices helped form the contours around which these young people processed this historical text and claimed it as their own.

From the very first session devoted to *Panther*, young people identified characters and actors as "playing in" other films of the new black cinema like *Friday* (1995), *Jason's Lyric* (1994), and *Menace II Society* (1993). When such actors appeared on the screen, they became the focus of much spirited group discussion. For example, the main antagonist in *Panther* is a local drug dealer who teams up with the police to help quell the group. This actor, A. J. Johnson, was featured as a "hype" or crack addict named Ezel in the film *Friday*, a comedy featuring rapper Ice Cube. *Friday* is about a seemingly typical day in the life of two teens in an LA "ghetto." It was a highly successful film, and many young people considered it one of their favorites. Whenever A. J. Johnson appeared on the screen, young people said things like "There goes Ezel!" and routinely referred to "Ezel" when discussing the film.

Another actor in *Panther*, Tyrin Turner, played Caine in the extremely popular *Menace II Society*. In many respects, *Menace* is an entirely different film from *Friday*. *Menace* is a very violent drama about two teens, Caine and O-Dog, growing up in a "ghetto" in California. The film also features rapper MC Eiht. When Turner, who plays Cy, a friend of Judge, appeared on the screen, young people routinely called him Caine, saying things like "That's Caine right there!" During one discussion, when the film showed that Cy had been shot, someone said, "That's how he was on *Menace II Society*," to which another responded, "Except he look tore up in *Menace*." Indeed, these young people often compared the different roles of characters in the two films throughout the viewing, noting both similarities and differences. For example, though Turner died violently in both films, this young person commented on how much worse off he looked when he was killed in *Menace*.

Another actor, Bokeem Woodbine, who plays a tough Black Panther named Tyrone, was featured in *Jason's Lyric*. The film, different again from either *Menace* or *Friday*, is a love story that takes place in the rough Fifth Ward in Texas. In *Jason's Lyric*, Woodbine plays the brother of the protagonist and shoots himself at the end of the film. Similarly, he blows himself up at the end of *Panther* to save his comrades, the consummate sacrifice that concludes the film. During this scene, when it became clear that Woodbine would kill himself, one young person said: "Don't kill yourself. This gonna be the second time killing hisself. He kills hisself on *Jason's Lyric*. He shot hisself in the head."

Thus, these other films were all part of a certain genre of movie-making these young people were wholly invested in. Yet, these films were each quite different—a comedy, action/drama, and love story, respectively. While all were released as part of the new black cinema, they attest to the ways that genres are inherently open and flexible, with broad-based similarities and differences (Kamberelis, 1995). While the specific themes were often different, they all detailed and focused on the experiences of young blacks in poor areas. Each also featured a rap soundtrack and highly stylized violence (George, 1994). *Panther's* links to this genre stem, in part, from the fact that it features actors who have made careers for themselves in these other films. Part of the pleasure for these youth, again, seemed to be drawing intertextual links between the films.

Filmmakers have plainly capitalized on young people's knowledge of these artists and their different roles. For example, A. J. Johnson played a comedic role in the film *Friday*. While his role was, on one level, very different in *Panther*, he had certain comedic dimensions to his character toward which these young people gravitated. He played a fast-talking, funny, and wily character. When he was shot in the ear at the end, many young people laughed at Johnson's reaction. In contrast, Bokeem Woodbine plays more physically imposing characters, in *Panther* as well as in other films. These actors, in large measure, are typecast, in ways that allowed these young people to connect them to other films and to predict how different films might unfold.

These films also tend to foreground rap artists as actors, blurring the boundaries of their careers. For example, rap artist Ice-T was acknowledged by many of my participants as an actor first and foremost. As one young person put it, "He needs to give up rapping!" When I asked one young person who his favorite rapper was, he commented, "Smokey," referring to the always stoned character Chris Tucker played in the film *Friday* (Tucker has never been a musician of any sort). These young people were thoroughly familiar with these actors and rappers and the various roles they have played. This kind of cross-fertilization between genres and characters was capitalized on by rapper Master P, who features many of the rappers on his No Limit label in his movies (e.g., *I'm Bout It*) and uses the same character actors in many of his films. In fact, I would attribute Master P's great financial success to his recognition of how deeply young people are invested in "stars" and the various roles they enact in multiple contexts.

Noting characters and actors is also a way to assume a certain kind of privileged knowledge vis-à-vis the group, a way to indicate one has seen the film. This accords one a certain kind of social capital or currency in relation

to the group, marking one's taste in the context of a local hierarchy of taste (Bourdieu, 1984). It also indexes one's monetary capital, as (in the mid-1990s) one would have to have cable TV or a VCR (and be able to afford to pay for the tape) or to have seen the film in the theater. This was a profoundly social process for these young people, one that allowed them to position themselves through these texts from in and within an invested group of peers. While I found that most of these young people were remarkably well versed in these films, I saw that others were not and that not being so could be the source of great pain. In fact, young people pulled me aside and commented that they had nothing to say in these focus groups because they could not afford to see these films or listen to these hip hop tapes. Others who had more money, however, could easily and quite literally afford to purchase this kind of capital relative to the group, acquiring this kind of highly valued knowledge.

These black popular cultural forms thus provided young people with a very important kind of capital. On one level, I could assume an almost uniform and largely exclusive privileging of these movies. I have conducted numerous surveys of young people concerning their likes and dislikes, and there was an almost exclusive focus on such films. Young people who had a wide knowledge of these films and this music were privileged in this sense. Yet, there were other kinds of capital that operated here, other ways one could mark oneself relative to the group. A key example is gang activity, a kind of lifestyle often valorized in these films. There were some young people, therefore, who did not know much about the music and these cultural forms but who were often also quite poor and angry and sometimes gravitated toward gang life. This allowed them to accrue another kind of social capital vis-à-vis the group. These popular genres, then, are an important source of cultural capital but not the only one.

In addition to making links between films, these young people used *Panther* to talk about their own social positioning relative to their social networks. During the very first session devoted to the film, these youth began to claim characters. For example, when the character of Huey Newton appeared, one young person commented, "There go me!" to which another responded, "That's me right there! I already called it!" Seemingly, there was a kind of exclusivity to claiming roles here, as only one person could claim each of the available characters. Again, these young people used the positioning of characters in the film to inform their own positioning relative to the group. The film, quite clearly, afforded particular roles, as indicated by comments like "I'm the black dude!" and "That's my man!"

Interestingly, these comments were often made by young people who already had a degree of social capital relative to the group and others at the club. Indeed, these were also often highly competitive individuals who made (successful) concerted efforts to position themselves as valued in other locally validated activities. One homologous activity here was sports. Nearly all the youth who claimed these roles during these sessions were active in sports and often got similarly worked up during competition, whether in ping pong, basketball, or pool. These same young people who competed for "claiming" Huey Newton also taunted each other during ping pong games (e.g., "You're sorry! Get off my table!") or taunted other clubs when competing at sports like basketball ("We're gonna smoke that team!"). Interestingly, those who did not claim characters during our film-viewing sessions tended to be noncompetitive in sports and not so antagonistically vocal during activities like ping pong.

For the youth at the center, the social positioning in the film also implicated their own particular social networks or cliques. Indeed, in this same discussion group, the talk turned to some of the fights that group members got into and the ways in which they stood up for each other. At one point, they talked about a young man named Jalin and how he had been picking on a group member's sister. Another member of the group commented, "All us right here [in the group], gonna jump on Jalin." Sensing an opportunity to interrogate the kinds of conflicts these young people engaged in, I asked why they stuck up for each other. One responded, interestingly, " 'Cause we help each other. We the Black Panthers." Thus the kind of positioning and community represented in *Panther* was deeply implicated for these youth in their own cliques.

These informal cliques also had homologies in other popular cultural forms. Indeed, after the young person above said, "We the Black Panthers," another said "We NWO [New World Order, a group of wrestlers]." At the end of this focus group, members called out in excitement, "World championship Black Panthers!" and "Black Panthers for life!" These are references to professional wrestling, including the famous chant of NWO: "NWO for life." Professional wrestling is marked today by wrestlers who form formal groups that are very similar to the self-proclaimed cliques that young people form (both are linked to broader conversationalizing discourses, as noted elsewhere [Kamberelis & Dimitriadis, 1999]). These young people thus appropriated the relationships in the film to comment on their own social networks in ways that connect them to other popular cultural texts. These links, however, seemed odd relative to more traditional black cultural practices, speaking, as they do, to the particular co-articulation of discourses that mark so much popular culture today.

(Bakhtin [1986] proves helpful here.) For example, one could hardly imagine an older person making similar comments about Martin Luther King Jr. in relation to wrestling. One might find chants like "Student Nonviolent Coordinating Committee for life!" or even "Nation of Islam for life!" profoundly odd.

It is important to note that these group processes were at work in the actual viewing practices of these young people, in what they conspired to focus on and where they were disruptive. Most important, these youth tended to engage in off-task activities during narration and quiet dialogue and focus on the film during highly violent or action-filled scenes. These were routinely called "the good parts" and were met with collective focus. Indeed, staying focused on a particular text is a group process and can either facilitate or disrupt the group's resonance with a particular text. For example, there was an intense focus on the last scene, in which the Panthers had a gun fight with "Ezel" and his bodyguard Tiny. My young viewers commented "There go Ezel!" and, during the shooting, "Ezel killing everybody!" to which another young person commented, " 'Cause he got that buff dude named Tiny!" During this scene, "Ezel" got his ear shot off, and this elicited a great deal of laughter. This audience focused carefully on these scenes. There was no effort to disrupt the group process with individual agendas as there was during other scenes. While it is entirely possible that young people viewing the film by themselves would also be distracted during scenes that did not feature heavy action, I did, nonetheless, see this group dynamic at work here. These violent scenes very much informed the collective responses to the film, including the kinds of messages these young people gleaned about the Panthers and how the Panthers were connected to a range of popular media forms.

It is significant, then, that these young people tended to look away, talk, or tease each other during scenes that featured heavy talking. These were the "boring parts" during which talk turned to other subjects or there was just general lack of interest. This empirical observation is crucial, as many of these scenes established the subtext that the government was complicit in the influx of drugs into black communities as a way to attenuate the radicalism elicited by the Panthers. Much of the focus on Judge being a double agent was lost and, in later discussion, many expressed confusion about what his role was exactly. The scenes that developed this theme were marked by heavy talking and were, again, all but ignored. Thus, the dialogue that these young people collectively established with each other during the film helped influence the kinds of meanings they took from it and were able to mobilize as a result. By and large, highly stylized violence and conflict were privileged here.

These young people thus took the film as part of other popular entertainment genres, including sports and music, and not as a historical document or one of social critique. They identified, first and foremost, with scenes that featured the kinds of action that are prevalent in other popular genres, while the film's broader critique was largely lost. As argued elsewhere, young people today privilege increasingly dominant conversationalized discourses that stress personal and interpersonal conflict over those that feature broader social critique (Kamberelis & Dimitriadis, 1999). This discourse works today in numerous popular realms, including talk shows, rap music, and wrestling. One observes this here as well, as the youth focused on violence and interpersonal conflict instead of on the broader political critique about how the government was complicit in the influx of drugs into black communities.

Yet, it would be a mistake to assume that the group response to *Panther* was apolitical. This stress on conflict and highly stylized violence was linked in the film to an antipolice community empowerment agenda that was very much a part of the Panther's program as well. Indeed, one of the most dramatic scenes in the film featured Huey Newton confronting the police with a group of Panthers. During this scene, the Panthers come upon a black man being beaten by the police. The Panthers take out their guns—then legally, because they are in plain view—and challenge the police on the abuse. Newton calls them "pigs" and says that he has the right to observe them carrying out their duties from a "reasonable distance." At one point, an officer asks Newton whether his gun is loaded. He clicks his gun, putting the shell in the chamber and says, "Now it is!"

Nearly all the young people said that this was their favorite scene. As one member put it, "I liked when he called him pig!" As another young person put it: "I like the part when...that man, Huey Newton, start talking to the police and then they start backing down...The police knew that was their right and they couldn't do nothing about it." Still another commented: "I like the part when the cops said 'Is that gun...automatic loaded?' He said 'It wasn't but now it is.'" The young people clearly felt a sense of power during this scene, noting that the police, for a change, were scared of African Americans. The Panthers clearly empowered the community here and gave people the courage to stand up for themselves. Indeed, during this scene, a crowd assembles to watch the Panthers; the police tell them to leave, but Newton says they have the right to stay. As one young person said, "Them other people was scared of the police, but then they told them, not to, uh, they don't have to go nowhere."

Many of these viewers expressed satisfaction when watching this scene. As numerous authors have noted, there is a long history of anger toward police

in black neighborhoods (Fine & Weis, 1998). This city is no exception, and many young people have commented that the police exercise their power in arbitrary ways and also treat black people differently than they do whites. As one adolescent put it, people get "bullied around by the police and stuff," adding that the police will often speed through his neighborhood past stop signs and red lights.

Another teen gave a very clear example of how whites and blacks are treated differently by the police. A small Rottweiler dog belonging to a relative got out of its cage, he said, and was taken by the police. This teen noted that incidents such as dogs barking too loudly are treated very differently by the police according to whether the owner is black or white. A white person might say something like, "Oh my dog is very protective of me and he thought the other dog [was attacking me]," to which the police would respond "Okay, have a nice day." In contrast, if a black person were the owner, the police would reply to such a comment, "Well you can't be having your dog out here, biting on people, or we're going to take him down." It would be, the teen summed up, a "whole other story."

This same teen noted that the police routinely stop black teenagers walking together, especially in white neighborhoods. He said: "They be harassing me...Check this, take four black people, four black teenagers, wait till about nine o'clock, not even curfew, just dark. And walk down the street in a nice neighborhood. Ten dollars to a penny, you'll get stopped every time." Many teens have expressed similar outrage at being harassed by the police and therefore identified as a group with the scenes in the film that dealt with the ability of people to stand up to the police. In large measure, this was a part of the greater meaning these young people took from the film, as it resonated most clearly with other dimensions of their lives.

Similarly, when I asked young people whether there were any organizations around that reminded them of the Panthers, most of them responded, "Gangs." The connection seems logical, one enabled by the kinds of messages taken from the film, including the antipolice sentiment, the liberal use of guns, and the more general use of highly stylized violence. There are also important historical connections here as well, as the Panthers were very successful in recruiting members of street gangs in the 1960s and were even negotiating with the Blackstone Rangers in Chicago to merge the groups. When I commented to an older teen that some of the younger kids were making this connection, he noted: "I kinda see where they coming from...'cause...they see the guns...and they see

most gang members with guns, so therefore it put them in the mind of gangs. And then they got like a little clique and everything like the gang's got."

*Panther*, in addition, resonated with young people in ways that more traditional documentary-like work did not. For example, we watched the *Eyes on the Prize* television episode that dealt with the Panthers, and it was not very well received. The episode relied on many traditional documentary conventions, including stock footage and long interviews with key figures. There was, of course, no action or violence.

Interestingly, when I asked what they thought about the TV show in comparison to the film *Panther*, one young person commented, paradoxically, that the film was more "realistic" than the documentary, noting that it had more "action." A teen made a similar connection in another context, noting that she liked films like *Menace* more than television news because such films are more emotionally charged and feature clearer use of narrative:

> The news don't got good stuff in it every day—not saying good stuff like they be killing each other...it's the way they portray it. It's the way the message get across. On the news...it don't give a lot of details. It just give like the basic outline of what happened, what went on, who died, stuff like that. And then, in the movies, they go to why they got killed, and who killed them, how many times they shot 'em. Then they go when they do it again. Stuff like that.

Narrative conjured up the "real" for these young people, a point underscored by much research in the affective dimensions of language (Besiner, 1990). Similarly, another teen commented that he preferred *Panther* to *Eyes on the Prize* because it was in color. Another noted: "One thing I liked about the movie, you know how Huey was always, he had went to law school and he was like 'I am 12 [to] 28 feet from you, man, so I can have the right to take my, to have my weapons with me.'...He snapped." The drama of this scene was thus favored over the more conventional pedagogical narrative of the documentary.

### *Making it Real:* Panther *and the* Ku Klux Klan *in this City*

In summary, while this film allowed young people to learn something about the Panthers, they did so in specific and highly circumscribed ways, allowing certain meanings while disallowing others. These meaning-making practices had very

real consequences for these youth, as evidenced by the ways in which they were able to deal with a proposed march by the KKK in town.

During the fall of 1997, the Ku Klux Klan proposed a series of rallies throughout the state, one of which was to take place in this city. Though the rally never happened, it raised many concerns and questions. In particular, many young people were terrified by the prospect of the Klan coming to town. Many thought they would be targeted with violence. As I noted in the previous chapter, many young people have complex family histories in the South, and many spoke of Southern racism, particularly as realized in the Klan's violence. A number of younger people felt, in turn, that the Klan was going to come and burn down their homes or attack them physically.

The unit director, Johnny, commented to me one day that "the Klan got these kids scared" and also noted that many parents are not doing a good job "educating" their children about the Klan and letting them know that they are not a real threat. When one young person expressed fear about burning crosses, Johnny commented that the cross is a "symbol" the group uses, just like the Gangster Disciples gang uses a six-point star. Johnny, as director, also made efforts to educate young people about the group and tried to dissipate some of their fears by noting that they had the "right" to march, and even to call black people "niggers"—but not to physically assault them. He said he would not be out protesting and would respond only if they came to his neighborhood. Clearly, he sought to demystify the Klan's presence, most especially by invoking the discourse of rights.

This was a familiar discourse for these young people, one which they encountered in school and one they reproduced in their everyday talk. When asked about black history, young people, mirroring the school-like discourse evoked earlier, tended to stress iconic figures (e.g., Martin Luther King Jr., Harriet Tubman, Rosa Parks, and Frederick Douglass) and "rights." When asked about important events in black history, for example, young people would cite the historical fact of separate schools and water fountains. However, as I will note, this discourse was not mobilized by these young people to deal with this emotionally charged event.

Indeed, the Klan seemed a source of real terror, and many even claimed to have seen Klan members in town (though I am doubtful about this). One teen remarked:

> They already here, they was chasing people. They almost got shot up. It was out at the park...Remember that park we went to last, for the summer picnic? They was down there chasing people...We was driving by, all you see is people in white sheets.

This knowledge about the Klan was mediated by both popular culture and interpersonal relationships. For example, young people spoke about the miniseries *Roots* and the movies *Malcolm X* and *Rosewood*, both of which feature hooded Klansmen, and *Higher Learning* (1995), which features skinheads (who many felt are essentially the same as the Klan). Many young people also spoke of relatives who told them stories about the Klan, especially down South, where, as many young people noted, the group is still very active. One stated that his grandfather's friend was killed by the Klan. These stories became affectively invested—made more real—by way of the films noted above.

Interestingly, some young people spoke of watching and discussing such films and TV shows with their relatives. For example, one young person said, "My grandmom that live upstairs, she got like a *Roots* thing...with all the movies." Another teen said, "My grandmom I asked her...I asked her, did she know about Klan, she was like 'yeah,' she said...sometime she seen them on TV." In fact, our discussions prompted others, like this young person, to further investigate the Klan on their own.

In addition, the racism that the Klan symbolizes was often given a veneer of invisibility or secrecy by my participants, much as racism seems to function today. One person commented, "Some places you might see some white people and then they try to be your friend and then next thing you know, they be like, 'I'm a Ku Klux Klan.'" Another said, "They ride cars, then try to act normal, but at night, they just come out." Another commented that his grandfather, who had some trouble with the Klan, told him to be careful and that you don't always know who is in the Klan and who isn't. In large measure, for these young people the Klan came to embody racism as a whole, constituting an ever-present and invisible fear, made real and given voice by way of this particular event as well as through popular cultural forms and social networks.

We must now ask how young people dealt with the proposed Klan rally in town, how they made sense of this event. In large measure, many of these youth drew on the kinds of highly stylized images of violence and myths of invulnerability realized in the film *Panther*. Young people commented that they would deal with the Klan in individual ways and with violent force. During an initial discussion, one young person said, "They come on Johnson Street, I'm going to war, bring like 40 guns." Another said, "I'm gonna have knives here, I'ma have guns here, guns here...I'm gonna look like Robocop." Robocop, a film and TV character who is half-man half-machine/human arsenal, is of course violent in the extreme. This same person, interestingly enough, commented: "We need the Panthers! We need some Black Panthers! Really, I need some Black

Panthers by my house." Thus, young people indexed the kinds of invulnerability discussed earlier—an invulnerability linked to film, wrestling, Robocop, and, of course, the Black Panthers. While they drew on historical constructs to deal with the march, they were highly circumscribed constructs connected with popular culture.

Yet, while these participants identified with the violent ganglike aspects of the Panthers, they evidenced a reflective critique of this approach as well. Indeed, we had a very interesting discussion about how the Panthers would deal with the Klan as opposed to how gangs would deal with them, which brought this critique to the forefront. When I first asked the group what they thought the best response to the Klan would be, many commented that gangs were going to provide the community with protection. There was some talk about how these groups were already planning a response—notably, the Black P Stones (the latter-day manifestation of the Blackstone Rangers, who were initially going to merge with the Panthers). However, some commented that gangs might not be strategic enough in their response, substituting a wholly violent response for a more measured approach. One said: "Panthers, they handle it a different way. The gangs, they'll just go get guns . . . Panthers they'll just call a white person a pig or something. 'You pig!' Like they did in the movie." Of course, this young person was referring to the scene, discussed earlier, in which the Panthers confronted the police, who were, for this young person, implicitly connected with the Klan. Another commented that gangs would get high and do a drive-by on the Klan and possibly kill innocent people or one of their "own people." Overall, these young people sought a highly physical response to the Klan but also seemed to be conscious of the limits of such an approach.

Thus, the youth at the center were able to use this film to critically examine the Klan's presence and what the best response to them might be. Their proposed response was both complex and very different from the response seemingly favored by Johnny, the unit director—education about their right to march while acknowledging the fact that the Klan could not physically attack anyone. The discourse of rights as wholly implicated in traditional notions of schooling was not mobilized here at all. These young people seemed to foreground a physical response mediated by popular culture, though they were critical about its limits. We see a kind of group consciousness emerging here for these young people, one that is enabling and constraining as well as highly situated by and in popular cultural forms.

# Conclusions

The group response to the Klan was very much linked to the kinds of popular histories the youth in this study found most compelling. The kinds of historical knowledge offered in school, as noted, did not resonate with these young people as clearly as they might have and were not made use of in this crisis. This kind of knowledge, as noted, tended to be driven by a discourse of icons and rights. Rather, the popular filmic representation of the Black Panthers was mobilized, implicated, as it was, in other popular texts, including hip hop culture, film, action heroes, and wrestling. As such, these young people made the kinds of unpredictable links enabled by a black popular culture shot through with multiple co-articulated discourses (Bakhtin, 1986). To echo Della Pollock (1998), these young people "made history go," using popular texts to make history relevant in the here and now and thus transforming history from a noun to a verb. Like the "traditionalized" discourse of the South offered in the previous chapter, these young people used the film *Panther* to actualize history—to perform history—mobilizing a specific discourse to deal with a profoundly unsettling event, a proposed KKK march.

To return, then, to the questions that opened this chapter, these young people seem not to have lost all sense of history because of popular culture. Rather, popular culture has made a set of resources available to the young that they have been able to mobilize in specific ways, in specific kinds of activities. History, here as everywhere, must be viewed in concrete and situated circumstances. A close look at *Panther* and the viewing practice of the young made this quite clear, offering educators a way to begin to understand not so much the limits of, but the stakes involved in, popular cultural forms and how such forms might be made more clearly a part of school curricula.

This work underscores, as well, the importance of seeing media forms and practices as interconnected and co-constituted. *Panther* was only made "real" for these youth by and through its connection with a range of other popular practices, texts, and media—including (for example) those associated with hip hop film and televised wrestling. This "moving across" texts and media platforms has become an increasing part of how young people understand their worlds and popular culture more broadly. This is an insight made clear by Henry Jenkins in his recent *Convergence Culture* (2006). While the majority of my research was done before the massive proliferation of new technologies in popular culture, the lesson remains the same. One cannot understand popular

culture texts in isolation from each other. The lesson is particularly poignant, as noted, for those interested in questions of history and its mediation. To understand young people and history, one cannot focus on individual texts but must see them as existing in dynamic and fluid interrelation with each other, including across media platforms.

# THE SYMBOLIC MEDIATION OF IDENTITY IN BLACK POPULAR CULTURE: THE DISCURSIVE LIFE, DEATH, AND REBIRTH OF TUPAC SHAKUR

## (CO-AUTHORED WITH GEORGE KAMBERELIS)

Chapters 3 and 4 of this book examined how young people constructed senses of place and generational identity through the resources made available in popular culture. Throughout, I stressed the importance of looking at the highly unpredictable links between individuals, institutions, local social networks, and popular resources. In this chapter, I would like to focus more clearly on questions of self and on the kinds of selves that were favored and performed by young people at this site. I will look, specifically, at talk about the life, death, and discursive rebirth of rap artist Tupac Shakur (or 2Pac or Pac). A central icon with whom many young people profoundly identified, Tupac emerged as part of a broader move toward personal biography and psychologized notions of self in hip hop culture. Indeed, hip hop has become a field of highly personal, competing stories and talk show–like conflicts (many of which end tragically). Tupac drew on these conversationalized discourses (touched on in chapters 3 and 4) as well as, more broadly, on myths of invulnerability. These myths have been key to black popular culture for decades, from the early folklore of Stackolee to the modern-day gangsta rap of artists like Master P. Drawing on Burkean narrative analysis, I will offer a close reading of how these young people

collectively co-constructed a myth about Tupac, a highly prized and privileged icon in life as well as in death, to help deal with their profoundly uncertain social realities.

# The Symbolic Mediation of Identity in Black Popular Culture

## Narrative and Popular Culture

Our identities, as many researchers and theorists have noted, are discursively mediated in complex and contradictory ways. Following Bakhtin (1986), we exist at the nexus of a plethora of discourses and discursively mediated symbols and signs, meaning-making systems implicated in patterns of language use. We come to understand ourselves and others as we come to live through these discourses, always in particular ways and in socially and historically situated contexts. The role of narrative is important here, as narratives provide key instantiations of particular discursive formations and the sense-making apparatuses they enable. Narratives order events and relevant participants in ways that implicate larger meaning-making systems or discourses. These narratives, or stories, are the tools through which we understand ourselves and our relationships to others. They are the "stuff of culture," both micro and macro (Bruner, 1990). As Perinbanayagam notes:

> The human being is blessed, or cursed as the case may be, with language and uses it to occupy his or her mind as well as to occupy his or her relationships with others. The stories he or she tells others, he or she tells himself or herself and the stories he tells himself or herself only, constitute the sum and substance of a life. (1991, p. 1)

A plethora of tools and approaches to narrative analysis exist. As Manning and Cullum-Swan point out, "To a striking extent, narrative analysis is loosely formulated, almost intuitive, using forms defined by the analyst" (1994, p. 465). These forms have been broad-ranging and include those of Kenneth Burke and William Labov. Both provide specific ways to analyze how social agents represent their past in terms of social and personal moral orders.

According to Labov, a "fully formed narrative" contains six elements: the abstract, which summarizes the story; the orientation, which introduces the parties, place, and time relevant to the story; the complicating action, or what happened to mark these events as special; the evaluation, or the way the speaker

responded to the complicating action; the resolution, what finally happened; and the coda, which returns the speaker to the present (1972, pp. 362–396). Thus, Labov's narrator represents some past action in a particular way, presenting himself or herself as actively evaluating and responding to a particular situation in a particular way. The work of language is thus central here. By forging experience into "narrative syntax," the speaker presents himself or herself as a moral agent, as acting by way of a certain meaning-making system. Labov gives a fairly detailed typology for the different kinds of evaluations that speakers draw from to comment on the complicating action. Labov calls the evaluation "perhaps the most important element in addition to the basic narrative clause" (p. 366), as it gives us access to the norms at work.

In turn, Burke's (1969) narrative model, his "grammar of motives," helps us understand the role of "motive" in individuals' understandings of themselves and others in relation to specific events. By understanding how scene, act, purpose, agency, and motive are used in relation to each other vis-à-vis a particular event, one comes to understand the underlying norms which motivate particular speakers. Indeed, although Burke was a literary critic and referred often to literary texts, his work has great value for understanding the stories or narratives individuals tell about themselves and the world around them. Burke gives an example of what he calls a scene-agent ratio in the naturalistic novel, noting that an author "may choose to 'indict' some scene (such as bad working conditions under capitalism) by showing that it has a 'brutalizing' effect upon the people who are indigenous to the scene" (1969, p. 9). Scene is valued over agency in this example, giving us key insight into the author's ideas about the world. Burke's narrative approach is a "dramatistic" one that fits nicely with the notions of performance drawn on throughout this book. It will be of particular help in understanding how young people understood the life of Tupac Shakur (his agency) and events surrounding his death (the scene).

As Bruner points out, studying narrative is key to understanding the particular values that particular communities hold: "values inhere in commitment to 'ways of life' and ways of life in their complex interaction constitute a culture" (1990, p. 29). These "ways of life" are instantiated in particular narratives, in the particular perspectives on the world they help constitute. A key question thus becomes how people perform these stories in particular ways and how these stories may or may not respond to changing historical forces. Some stories do not change over time and must be told in specific ways. Others respond to historical events and situated agents in more fluid ways. Stories of the former kind, for example, are often realized in rigid school curricula and in religious

dogma. Stories of the latter kind are often realized in speech events such as a community's folktales.

The role of authoritative narrative in relation to dialogic narrative has been an important area of inquiry for those in performance studies. Richard Bauman (1986), for example, has looked at how different storytellers tell the same story over time in different settings, registering and responding to different "contexts of telling" in particular ways. There is, according to Bauman, an "indissoluble unity" between "text, narrated event, and narrative event" in such storytelling activities (p. 7). The events that are spoken of or reported, the text or narrative itself, and the situated event of telling are all mutually overlapping. All must be understood in all of their complexity, individually and together, to understand the degree to which language practices work to effect cultural reproduction. Situated realities, thus, are constituted through narrative, and these narratives are open (at least potentially) to situated tellings, which are dependent on a whole host of contextual and historical contingencies.

The work of popular culture is key here, as well. In many respects, popular culture provides the key narratives or stories—around love, respect, friend- ship, adventure, etc.—that people make use of in coming to inhabit validated identities. Increasingly, in fact, young people are turning to popular culture to inhabit particular identities, often in lieu of narratives available in traditional institutions such as school and family (Berger, 1999; McCarthy et al., 1999). Indeed, popular culture is typically not validated by official institutions, which tend to stress authoritative narratives almost exclusively. As de Certeau (1984) notes, people pick up these popular resources and perform and re-perform them to make sense out of their worlds in multiple contexts, making places for them- selves out of the spaces made available in dominant culture.

The roles of celebrities or icons are particularly important here, as such "stars" are repositories for numerous affectively invested stories and narratives. For example, as Gil Rodman (1996) notes, Elvis Presley has inhabited and embodied many of the most charged discourses—especially around race—in contemporary U.S. culture. After his death, these discourses, including the facts of his life and career, were subtly transformed in making him a mythic, even godlike, figure. Similar processes are at work today for numerous popular icons or stars whose lives are worked and reworked in particular ways in the popular imagination. The power to use these symbols is, in large measure, in the hands of the people (de Certeau, 1984). These are not the official sto- ries that get handed down, often through canons and historical texts. These are the unofficial stories that people make relevant to their own lives, in

unofficial sites, such as at the community center where this research took place. This is the whole area Fiske and Dawson call "audiencing," "the process in which audiences selectively produce meanings and pleasures from texts" (1996, p. 297).

## Tupac and the Emergence of Conversational Narrative in Rap

Popular icons are thus open to multiple performances, interpretations, and retellings. Yet, we must also explore the kinds of meanings that have been historically enabled and constrained by these icons, interrogating the larger discourses in which they are embedded. It is thus important to situate rap music within broader discursive/cultural formations. As I will note, and as I touched upon in chapter 1, rap music is driven today, in large measure, by individual and highly psychologized icons. The music is marked, most typically, by individual rappers, with often clearly explicated personal biographies that inform much of their music and videos. Examples today include Master P (from the South), and most especially Tupac Shakur (from the West) and Biggie Smalls (from the East).

Most specifically, rap is linked to emerging global trends toward "conversational discourse," a trend highlighted by Norman Fairclough and others (Kamberelis & Dimitriadis, 1999). According to Fairclough (1995), public discourse has tended to take on an increasingly conversational character. Printed media, advertising, and also official documents such as employment applications and insurance forms, radio and television programs, formal government reports, and academic texts are all affected by this tendency. The following are some important features of conversational discourses: utterances replete with affective verbs (e.g., "feel," "love," "want"); an abundance of reported speech, colloquial lexicons, and idioms; many oral discourse markers (e.g., "oh well," "yeah," "like," "really"); dense intertextual links to the public media and other forms of popular culture such as song lyrics or advertising slogans; and thematic content that might be considered private, such as sexual affairs and financial dealings.

A brief analysis of media forms in almost any domain of public culture would show that the boundary between news and entertainment has become increasingly blurred during the past several decades, and perhaps even longer. This trend is evidenced, for example, in tabloids such as the *National Enquirer*, in television news magazines such as *20/20*, in reportage of special events such

as the Olympics, and even in the official news programs of network television. Fairclough (1992) provides micro-level analyses of conversationalized discourse within the public sphere across a number of different texts, including university advertisements, television shows, and newspaper headlines. For example, he shows how newspapers routinely represent the voices of powerful individuals or social forces in informal or colloquial ways, using a headline from the *Daily Mirror* to support his claim: "Di's Butler Bows Out...in Sneakers!" He points out that "the voice of the royal butler...is a popular speech voice, both in the direct discourse representation...and in the attributed use of 'sneakers'" (pp. 111–112). Princess Diana, in turn, becomes "Di," and she is described as "'nice,' 'ordinary,' 'down to earth,' and 'natural'" (p. 112). In the very commercial context of this newspaper, information about the royal family revolves around personal and personalized issues and concerns. This personalization is instantiated in the texts themselves, which are markedly colloquial.

Fairclough notes that the use of more informal language in public texts is indicative of two tendencies: "the tendency of public affairs media to become increasingly conversationalized" and the "tendency to move increasingly in the direction of entertainment—to become more 'marketized'" (1995, p. 10). As market forces overtake media such as records, radio, and television, they become more personal or conversational. Quite often, efforts to render news and information more informal and approachable are deemed democratic. More people have access to news and other public information because media events are "brought to the level" of the average citizen. However, such "marketization undermines the media as a public sphere" as well (p. 13). Conversationalized public discourse renders the meanings of social and political events and issues in terms of individual agency and everyday social practices, key motifs of liberal-pluralist ideologies. As Fairclough notes, "There is a diversion of attention and energy from political and social issues which helps to insulate existing relations of power and domination from serious challenge" (p. 13). Conversationalized discourses routinely collapse personal and political issues, quite often reducing conflict to individual differences, which can ultimately be resolved by individuals through dialogue. In addition, conversationalized public discourse blurs the line between information and entertainment and between the public and private. Among other things, this blurring helps render constructed selves and worlds durably real. It also encourages bringing issues traditionally considered to be private into the public sphere for discussion and evaluation.

## *Rap and the Psychologized Hero*

Recent developments in rap music seem linked in constitutive ways to the emergence of these conversationalized discourses. Indeed, hip hop, as noted, began as a largely party-oriented music, almost entirely dependent on face-to-face action and interaction. The musical event itself was more important than any particular verbal or vocal text that might occur in it and later be lifted for reproduction and marketing. Loose collectives such as the Sugarhill Gang and the Furious Five traded verses in live interactive settings, with the primary goal of getting crowds involved in an unfolding event. As rap grew in popularity, however, the individual icon and the self-contained vocal text became increasingly important. The first such figure or character type was the "gangsta." In large measure, the gangsta was a larger-than-life character whose exploits existed at the surface of exaggerated violence and brutality.

These gangstas became the most visible and important part of hip hop culture during the late 1980s as rap became wildly successful in recorded commodity form—a phenomenon I detailed above. Yet, I would like to stress here that the gangsta is implicated in a narrative traditional to many generations of African Americans—that of Stackolee. Folklorists Roger Abrahams (1970) and Bruce Jackson (1974) have both documented the ways this character or archetype was—and has remained—historically salient for this beleaguered population. Stackolee reached its most popular manifestation in 1958 with Lloyd Price's hit "Stagger Lee." However, as Greil Marcus notes, a bluesman named Mississippi John Hurt recorded a version, "Stack O'Lee Blues," as early as 1929 (1975, p. 66). Both of these are variations on a single story, the conflict between Stackolee and "Billy" and the murder of the latter by the former. As Greil Marcus so eloquently writes:

> Somewhere, sometime, a murder took place: a man called Stack-a-lee—or Stacker Lee, Stagolee, or Staggerlee—shot a man called Billy Lyons—or Billy the Lion, or Billy the Liar. It is a story that black America has never tired of hearing and never stopped living out, like whites with their Westerns. Locked in the images of a thousand versions of the tale is an archetype that speaks to fantasies of casual violence and violent sex, lust and hatred, ease and mastery, a fantasy of style and steppin' high. At a deeper level, it is a fantasy of no-limits for a people who live within a labyrinth of limits every day of their lives, and who can transgress them only among themselves. (1975, p. 66)

Gangsta rap is the modern-day embodiment of this archetype, and it became pronounced, as noted, during the mid- to late 1980s.

During the early to mid-1990s, however, more personal and more complex portraits of these figures began to emerge. Most importantly, rappers like the Geto Boys, Biggie Smalls, and Tupac Shakur psychologized the gangsta type, adorning their stories with disturbing personal and psychological insights. The goal was no longer only to present a violent snapshot of gangsta life, but to help us understand what was happening inside the figure of the hero. Biggie Smalls (or The Notorious B.I.G.), for example, framed his debut album *Ready to Die* as an aural/musical biography, beginning with his birth and ending with his suicide. Smalls thus used his biography to contextualize his music, blurring the line between the personal and the public, between information and entertainment. This album was intended not only to get crowds dancing (as in early hip hop) or to relate violent exploits (as in gangsta rap), but also to give us a peek into Biggie Smalls's psyche—his motivations, desires, and feelings as explicated in deeply psychological narratives.

Tupac Shakur is another prime example of the psychologized rap hero. His biography, as noted, is a crucial part of his public image, and the details of his life, which was talked about on record and off, have become almost legendary. One key example: The song "Dear Mama" chronicles his early life in explicit detail, including the absence of his father, his reliance on his mother, her use of crack cocaine, and his turn to crime. Again, Tupac goes beyond a two-dimensional sketch of his life, to present a complex, deeply structured, and highly textured portrait of it. In weaving together the narrative of his mother and her struggles, he simultaneously constructs an "account" that functions to justify or explain the choices he made (Buttny, 1993).

Tupac's self-revelations often position him at the nexus of complex and seemingly conflicting social forces. In fact, the personal narrative of "Dear Mama" is made all the more poignant by the fact that Shakur's mother, Afeni Shakur, was a famous Black Panther, a member of the famed Panther 21, who were arrested for allegedly attempting to orchestrate a series of bombings in New York City. According to popular accounts, Tupac inherited much of his mother's militant black power worldview. These accounts emphasize, for example, the fact that Tupac has a black panther tattooed on his arm and that a number of his songs depict or celebrate the struggles of black people (e.g., "White Man'z World" and "Keep Ya Head Up"). To a large extent, Tupac is heralded as a contemporary bearer of 1960s-inspired black nationalist attitudes and sentiments.

Yet Tupac is as much gangsta as revolutionary—a tension inherent in much of the Stackolee myth. Greil Marcus (1975, p. 66) notes that famed Black Panther Bobby Seale named his son after Stackolee, the image being a central one

for the organization as a whole. Indeed, the Panthers fought, and ultimately lost, the battle to channel the outlaw energies of Stackolee into a productive political agenda, a point Marcus makes as well. Tupac, the son of Black Panther Afeni Shakur and godson of Panther Geronimo Pratt, fought the same battle.

Tupac was involved in a number of shootings (including one with two off-duty police officers); he was sentenced for up to four and a half years in prison for sexual abuse; he was almost fatally injured in an assassination attempt and robbery; and ultimately he was murdered in a drive-by shooting. Much of his music reflects this gangsta lifestyle, as evidenced, most especially, on *All Eyez on Me*, which was recorded on the Death Row Records label (see, e.g., "Ambitionz Az a Ridah," "2 of Amerikaz Most Wanted," and "Can't C Me"). Many interviews and news stories about Tupac have stressed his complex and divided soul, pointing out how his internal struggles between "good" (fighting for black rights while detailing his inner life) and "evil" (his uncritical gangsta posturing) were central to his music, which, again, ran the gamut from the more "positive" to the wildly "negative." *Rap Pages*, for example, subtitled their December 1996 tribute to Tupac "Exploring the Many Sides of Tupac Shakur." The issue included a feature article entitled "Loving Tupac: The Life and Death of a Complicated Man."

Many rappers, including Biggie Smalls and Tupac, have become near-mythic public figures whose personal struggles were and are an integral part of their music. This fact was set into high relief in the feud that erupted between Tupac (and his record label, Death Row Records) and Smalls (and his label, Bad Boy Records). The history of this feud is complex. According to Tupac, he and Biggie had been friends early on in their careers. In 1994, however, Tupac was ambushed and shot while heading to a recording studio to meet Smalls. He was shot five times but survived. Although the crime was never solved, Tupac publicly accused Biggie Smalls of organizing the attack. A number of seemingly related incidents, and popularly disseminated accounts, followed. A friend of Suge Knight (head of Death Row Records) was killed at a party, and Knight blamed Puff Daddy (head of Bad Boy Records) for the murder. An entourage of Death Row Records members, brandishing guns, then threatened Biggie Smalls at an industry award party. Finally, Suge Knight, reputedly associated with the LA-based gang the Bloods was rumored to have threatened Puff Daddy's life.

These real-life events overlap and blur into events chronicled on a number of recorded singles released by these two artists. Biggie Smalls, for example, released the caustic "Who Shot Ya?" in 1995 as a b-side to the hit "Big Poppa." This single plays off the phrase "Who shot ya?" presumably alluding to the earlier, unsolved shooting of Tupac. Thus, Tupac is the private audience targeted

by this ostensibly public message. Lines like "Cash rules everything around me, two Glock 9s for any mother fucker whispering about mines" abound on this track, along with various threats and boasts by Biggie and Puff (e.g., "Didn't I tell you not to fuck with me!...Can't talk with a gun in your mouth?").

Tupac, in turn, released his scalding "Hit 'Em Up" in 1996, on which he viciously attacked both Smalls and Junior M.A.F.I.A. (Smalls's group, his protégés). This track explores in explicit detail the personal falling out between Tupac and Biggie. Tupac begins the track by saying, "That's why I fucked your bitch, you fat motherfucker," an allusion to the rumor that he had slept with Biggie's wife, R&B singer Faith Evans. Faith has denied the claim, but, as I will note later, it has gained "factual" status within the popular imagination. Tupac goes on, during the course of this track, to threaten Biggie, Junior M.A.F.I.A., and all of Bad Boy Records with attacks grounded in their personal histories. At one point, Tupac raps about their early friendship, "Biggie, remember when I used to let you sleep on the couch?" Yet, he raps: "Now it's all about Versace? You copy my style/Five shots couldn't drop me/I took it and smiled." According to Tupac, Smalls returned his friendship by trying to imitate Tupac's musical style (which revolved around the expensive tastes of the "playa" lifestyle, as evinced in the reference to Versace) and eventually orchestrating his attempted assassination.

This conflict demonstrates how the line between what artists portray through their lyrics and what happens in real life gets blurred. This blurring is in no small measure related to the tendency within the rap music industry in the early 1990s to foreground the inner lives, experiences, and conflicts of its artists—artists who are portrayed as mythic figures with complexly explicated biographies. Equally important for my argument, this particular moment in hip hop's history seems linked in constitutive ways to more global cultural imperatives marked by a tremendous increase in conversational or personalized discourses in the public sphere. As such, I do not want to stress only the "openness" of Tupac-as-icon without exploring the meanings enabled and constrained by the discourses in which he is historically embedded.

## The Discursive Life, Death, and Rebirth of Tupac Shakur

### Tupac and the Everyday Lives of Young People

Tupac embodied the Stackolee myth of an invincible outlaw who settles his problems swiftly and violently, providing feelings of physical invulnerability to

an often intensely vulnerable population. Yet, it is important to note, Tupac personalized these feelings of invulnerability. In many respects, Tupac represented this archetype from within contemporary commercial currents toward conversationalized discourses. Tupac's music achieved unprecedented sales and spoke to an entire generation of young people in entirely unique ways, as noted above, through his positioning at the nexus of these two discourses.

In fact, while Tupac was alive he was an almost constant subject of discussion. His music, which drew on the complex details of his life, was valued in unparalleled ways. Tupac was called "the coldest" of all rappers, a person who could stand up "against all odds" while also touchingly detailing his inner emotional life. A few examples of these young people's manifold and complex reactions to Tupac will suffice. Early in this project, we constructed a newsletter, as a group, documenting our favorite artists "past, present, and future." Many chose to write about Tupac, who was still alive at the time. One young man (now in jail) wrote that Tupac "has been through things we have been through." In a similar vein, another (also in jail) noted Tupac's constant harassment by the police, stressing the ways he himself had been harassed: "what strike me [about Tupac's music] is really...the way the police be harassin' him...'cause I be gettin' harassed the same way. It's like most of the stuff he be talkin' about...that's how I be feeling." One young woman, taking a slightly different approach, eloquently wrote:

> Tupac is an inspiration to me because he talks about everything that happens in the real world. The stuff he be talking about—his momma and how she was a drug addict but how she still loves him and tries to do what she can for him and how he still loves her because his momma loves him a lot even though she was in jail and his grandma took care of him. And his father was never there for him.

The wide range of responses reflects the diversity of Tupac as a public icon. Tupac was a complex figure who had many different kinds of appeal to young people—from his bold confrontations with the police to his tender relationship with his mother.

Indeed, Tupac's life story and music intersected with the everyday lives of many different young people with a broad range of day-to-day concerns. The second youth quoted above, for example, had a history of both personal and familial confrontations with the police. Plainly he felt his anger at the police expressed in Tupac's music, "Like when he's talkin' about the police harassin' him all the time?...Every time the police see me, they got something to say to me, about my daddy, and my brothers...tellin' me I sell dope and all this." This young person's feelings toward the police and the life stance he has had to take

gelled together into a kind of philosophy of invulnerability and a kind of grim resignation to death. He notes:

> To live in fear is not to live at all...You can't run from every damn thing all the time...You might as well not even live...It's like you dead anyway, you keep thinking motherfuckers gonna kill you...I ain't trying to say make yourself die...[But] don't worry when it comes to you 'cause it's gonna happen anyway...We live to die. You know what I'm saying? That's one thing we know for sure. Like, like you say you're gonna go to college when you get older? You might not make it to older. Like you say...I finna go down to the gas station and get some squares? I might not make it to the gas station...But I know I'ma die. I know I'ma die. We live to die.

This young person saw a similar philosophy in Tupac's music: "Don't fear no man but God...Just like Pac said...he talk a lot about not fearing death." These songs, it seems, provide young people like this one with a certain kind of "equipment for living," discursive strategies for confronting and coping with specific day-to-day concerns (Burke, 1941).

Again, Tupac's life story and his music—his confrontations with the police and his seeming resignation to his own death (as evidenced by songs such as "Only God Can Judge Me" and "If I Die 2Nite")—gave voice to the everyday reality this young person faced. As another young man who also had a history of trouble with the police commented, "I like Tupac because I like the way he expresses his feelings and he's a role model for us thugs." When asked what a thug is, he responded, "A thug is a person who don't like them crooked ass cops and make money the best way he can and a person with a strong mind."

Other dimensions of Tupac's life appealed in other ways to these young people. For example, Tupac's personal story, including his valorization of his mother, registered in profound ways for many young people living in single-parent households. As one young woman put it: "Tupac's life is kinda like mine except I ain't never been in jail because my momma been the only one there for me. I really don't know my daddy so I'm havin' mix feelings about him. Sometimes I feel like I hate him and other times I really love what we did when we was together." Tupac's anxieties about his mother and his father (about whom he commented, "the coward wasn't there for me") clearly registered with this young woman in important ways.

Thus, in addition to his vitriolic attacks on other rappers and his defiance of the police, Tupac was capable of expressing great respect and tenderness to and for women, including, perhaps most notably, his mother. This was an important theme for many of my participants who were raised by single, struggling

mothers and had great devotion to them. Speaking about her male friends, for example, one woman commented, "Even though they be trying to talk hard and stuff, they still got respect and much love for they mama." In addition, Tupac recorded a number of odes to women, including "Keep Ya Head Up" and "Just Like Daddy," songs that addressed many of the specific concerns of young people in relationships today. For example, this young woman, who was raised by her mother, said that she liked the song "Just Like Daddy," which contains the line "You never had a father or a family, but I'll be there, no need to fear so much insanity." She noted:

> That's like true, 'cause that happen to a lot of girls, they like don't have a father at home, so they look for like a boyfriend or whatever, find that father figure, have a father role model in they life. And that happen a lot of time, but he still giving her respect ... he ain't just saying "yeah you ain't got no daddy, Im'a be your man." He saying even though you didn't have a father, I understand.

Tupac, once again, appealed to different young people in different ways—in fact, he was appealing in his differences. Indeed, the two songs that resonated most clearly with young people and were spoken about most often were "Dear Mama" and "Hit 'Em Up," two very different, near-dichotomous, songs (as noted above). Clearly, Tupac's music resonated with great force for these young people on multiple levels, from the invulnerability of Stackolee to the personal pains of poverty. Tupac was a vehicle for young people to register their complexity, belying the narratives that are often provided to understand black youth, the kind that construct them as aberrant, nihilistic, and pathological. He was, perhaps, the most central icon in their lives up until—and after—his death.

## The Death and Rebirth of Tupac

When Tupac was shot and killed, he was discursively reborn, his life and music becoming fodder for a range of myths from the mundane to the implausible, performed and re-performed in unpredictable ways. Drawing on a number of texts and discourses, these young people reconstructed his life, transforming it in important ways. These myths, following Bakhtin, Bauman, and others, were open and subject to dialogue and mediation among these participants. They were entirely unlike the more monologic myths that young people are offered in official institutions such as school. Here, knowledge is typically offered as a product to be consumed and regurgitated in specific and highly controlled ways. Rather, the ways in which these young people came to understand Tupac's life

and death were open and subject to multiple manifestations. The rest of this chapter will explore how young people constructed an icon who was critical to their collective lives and individual selves.

As one might imagine, Tupac's death in 1996 was devastating for these young people. Tupac had taken on an aura of invincibility prior to this tragic event. He was shot five times two years earlier and he survived, even leaving the hospital against doctor's orders to attend his upcoming criminal trial. At the scene of the first shooting, he was photographed being lifted on to an ambulance and giving his middle finger to a police officer, the ultimate act of defiance and a gesture most clearly in line with the imperatives of Stackolee. He was widely photographed years later bearing the scars of this shooting and even bragging on record about surviving it—"Five shots couldn't stop me, I took it and smiled." The image—so deeply enmeshed in the historical fantasies of African Americans—captured the public imagination.

It is little wonder, then, that when Tupac was shot a second time, many expected him to survive. I did, for many of the reasons touched on throughout. He was in the hospital for six days, and the medical reports were seemingly positive up to the point of his death. When the first reports of his death came through, there was general shock and anger. Reports of panic by Tupac's associates at the hospital were widespread, and members of the Death Row entourage reportedly accosted doctors asking why they had "let" Tupac die.

I was at the community center that night, watching Black Entertainment Television with a teen. When the report of Tupac's death was announced, he angrily punched the air and left the room. Soon, a large number of young people of all ages congregated around the television, uncharacteristically quiet, receiving the reports. Some very young children were visibly upset and even crying. I distinctly remember one young girl—perhaps seven or eight years old—coming up to me teary-eyed, asking, "Is Tupac dead?" My response, in retrospect, was cautionary, almost disbelieving, foreshadowing the rumors that would soon become prevalent: "That's what the television said."

Shock was the first reaction here and would last well after the first reports of his death. However, as I will note, this shock turned to blame, which, in turn, gave way to rumors that Tupac was still alive—rumors that circulated nationally and internationally. The facts that were called on to support this myth were culled from the available information—details from the crime scene and its aftermath as well as his last, near-prophetic albums and videos, which were slowly released by Death Row Records in the months following. All were mobilized to support the overarching belief that Tupac was alive. Interestingly,

as I will note, when his rival Biggie Smalls was later killed, none of these myths emerged, even though the facts, similarly construed, could have supported such a story. These young people were much less invested in Biggie's life. Tupac's life and death were articulated in specific and highly circumscribed ways.

In contrast to other treatments of myths and mythic formations, this chapter takes a distinctly historical and process-based approach, looking at how this myth of Tupac's life after death developed over time out of available discursive resources. One teen summed up quite eloquently her process of grieving. She began by relating her feelings of shock and grief: "I was over his [her cousin's] house...and I was, um, talking to my girl cousin Jill. And she told me that the night before they had announced that he was dead. I was like, please he can't be dead. I was like, I can't believe it, Tupac wasn't never supposed to die." Many seemed similarly and grimly resigned to the fact of his death. She continues:

> I didn't believe that he was dead at first but then when they said he was dead, it just made me holler and then I was like, okay, I finna see. And so when we was at school, we was readin' magazines...into the week...we was reading magazines about how it had happened and all that stuff, then I was like, how can that be? And they started saying how maybe the police did it and maybe Biggie...all these people were supposed to have did it. And then they was like, uh-huh, that man ain't dead. Tupac ain't dead. He ain't dead.

This teen's remarks underscored how Tupac's death was met by shock, then by efforts to assign blame, and, finally, by the myths about his being alive.

Much of this shock seems to be about the investments that these young people had in his life and music. During this same conversation, one teen commented: "I ain't trying to say, like he ain't my god or nothing, but I kinda got faith in him...I don't think he gone yet. His music was too good for it to be just over. I ain't crazy, trying to rationalize in my mind. But, I just don't think so." It is thus no wonder that many young people offered the plethora of recently released Tupac material as evidence to "prove" that he was alive. Indeed, perhaps more than anything, the fact that Death Row Records continued to release Tupac's work after his death helped fuel these myths. Tupac reportedly left behind several hundred unreleased tracks, both solo and with other rappers, including his "crew," the Outlawz. Several of these have been released on albums (e.g., *The Don Killuminati: The 7 Day Theory* [released under the alias Makaveli] and *Still I Rise*) and movie soundtracks (e.g., *Gang Related*). Others have been released in bootleg form (e.g., *Makaveli 2* through 6).

In addition, before his untimely death, Tupac starred in several very popular movies and released a number of videos, all of which helped fix his place in the lives and hearts of these young people. Indeed, Tupac's physical presence was a striking and highly charged part of his public image. As two teenage girls wrote in a collaborative essay: "Tupac is fine. He got a body. He built." He often posed shirtless on stage and on film, showing his taught, muscular physique adorned with tattoos. Yet, he did not present himself only as hypermasculine. Critics and fans often commented on his eyes, which were called piercing and even doe-like—in fact, family members recall his being picked on as a young person for his almost feminine facial features. Tupac, apparently, was a charismatic figure in a genre of music increasingly constituted through the visual. As I noted in chapter 1, the visual medium has been inextricably entwined with the emergence of the gangsta rap music genre. Films such as *Menace II Society* and *Juice* told narratives similar to the ones featured in gangsta rap and often featured rappers as actors. Thus, the release of videos and movies (e.g., *Gang Related* [1997]) after Tupac's death helped these nascent claims resonate with all the more force because his physical presence was so strikingly "real."

During one such discussion, a teen noted that the videos for "I Ain't Mad at Cha," "To Live & Die in LA," and "Toss it Up" all came out after his supposed death. She noted that she would "let the first one slide [but] ain't no way two more videos can come out." "I Ain't Mad at Cha" is particularly interesting here, as the video relates a visual narrative of Tupac being shot and killed and going to heaven and meeting other famous black singers and entertainers, including Billie Holiday, Jimi Hendrix, and Sammy Davis Jr. It was released mere days after his death, and many youth, quite understandably, commented on the strange coincidence. Many pointed to this video as proof of Tupac's foreknowledge of his death, and thus, they reasoned, his complicity in it. Many presented this video as incontrovertible evidence that he was alive. In summary, Tupac's music and image seemed so affectively invested for these young people that any thought of his being dead was simply incongruent. As the above teen summed up, "His music was too good for it to be just over."

Thus, these young people "kept" Tupac alive, slowly but surely mobilizing the facts around his death in particular ways. As noted, these myths emerged after the initial shock of this icon's death settled in, after the assigning of blame subsided. However, neither discourse ever really disappeared. Almost immediately, the young people proposed that the conflict between Tupac and Biggie Smalls was a reason for the incident, and they would call on its explanatory force again and again. Indeed, I do not want to set up some sort of a linear

progression in their emotional responses to Tupac's death—from shock to denial—assuming each superseded the previous one. Rather, I will explore how different explanatory frameworks were born and how they competed with each other in the coming months. Following Fairclough (1995) and others, this kind of competition between explanatory frameworks indexes broader cultural tensions and struggles.

Again, talk about Biggie Smalls was all-pervasive. The very night Tupac was murdered a young person commented to me that it must have been over Faith, Biggie's ex-wife. During the first organized discussion group around Tupac's death, there was a lot of talk about Tupac's single "Hit 'Em Up" and how it must have angered Biggie enough to want to kill him. The intricate conflict between the two was often foreground in such discussions in the weeks following, giving young people at the center a way to understand this conflict in highly personalized terms. As noted elsewhere, these young people appropriated the "television talk show" speech genre to process this event, allowing them to foreground the violent "feelings" that these men had for each other as a result of their personal differences and grievances (Kamberelis & Dimitriadis, 1999). These included, most especially, the rumor that Tupac had slept with Biggie's wife.

The effort to assign blame, however, went beyond Biggie Smalls. During the second session devoted to Tupac's death, one member commented that Tupac had been registering young people to vote and this might have gotten certain (white) people mad. In this group discussion there was also talk about how Tupac was taken off life support too early. One teen said that they wouldn't have "done the president like that." Clearly, these young people were trying very hard to make sense out of Tupac's death, often turning from shock to involved discussions about the specific circumstances of his death. The role of Biggie Smalls and his conflict with Tupac was by far the most prevalent explanatory framework here, though some raised other questions as well. However, in none of these discussions, notably, was Tupac seen as an active agent; he was a victim of forces beyond his control.

Kenneth Burke (1969) notes that the assigning of "agency" is a crucial part of interpreting and constructing narratives. Narratives, he argued in his classic *A Grammar of Motives*, rely on a complex understanding and assigning of motives. Burke wrote, "Any complete statement about motives will offer *some kind* of answers to these five questions: what was done (act), when or where it was done (scene), who did it (agent), how he did it (agency), and why (purpose)" (p. xv). Understanding the "ratios" between these key questions—for example, how scene is stressed in relation to agency in the telling of a particular

story—gives us some window onto the meaning-making system at work in any particular narrative.

Interestingly, in these discussions, the "agency" of Tupac came to take center stage as time elapsed. The "scene" and "act," which were so key for early discussions, were soon eclipsed in favor of myths about Tupac controlling and orchestrating a complex situation. Thus, some people noted that he knew about his death beforehand. Evidence for this position was often given in the form of the posthumous videos such as "I Ain't Mad at Cha," as noted above. In one of the clearest examples of this dynamic, someone noted—quite accurately—that Tupac left his house that night without a bullet-proof vest. While interviews with Tupac's fiancée reveal that the decision was a result of the oppressive Las Vegas heat, this young person construed that Tupac knew he was going to die. In fact, this young person noted (or imagined) that, when he got shot, Tupac leaned back and spread his arms as if he was on a crucifix and said, "Death's came to Tupac." There is a certain kind of agency here, one that positions Tupac as a knowing agent in his death, someone who willingly sacrificed himself as did, this teen implies, Jesus.

This religious reference is underscored by another bit of textual evidence—a posthumous album entitled *The Don Killuminati: The 7 Day Theory*. While in prison, Tupac read *The Prince* by the Italian philosopher/strategist Niccolò Machiavelli and, upon his release, decided to record an album under the pseudonym Makaveli. The album liner notes read "Exit—2Pac/Enter—Makaveli," and the cover features, most notably, a drawing of Tupac nailed to a cross. The young person thus mirrored this image when he spoke of Tupac, assigning Tupac "agency" or complicity in his own demise.

However, his claims were not above reproach. As one teen stressed (quite logically!), "Man, stupid, if he know he was gonna die, he woulda worn his vest!" In response to these charges that Tupac foresaw his own death (e.g., in choosing not to wear his bullet-proof vest), many young people implied that Tupac not only knew he was going to die, but planned the attempt and, in fact, faked it. Why would he simply let himself die? Something more must be at work here. The reasons offered for this account ranged from the idea that he was going to orchestrate a surprise attack on Biggie Smalls to the idea that he was evading the IRS.

Rumors soon circulated that Tupac had paid a doctor a large amount of money to help him in this scheme and that Tupac was now hiding out. The most often cited places were the Bahamas, Cuba, and Africa. Some suggested, in contrast, that he had been caught and was now in jail. However, the myths

that stressed Tupac's invulnerability and cunning won out. He was, quite simply, too good, too smart, and too tough to get caught. He must be hiding out, living the good life. Tupac, for these young people, was the consummate director of these complex activities, with a clear master plan.

It was often difficult for these youth to reconcile what they accepted as fact from these more clearly hypothetical scenarios. Young people often created long, seemingly fictional narratives to help explain how Tupac was actually shot, wound up leaving the hospital, faked his death, and was caught. One young person (noted in the introduction) said: "I think Tupac got set up. They shot him but he survived. But then nobody knew he survived, 'cause I think he probably, say like during the night he, he had snuck out... he, he had started feeling better and snuck out." He continued, noting how he was caught and was now in jail, "They got him on some top security. They know... Tupac's smart, he can deal some schemes, try to get out and stuff, but they got him on top security." Again, the resources of Tupac are stressed, and they had to be weighed against the idea that he was caught and now in jail, in effect beaten by a system he fought, in one way or another, his whole life.

Again, these myths about Tupac being alive proliferated almost immediately and were a constant source of discussion among people inside and outside of my discussion groups. While many offered evidence to back up their claims (e.g., new films, videos, and recordings), others relied more clearly on circular reasoning, informed by something like blind faith. Many young people simply said, "Tupac's not dead," when the subject came up without offering more evidence. A typical response was "Tupac ain't dead because I just know." During one discussion, when an older teen said she thought Tupac was dead, a younger person covered his ears. When she said she was going to leave the room if he didn't stop, he commented, "Leave, 'cause you talk too much that Tupac dead." Indeed, Tupac was near-divine to many young people. Reason, as traditionally defined, was not relevant here. Believing in Tupac was far more important a way to mitigate his loss. As such, when we watched a video detailing the disarray of his estate and the problems his mother was having, a younger person said, "Man, that was stupid. But I ain't worrying about it 'cause Tupac ain't dead."

Many of these individual accounts were not internally reconcilable, even on their own terms. As Gil Rodman (1996) notes, however, myths and mythic formations do not have to be internally coherent. Rodman notes, "Whatever the facts connected to a specific event might be, it is ultimately their articulation to particular myths—and the subsequent organization of those myths into mythic formations—that renders them culturally significant" (p. 30). However,

those formations can be self-contradictory. He notes that "a mythological formation...is a set of related myths that revolve around a particular point (or points) of articulation" (p. 31). Often, he says, "the myths that comprise such a formation won't be mutually compatible; in fact, they may even contradict one another point for point down the line" (p. 31).

Tupac—writ large as text—became such a mythological formation, one constituted through often contradictory stories and accounts. Belief in him was most important as a coping or defense mechanism. Sometimes, in fact, I got the sense that young people were in willful denial. The young woman, for example, who wrote the earlier statement about the inspirational force of Tupac's music, related to me, early on, a typical story about Tupac—that he paid his doctor $200 to fake his death and got caught and was now in jail. I asked her how they could keep such a massive series of events a secret from the general population, a standard problem with such conspiracies. The young woman simply sighed, smiled, and said, "I know, I know."

Thus, many posited a kind of blind faith in Tupac being alive, one that mitigated their sense of loss. Yet, this same sense of loss caused many young people to feel anger with Tupac for not revealing himself in more public ways. For example, the young woman who commented that Tupac's music was "too good for it just to be over" also commented, as a kind of aside, that faking his death was a "stupid" thing to do because he left so many people to deal with such grief and misery. In fact, at the time of the murder, many thought Tupac would be returning soon despite the apparent fact of his death. When this did not happen, many struggled between believing he was still alive and dealing with the fact that he had in effect abandoned them and acknowledging that someone had defeated him by ending his life. It was not a pleasant decision for these young people, so many of whom were so invested in Tupac's life and music.

I turn now, in more specific ways, to how these young people—or at least some of them—discursively transformed the life of Tupac into something like a mythological formation. As noted, young people ascribed different kinds of agency to Tupac. However, all were instrumental in constructing a hero salient in and to their lives, one embodying a Stackolee myth from in and within contemporary conversationalized discourses. I will elaborate on one particular and highly telling incident that took place over the course of several discussion groups.

During a discussion group that took place about two months after Tupac's death, I told the group what I knew about the first time Tupac got shot: He was

going to a recording studio to record a verse for an artist named Little Shawn and was ambushed inside the building by three gunmen. I noted, as an aside, that he went into shock after the assault and initially didn't realize he had been injured. He took the elevator up to meet his friends (including Biggie and Puff Daddy), who were in shock and became near-hysterical when they saw him. Tupac, I noted, started screaming as well when he realized what had happened. This relatively simple story, however, became imbued with a very different message from the one I had intended.

When I told this story, the young people immediately seemed surprised that Tupac actually screamed, and they generally did not believe my account. One young person said, "He started screaming?" I did not intend this as a central part of the story, which I had gleaned from a magazine article. However, this group focused on it as a potential inconsistency in the collective "version" of Tupac's life. This same young person said, "I be like, 'what's up y'all?'" indicating that he would have been considerably more nonchalant about the whole incident. This group member then commented: "The only reason why I think Tupac didn't die when he got shot five times, because he didn't feel it. He didn't feel it. But if he woulda felt it, I think he woulda died." Thus, Tupac going into shock—a medical fact—was interpreted as his invulnerability to pain. He didn't feel it, so he lived. His screaming is downplayed, if not ignored.

The details of this discussion resurfaced exactly one month later. Biggie Smalls had just died, and we were watching an episode of the TV show *Unsolved Mysteries*, which dealt with both their deaths. The show drew speculative links between the two murders and aired an extended version of a Tupac video, "2 of Amerikaz Most Wanted," in which Tupac confronts "Piggy" and "Buff" (i.e., Biggie Smalls and Puff Daddy) for setting him up. In this video, Tupac enters what looks like a darkened office, bleeding, with his arm in a sling, and confronts a surprised "Pig" and "Buff," who believe him to be dead. The scene alludes in every way—in the dialogue, in the use of props, etc.—to the 1983 film *Scarface*, when Tony Montana (played by Al Pacino) confronts a mob boss who set him up. The video draws clear parallels between Tupac's real-life shooting and this filmic fantasy. However, in the Tupac video, Tupac does not kill "Piggy" but says: "I ain't gonna kill you, Pig. We was once homeboys once, Pig. Once we homeboys, we always homeboys." He then walks away. In *Scarface*, however, Montana says: "I ain't gonna kill you. Manolo [his partner], shoot that piece of shit," and orders the man's life ended.

After watching this clip, one young person called out, "He didn't feel it!" and "He wasn't crying!" Clearly, this young person remembered the story I told

earlier and compared it to this recorded version, stressing Tupac's invulnerability and using the video to support his claim that he did not cry. Tupac's reaction in the video is much like the one this young person imagined for himself—saying "I woulda been like, 'what's up y'all?'" with steely nonchalance. The group fixated on this one scene and all but demanded I replay it a number of times. They were transfixed throughout. It was called "the best part ever." A number of young people even thought that the scene was actual footage of Tupac after this failed assassination attempt. In addition, a number said that they wished Tupac had actually killed Biggie. One young person said, "If he woulda shot me, I'ma like, 'even though I can't feel it, and it ain't hurt, you tried to kill me!' Pow, pow, pow!" Another said, "That cigarette he had, I would light it up and throw it on the ground...Burn 'em up."

As noted in the previous chapter, in audience analysis, it is crucial to investigate what kinds of scenes young people decide to focus on. In addition to this scene, they also gravitated toward the casino surveillance video recorded right before Tupac died, which also aired as part of the TV show. In this recorded footage, Tupac and his friends are taped beating a man named Orlando Anderson over an earlier conflict. Many believe that Anderson, who was shot and killed in an unrelated incident in 1998, came back and shot Tupac in retaliation. Again, the entire group focused on the show during this highly violent scene, a scene similar to the ones they focused on while watching *Panther*. The similarities here are important and indicate the degree to which their viewing practices can be traced across different texts, demonstrating coherence in genres as well as in reception practices.

The valorization of Tupac, I note especially, was highly specific. These same young people did not care about the death of Biggie (recall he was killed some months later); indeed, they did not want to speak about him, and they even ridiculed his violent demise. When I introduced the topic of Biggie for the above discussion, one teen commented: "I don't never want to know about Biggie...because I hate him. He shot Tupac." Another young person noted that if Biggie Smalls came to this town "he'd be tore up." Other comments included "I was like, 'it's about time'" and "I was like 'oh well, he shouldn't of been messing with Tupac.'" One older teen summed up her feelings about Tupac and Biggie: "I'm sorry, I don't know why, I kinda smirked [when I heard Biggie died]. I wasn't like I was like 'ha ha he's dead' but I was just like, 'hm'...I ain't feel like I felt about Tupac."

Clearly, these young people did not have the same investment in Biggie's life that they had in Tupac's. Importantly, no one ever suggested that Biggie was

still alive, though such rumors still persist about Tupac to this day. Yet Biggie's life and music could clearly have been used to substantiate similar rumors. For example, his first album was called *Ready to Die*, and he followed it up with *Life After Death*, released posthumously. However, there was no effort to assign him foreknowledge about his death based on these strange details. In fact, one teen said, "He said he was ready to die!" suggesting, "So who cares?" Most likely this young person would have used this fact quite differently to argue that Tupac faked his death and was really alive. Similar resurrection imagery was used by these young people (via Makaveli) as "proof" that Tupac was still alive. However, with Biggie, there was no such talk.

There are a number of possible reasons for the differential value these young people assigned Biggie Smalls and Tupac Shakur. Clearly, Biggie did not embody the kind of highly personalized narratives that Tupac did. He did not detail his life history in the ways Tupac did on songs like "Dear Mama," nor did he touch the everyday realities of women the way Tupac did on songs like "Keep Ya Head Up" and "Just Like Daddy." Nor did he ever survive so highly publicized an assassination attempt. As Tupac rapped, "Five shots couldn't stop me, I took it and smiled." And, as such, Biggie could not embody all of these contradictions in so compelling and charismatic a way.

Tupac, again, became something of a god to many of these young people. In fact, during a subsequent discussion of the relative merits of Tupac and Biggie, one young person raised the question "Who think Tupac go to church?" He then asked for a show of hands to indicate who thought Tupac prayed, in relation to whether Biggie Smalls did. The consensus was that Tupac prayed and Biggie didn't. Another commented, "I think he prayed before he go to bed," to which another responded, "I pray too." When discussing Biggie, a young person noted: "I think Biggie just be like 'oh man, uh, Tupac a punk and I want to kill that fool' then he go to sleep. He don't say nothing about no prayers or nothing." Clearly, Tupac came to occupy a very special moral space for these young people, one Biggie did not.

In addition, Tupac transcended other kinds of boundaries for these young people, in ways others could not. For example, young people at the club typically talked about which artists are in which gangs. Albums are examined for numbers and symbols that have currency in gang culture—e.g., references to the number 5 indicates membership in the People's Nation (which includes gangs like the Black P Stones, Vice Lords, and Latin Kings), while references to the number 6 indicate membership in the Folks Nation (which includes the Gangster Disciples and the Black Disciples). The youth I worked with have

said, using his image and lyrics as evidence, that Tupac was a Crip, a Blood, a Gangster Disciple, a Vice Lord, and a Black P Stone, all at different times. These are all the major gangs, and Tupac "flipped" from one to another, both across gangs and between nations.

However, Tupac was not reproached for his seeming ambivalence, as were others. Flipping gangs or "pancaking" is considered a sign of weakness and indicates that someone is not worthy of respect for who he or she "is." Indeed, membership in gangs is often grounded in ontological being: People will ask each other, "What are you?" the response being, for example, "I'm Folks" or "I'm Stone." The only other grammatically parallel option is "I'm nothing." However, Tupac was never reproached for this practice of flipping, even though his very sense of self and being seems to be at stake. If anything, he was lauded for his ability to "hang across the spectrum" with everybody. This is no small feat and was not an ability of anyone else I know.

Thus we can see that these young people treated Tupac's life as a kind of dialogic fodder from which to construct a particular iconic or mythological formation. This formation was unevenly constructed, employing semiotic resources situated and intensely valued in this community. When I asked individuals where they got their information about Tupac, many said magazines and the Internet, but most also noted that "everybody was talking about it." Tupac, in short, was a constant source of discussion and dialogue, an icon constituted in particular and particularly important ways.

Clearly, Biggie did not serve the same role for these young people. Biggie's music was valued before he died, but he, quite simply, never recorded a track like "Dear Mama," which resonated so deeply and so intensely with so many here. His invulnerability was not so clearly mediated by highly and affectively invested conversationalized discourses (though he was clearly linked to them). Again, Tupac's music resonated in its contrasts. He was someone who loved his mother and lavished praise on her while also showing himself capable of taking five bullets and walking away.

## Conclusions

Tupac, clearly, had great appeal to and for these young people. His discursive life after death points to the ways in which young people were able to work though his life in socially situated, interpretive communities, in a radically disjunctive commercial economy. Yet his life also resonated in the manner of age-old black

folklore, open to negotiation and multiple community tellings. Referring to author Zora Neale Hurston's efforts to collect black folklore in the early part of the century in the rural South, dream hampton notes:

> If Zora were still trekking backwoods (today they'd be postindustrial ghettos), searching for our essence, I have no doubt she'd add the speculation around Tupac's death to her collection of Br'er Rabbit-like tall tales. These improvisational tales of burrowing underground serve as symbolic resistance and, at least in Tupac's case, as a way of coping with loss by breathing life into his legacy. (1997, p. 134)

This, quite clearly, is not the stuff of school-like authoritative discourse, but the stuff of a community able to survive in multiple contexts, including in "postindustrial ghettos" and a postmodern media culture. These young people symbolically resisted the real, positing control over the narrative life and death of a figure they invested with the ultimate such agency and control. In this, there was an overwhelming consensus among my participants.

We have thus seen certain similar themes emerge over the previous three chapters, especially vis-à-vis the valorization of invulnerability. From the super-masculine Southern man to the Black Panthers' confrontation with the police and Tupac's seeming ability to survive two assassination attempts, young people seem to be creating myths that work to mitigate intense feelings of vulnerability—as young, black, poor, and gendered subjects in the United States today. In their understanding of Tupac's life, these young people cobbled together a story, co-creating a narrative that foregrounded a kind of superhuman invulnerability that had crucial social currency at this site and in their lives. Yet, Tupac also challenged the stereotyping of young African Americans as violent and pathological. While he detailed his own invulnerability, he also detailed his personal feelings in profoundly moving ways. Tupac—without question—represented a validated kind of self here.

Importantly, this notion of "self" has had tremendous durability. Over the decade since I conducted this work, the mythos of Tupac has only grown in range and depth. Tupac left behind a virtual treasure trove of unreleased material that has seen both official and unofficial release. Key official releases include *Until the End of Time* (2001), *Better Dayz* (2002), *Loyal to the Game* (2004), and *Pac's Life* (2006). All have kept Tupac's voice central to hip hop's evolving landscape. The rumors and speculations around his death have proliferated over time. Perhaps most notably, documentary filmmaker Nick Broomfield released *Biggie & Tupac* in 2002—a film that raised questions about Suge Knight's role in both murders. Much of this speculation was underscored by

a series of scandals which tied corrupt police officers to Knight's Death Row Records and strongly suggested their role in Biggie Smalls's murder. This is perhaps best captured in Russell Sullivan's *LAbyrinth: A Detective Investigates the Murders of Tupac Shakur and Notorious B.I.G., the Implication of Death Row Records' Suge Knight, and the Origins of the Los Angeles Police Scandal* (2003). As recently as 2008, the *LA Times* was investigating key incidents between Death Row and Bad Boy camps.

Perhaps the finest tribute to Tupac was the 2003 documentary *Tupac: Resurrection*. Filmed with the full involvement of Afeni Shakur, the film was narrated by Tupac himself—his recorded interviews, over time, spliced together to tell his complex, contradictory, and often disturbing life story—even his eventual demise. Carefully pulled together, the film did not so much fuel speculation about his death as reveal Tupac's own hopes, reflections, and often fatalistic thoughts on his life. The film's final scene takes the viewer to all corners of the United States and around the world, as a multiethnic group of young people proclaim their allegiance to Tupac as they display shirts, graffiti, and other Tupac paraphernalia in their own environs. Clearly, Tupac has lived on in the collective imaginations of young people over time—in a perhaps singular way. My ability to trace the emergence of these myths among one group of young people before and after Tupac's death was a terrible if illuminating coincidence of fate.

# III
# HIP HOP AND EDUCATION:
# IMPLICATIONS AND
# NEW DIRECTIONS

# · 6 ·

# BLACK YOUTH, POPULAR
# CULTURE, AND PEDAGOGY:
# SOME IMPLICATIONS

In section 2, I looked at texts in performance—how my young participants picked up and used key popular cultural resources and with what effects. In chapter 3, I introduced two teens, Rufus and Tony, and examined how they used popular texts to construct a sense of place in the small city where this research was conducted. Next, in chapter 4, I explored the ways in which young people forged historical consciousness and a sense of generational identity through their interaction with and talk about popular cultural artifacts—specifically the popular film about the Black Panther Party for Self-Defense, *Panther* (1995). Finally, in chapter 5, I explored how young people reconstructed the life and death of a highly valued popular icon, rap star Tupac Shakur (whose mother was a Black Panther) through their collective use of narrative. In this chapter, I offer some thoughts about and implications for black youth, popular culture, and pedagogy.

## Popular Culture, Voice, and Black Youth

As noted in the introduction, there has been a growing sense in many quarters that young people's lives—their needs, wants, interests, and desires—are being occluded from daily life in school. Teachers and parents alike, many maintain,

have little knowledge of, or interest in, engaging the lives of young people in all their complexities, a phenomenon highlighted by a spate of popular books, including Patricia Hersch's *A Tribe Apart* (1998) and William Finnegan's *Cold New World* (1998), and magazine articles, including the 1999 *Time* magazine cover story, "A Week in the Life of a High School." The everyday lives of young people have remained a source of interest and concern (see, e.g., Linda Perlsen's 2004 book *Not Much Just Chillin': The Hidden Lives of Middle Schoolers*). Work on youth, however, has been increasingly "diagnostic." That is to say, this work has focused on particular aspects of young people's lives and treated them as mysterious problems to be uncovered, probed, and solved. I recall here recent and perennial scares around young people and sex, young people and drugs, young people and video games, young people and violence, and young people and the Internet. Young people's lives, it seems, are an increasing source of fascination and fear for adults—particularly as they recede into cyberspace. (Witness the success of NBC's reality show *To Catch a Predator*.) One recalls here contemporary anxieties around how to "define" young people in gen-erational terms—whether Gen X, Gen Y, "tweens," or "Generation Me" (see, e.g., Twenge, 2007).

Popular culture has taken on a particular and increasing salience in these discussions. As many commentators on the so-called postmodern turn have made clear for some time now, our contemporary "media culture" has radi-cally reworked "the everyday" or "the real" for the young in ways difficult for older people to understand. Kellner writes, "A media culture has emerged in which images, sounds, and spectacles help produce the fabric of everyday life, dominating leisure time, shaping political views and social behavior, and provid-ing the materials out of which people forge their very identities" (1995, p. 1). Norman Denzin sums up much when he notes that "[t]he mass media...com-pletely permeate and dominate the languages and experiences of everyday life" (1992, p. 146). These theoretical suppositions have been borne out, I believe, by the examples documented throughout this book, where we see popular cul-ture, more and more, providing the narratives that young people are drawing on to deal with the issues and the concerns most pressing in their lives, from the general (day-to-day survival) to the specific (the Klan). These investments, as I have demonstrated, play out in often unpredictable ways—and they are particularly important for marginalized youth.

Without such an understanding of young people and their lives, I maintain, we will always be limited in our analyses, diagnosing the condition of the young in ways that reinforce our political predilections. This is particularly the case,

again, for marginalized youth, those under- and ill-served by contemporary school systems. As I argued in the preface to this edition and the introduction, there are a growing number of academic and popular books about hip hop culture. However, there remains a dearth—indeed, near-absence—of studies of rap music in the daily lives of black youth in the United States. Textual analyses of rap lyrics—analyses removed from specific contexts of use—have dominated discussion across the political spectrum. The discourse surrounding hip hop (specifically) and black youth (generally) remains overwhelmingly out of touch with the wants, needs, fears, and desires of young people and their uses of culture.

As noted in chapter 4, black popular culture and rap music have been constitutive in public discourse about the so-called generation gaps many now see emerging as decisive within black communities. Quite often, these discussions assume radical, near-seismic shifts in the lives of black youth, an assumption which runs through the work of contemporary critics and researchers, including Cornel West, Michael Dyson, and Elijah Anderson. West, perhaps the best known of these critics, argues that black youth today are uniquely different from the generations coming before them. Black youth today are "nihilistic," without stable funds of meaning, according to West:

> We must delve into the depths where neither liberals nor conservatives dare to tread, namely, into the murky waters of despair and dread that now flood the streets of black America. To talk about the depressing statistics of unemployment, infant mortality, incarceration, teenage pregnancy, and violent crime is one thing. But to face up to the monumental eclipse of hope, the unprecedented collapse of meaning, the incredible disregard for human (especially black) life and property in much of black America is something else. (1993, p. 12)

For West, thus, there is an "unprecedented" loss of hope suffusing black American youth today, effecting a radical schism in generational assumptions and identity.

These black youth, according to Michael Dyson, are exerting a kind of violent control over their local communities, forming what he calls "juvenocracies":

> For me, a juvenocracy is the domination of black and Latino domestic and urban life by mostly male figures under the age of 25 who wield considerable economic, social, and moral influence. A juvenocracy may consist of drug gangs, street crews, loosely organized groups, and individual youths who engage in illicit activity. They operate outside the bounds of the moral and political economies of traditional homes and neighborhoods. The rise of a juvenocracy represents a significant departure from home and neighborhood relations where adults are in charge. (1996, pp. 140–141)

Like West, Dyson sees a seismic shift in generational identity among black youth today, a shift that implies a fundamentally different set of relations between home and neighborhood, between old and young. Though, like West, he is entirely and profoundly sympathetic to the plight of black youth and the oppressions they face daily, this notion resonates throughout Dyson's work on popular culture, in texts such as *Reflecting Black* and *Race Rules*.

Cornel West and Michael Dyson are part of a critical group of black public intellectuals whose work has registered, largely, in the humanities. Yet, similar ideas about black youth and black culture have registered in the social sciences as well. For example, Elijah Anderson (1990, 1999), in a series of highly influential books and articles, argues that black youth are without the role models that have helped guide previous generations, that they have been left rudderless with only the street to guide them. There has been, he maintains, a general flight of the black middle class from urban centers and this has resulted in a loss of key older figures or "old heads." An "old head," according to Anderson, "was a man of stable means who believed in hard work, family life, and the church. He was an aggressive agent of the wider society whose acknowledged role was to teach, support, encourage, and in effect socialize young men to meet their responsibilities regarding work, family, the law, and common decency." However, such models have become increasingly rare, and a new kind of role model has emerged: "young, often a product of the street gang, and at best indifferent to the law and traditional values" (1990, p. 3). Anderson (1999) explicitly links this kind of criminal lifestyle to the music of rappers like Snoop Doggy Dogg and Tupac Shakur, reinforcing the notion that popular culture is inextricably intertwined with the emergence of this out-of-control, nihilistic generation of black youth (p. 36).

West, Anderson, and Dyson, among others, have raised many interesting concerns and questions about the current condition of black youth and black communities. Yet, I suggest that all three draw perhaps too sharp a distinction between contemporary black youth and those of previous generations. Importantly, this kind of approach draws attention away from the ways in which young people are, in fact, fighting for hope, for survival, for connections with older people, in near-insurmountable conditions. As my research highlighted, my young participants did much work to create and sustain notions of community, history, and self through their investments in and their uses of black popular culture. The young people I worked with were not "nihilistic," though many were involved in gangs and other kinds of destructive activities. These young people had been bequeathed a symbolic universe that they used to deal with a material reality not of their own choosing. Their uses of these texts

betrayed their efforts to maintain and sustain constructions many critics assume gone or missing from the lives of poor blacks.

## The Post-Soul, Hip Hop Generation

More recently, commentators such as Bakari Kitwana, Mark Neal, and Todd Boyd have highlighted the specificity of this generation and its needs and concerns In addition, Michael Dyson's and Cornel West's more recent work has addressed the particularities of this generation in perhaps more positive, expansive, and dialogic ways (see, e.g., Dyson, 2002, 2007). Much of this work has struggled with the legacy of the civil rights movement for contemporary youth, which is often held out as the paramount and defining historical struggle for African Americans. Contemporary scholars have wrestled with its impact for those who have grown up in its wake.

Bakari Kitwana opens up his excellent *The Hip Hop Generation: Young Black and the Crisis in African-American Culture* (2002) with a sobering reflection. Many youth today can remember exactly "where they were" when both Tupac Shakur and The Notorious B.I.G. were murdered—can remember the particular circumstances and details with the kind of visceral precision previous generations reserved for the murders of John F. Kennedy, Malcolm X, and Martin Luther King Jr. This "hip hop generation," he argues, is different in some key ways from the generation that grew up during the civil rights era. In particular, this generation has grown up surrounded by a discourse of democratic inclusion while facing new, brutal kinds of segregations and racisms. He writes, "Our generation is the first generation of African Americans to come of age outside the confines of legal segregation…However, continuing segregation and inequality have made it illusory for many young Blacks" (p. 13). Kitwana goes on to highlight some key issues facing young African Americans today, including poverty, housing segregation, and the criminal justice system. Like other authors of his generation, Kitwana argues that hip hop has become a salient resource for youth working through these concerns.

Todd Boyd is even more explicit in his critique. In his controversial 2002 book, *The New H.N.I.C. (Head Niggas in Charge): The Death of Civil Rights and the Reign of Hip Hop*, Boyd argues that the complexities and contradictions of hip hop music and culture have supplanted the transcendent claims of earlier generations. Above all else, Boyd stresses the dangers of nostalgia. Elsewhere, Cameron McCarthy and I have linked nostalgia to a broader set of "resentment" discourses, all of which have tried to contain the complexities of our

contemporary moment (Dimitriadis & McCarthy, 2001). These include the certainties of race and of nation, both of which were so critical to the civil rights movement of the 1960s. Yet, as Boyd so powerfully implores us, such nostalgia can delimit contemporary efforts for social change. As he writes, "The posture of civil rights was such that it made future generations uncomfortable having to wear such restraints as they attempted to represent themselves" (p. 152). Boyd argues throughout his book that hip hop music and culture has served as a powerful corrective here. "In the same way that civil right leaders spoke to the conditions back in the day, hip hop artists now speak to a populace often disillusioned by those considered overtly political in a traditional sense" (p. 10).

Boyd points to the stress on material survival and wealth that marks this generation's needs, concerns, and desires. Boyd notes, "What in an earlier generation might have been called 'showing off' has now grown into an integral part of self-expression in hip hop circles. The idea of the 'come up' represents social mobility in spite of overwhelming obstacles and the politics of this move are deeply embedded in hip hop's master narrative" (p. 77). Yet, such efforts are often met with intense public criticism from older blacks as well as whites, many of whom accuse artists and label owners of "selling out" when they become monetarily successful. He cites Master P, Jay-Z, Snoop Dogg, and Puff Daddy, among others, as facing such criticism. According to Boyd, such disconnects reflect an ambivalence about African Americans entering mainstream American life, in what he calls a post–civil rights moment.

Others have wrestled with the specificity of this moment and this generation in similar ways. For example, Mark Anthony Neal's *Soul Babies: Black Popular Culture and the Post-Soul Aesthetic* describes what he calls a "post-soul" moment, the moment when the transcendent certainties of the civil rights and black power movements have largely been elided. According to Neal, "soul" was the most powerful expression of modernity for African Americans of previous generations (2002, p. 3). For the next generation of African Americans, however, these claims to certainty have been called into question. This new generation, "came to maturity in the age of Reaganomics and experienced the change from urban industrialization to deindustrialism, from segregation to desegregation, from essential notions of blackness to metanarratives on blackness, without any nostalgic allegiance to the past (back in the days of Harlem, or the thirteenth-century motherland, for that matter), but firmly in grasp of the existential concerns of this brave new world" (p. 3).

For this next generation, hip hop music and culture has emerged as the defining cultural statement. The music and culture are filled with complex and often contradictory narratives, including narratives around issues such as gender and sexuality, topics Neal takes up with particular force. Yet, according to Neal,

these topics need to be met with an expansive set of explanatory criteria. He writes, "We cannot simply reject these narratives on a moral basis that is itself the product of a profoundly different world; we must at least critically engage them with the same energy and passion that many of these artists themselves inject into their creative efforts" (p. 11). Neal spends a great deal of his book attempting to unravel the work of hip hop artists and their whole cultural surround.

This new generation of hip hop scholars has boldly charted out a path and agenda for hip hop scholarship today. Indeed, as recently as 10 years ago, it would have been somewhat anomalous to speak of "hip hop studies." Today, such a field does seem to exist—across multiple disciplines (such as musicology, history, and English) and interdisciplinary spaces (such as American Studies and African-American Studies). A recent edited collection—*That's the Joint: The Hip Hop Studies Reader* (Forman & Neal, 2004)—acts as something of an "exclamation point" in this regard.

As this field consolidates, we must look soberly at its strengths and limitations. As this work powerfully demonstrates, our moment necessitates moving beyond the same kinds of liberation narratives so often associated with previous movements. These narratives often rely on stable notions of identity and clear notions of ideology critique. This is an important corrective that opens up a rich space for intellectuals attempting to think through our contemporary moment in new and different ways. Yet, work in this field is limited in some important ways. In particular, almost all of it has been produced outside of and beyond sustained and meaningful interaction with young people. Work here, as noted, often falls back too easily on its own notions of control and competence. That is to say, this work has not taken seriously the notion that young people themselves make sense out of this music and this culture in ways that often exceed the predictive ability of adults and others—including the critics noted above. In many respects, this "opening up" of hip hop to scholarly study has not been accompanied by the kinds of personal dislocations often associated with ethnographic work.

This is a great challenge for those of us wrestling with questions of education and pedagogy—specifically, for those of us who would think through popular culture as a pedagogical and curricular resource.

## Media Culture and Pedagogy

As the above discussion indicates, and as many are now realizing, media culture is a phenomenon with significant implications for schooling and school curricula, both official (e.g., textbooks and lesson plans) and unofficial (e.g., classroom

practices). As evidence of this burgeoning interest in media, by the late 1990s, nearly every state in the nation had integrated media education into some component of its mandated curriculum, a point made in *Education Week* by Kubey and Baker. They write, "The drive for improving curriculum standards, and the process of involving those who teach in writing those standards, have produced near-unanimity in this country on the inclusion of elements of what many call 'media-literacy education' in the state frameworks" (Kubey & Baker, 1999). This seems a sharp and decisive shift from even a decade earlier, when media literacy was not so clear a priority.

Yet, states have integrated these media components in various and particular ways, in ways that reflect some key blind spots. As the authors report, of the 50 states, 92% include a media component in their English, language, and communication arts curricula; 60% include a media component in their social studies, history, and civics curricula; and 60% include a media component in their health and consumer skills curricula. Only 14% include a curriculum that takes media as its primary focus. Thus, the humanities (broadly) and English (specifically) still seem the most receptive contexts for the proliferation of media studies. There still seems to be a popular notion that media forms can be looked at and treated as traditional texts, with the same kind of formal analysis and focus. Brunner and Tally, in *The New Media Literacy Handbook*, note that there has been a special relationship between the interests of those in language arts—or English—and those in media education. They write:

> Language arts teachers bring special insight to the enterprise of integrating technology into the curriculum. They are experts in verbal communication. They understand the power of the written word. Language arts and English classes have the distinction of explicitly encouraging students to think critically not only about subject matter but also about the way it is delivered. Literary criticism is the one critical language to which more students are exposed to. English class is where they learn to write, to read, and to investigate the relationship between how a literary work is constructed and what it means to them. The emphasis makes English teachers particularly important in defining how students learn to write with and for the new media and how they learn to read and interpret the kinds of texts to which they now have access via the new technologies. (1999, p. 124)

The reading, interpreting, and writing of texts seems of paramount importance here, as it is for those engaging with traditional English curricula. Again, the "literary" has emerged as the quintessential paradigm for integrating media studies into the curriculum—a point underscored recently by Ernest Morrell (2008) and others.

However, the danger here, I argue, is wholly applying the kinds of formal, decontextualized reading practices to media texts that have typically been applied to literary texts. Media texts, as I have demonstrated, are entirely implicated in their shifting contexts of use. As I argued in chapter 1, a performative approach to the textual allows us to see how shifting contexts of production (e.g., from performance spaces to privatized ones) enable particular kinds of texts to emerge, with particular histories, ideologies, and so on. Such an approach highlights these texts as ever open to renegotiation, allowing us to appreciate, as a concomitant phenomenon, that young people pick up and use these texts in performances of the everyday.

Taking this point seriously means giving up the kinds of notions of control and competence that often gird these discussions about media literacy. That is, these discussions often assume one of two things: Either we need to teach young people to protect themselves from the pernicious effects of media or we as educators have a clearly defined, *a priori* end point of school knowledge in mind. In both cases, we know where we "need" to get young people. Hip hop, here, is used in entirely functional ways to "hook" youth. In both cases, we miss the extraordinary opportunities with which hip hop presents us—opportunities to understand the lives of young people in less prefigured ways.

We also miss the opportunity, entirely related to the above, to rethink our own roles as intellectuals, researchers, and pedagogues. Indeed, much of the work on media studies mentioned in the preface to this edition (e.g., the work of Henry Jenkins and others) has richly interrogated the role of the researcher in the research process. This has been particularly the case for work in "audience studies" and "fandom." For many years, researchers have asked whether one positions oneself as "above" or "alongside" those one studies. Does one claim a kind of cultural and intellectual superiority to, say, the *Star Trek* fans or romance novel readers one writes about? Does one admit to a personal investment in these texts? These questions have been at the forefront for media critics for many years now. Those in education, however, have yet to ask such questions in sustained ways, though I imagine the answers would be rich, helping to forge a more vibrant set of intellectual and personal relationships in classrooms today.

Contemporary media culture, then, demands new and innovative educational responses. It demands that we look past textual analysis and decoding alone, the kind of responses encouraged by more literary approaches, toward more dynamic approaches. Young people have different and distinct relationships with these texts, relationships that are affect-laden and that resonate across

many and multiple dimensions of their lives in ways that textual analysis alone cannot predict. Popular culture is, following Kellner and Denzin, a lived curriculum, one which has suffused young people's lives in ways that belie the kinds of formal and distant identifications we might expect from more traditional educational practices. Recall that when young people faced the very real, very immediate (perceived) threat of a Klan rally in town, they turned to popular culture (the film *Panther*)—not to school learning or even to the guidance of older, trusted figures in the community.

In fact, in every case explored in this book, a bleak and unforgiving social context was inextricably intertwined with the interpretive constructions my young participants forwarded and lived through. Their uses of these texts evidenced how "the cultural" was mobilized in response to key material frailty in unpredictable ways. In the case of Tony and Rufus, their constructions of the South—paradoxical as they often were, and working at cross-purposes as they often did—allowed them some sense of stability in the small city where this research was conducted. Among other things, their constructions of the clique, of community, allowed Rufus to extend his family in this small city and allowed Tony to decrease his involvement in his gang when he wanted out. Their friendship was important to both, and both linked it, through rap, to the Southern hometown from which they migrated. Both made tradition present and real through popular resources—the same popular resources that many academics and commentators point to in decrying the loss of generational identity among the young. Day-to-day survival was paramount.

In the example explored in chapter 4, my participants used the film *Panther* to construct relevant, though highly circumscribed, notions of history that were mobilized full-force to deal with a profoundly unsettling event: a proposed Ku Klux Klan march in town. Here, as well, the context was highly fraught. Many feared physical attack from the Klan. As Elaine Scarry (1985) reminds us, we experience fear in physical ways: Our hearts beat faster, our pulses race, our realities are reconfigured. For these young people, physical affect was entirely and inextricably intertwined with their experience of interpreting *Panther*, a text they linked in unpredictable ways with other popular texts, including those of hip hop culture more broadly. For these young people, fear was paramount.

Finally, these young people experienced the loss of Tupac Shakur, a highly valued icon, in powerful and painful ways. Notions of invulnerability were mobilized here to deal with his death, registering all the ways these youth had to be invulnerable in the face of an intensely fraught social, cultural, and material reality. Tupac became an icon of survival for these young people, as

one who faced death and tricked it, walking away to live life comfortably in the Bahamas (according to one story). His ability to fight against all odds in his life and after his supposed death was key to these youth, who saw Tupac as a kind of supermasculine, invulnerable Stackolee figure. Here, personal loss and devastation, their need for an invulnerable current day "Br'er Rabbit," was most important.

Although this empirical work was conducted in the mid-1990s and published a few years later, a cursory glance at hip hop today tells us many of these same figures still circulate and remain ripe for empirical investigation. For example, since writing this book, crews like those described in chapters 1 and 3 have proliferated, the gangster image of Tupac has been reinvented by artists like 50 Cent (without his complexity, it seems), and the high-lifestyle or "balling" image associated with Biggie Smalls continues with artists like Jay-Z. And, of course, the rise of the first genuinely important and innovative white artist—Eminem—has been extraordinary. The investments young people have in these artists are certainly worth pursuing in some detail. Their scope and implications are immensely important.

We cannot understand these or other texts as reflective of simple ideologies alone; we must see them as a part of a set of resources that young people use to deal with a world that has left them largely alone and largely fearing for their own personal well-being on multiple levels. Survival, fear, and personal loss were determining factors for these young people. We miss much of this if we simply rely on decoding texts. Rather, we need to expand our notion of school curricula, as we need to understand the vulnerability many young people feel today in the broader social, cultural, and material reality in which they operate.

## Final Thoughts

Taking such an approach, however, an approach I have deemed "performative," pits us wholly against the contemporary *realpolitik* in the field of education. As Catherine Cornbleth argues, research shows "curriculum knowledge to be largely fragmented, fixed, public or distant from students, and presumably reproducible or applicable and transmittable to students. Knowledge has been reified as an object or product to be revealed to students over the course of their schooling" (1990, p. 184). As I argued in the introduction, No Child Left Behind has only accelerated these impulses, and the effects have been

particularly pronounced for the most vulnerable of our youth (Jones et al., 2003). Curriculum today has been either reduced to a series of replicable, low-level "skills" or reified, preserved, and passed on as "tradition," in the wholly conservative sense. In both cases, curricular knowledge has been disconnected from everyday lives, needs, and concerns.

We see this dynamic relationship between knowledge and everyday life realized in popular culture today, as the kinds of connections that young people made between texts I could not prefigure. For example, the links between the Black Panthers and professional wrestling were ones I could never have predicted without doing this research. A chant from young people leaving my focus group session—"Black Panthers for life!"—made this quite clear. Such identifications no doubt highlight the reconfigured landscape we all must face when discussing history today, the wealth of resources we must all understand as we operate individually and in concert with each other. Nor could I have predicted the extent to which Southern rap—a genre of music that often features intense violence and misogyny—would be part of reconstituting a stable tradition of place for Rufus and Tony. Nor could I have predicted, finally, the intense affective investment these young people had in Tupac Shakur and the way in which they mobilized that affect to read his life in death.

All this points to the necessity of a more genuinely negotiated curriculum, one that would allow teachers to approach the lives of young people in more open and less prefigured ways. This would suggest that educators need to be more creative in their understanding of the kind of links young people make with popular culture. I began to make such connections across texts only while working at this community center. One good example comes to mind. Tony had a report to do for one of his courses (he attended an alternative high school, where he could help design his own curriculum) and, after some discussion, I suggested Clifton L. Taulbert's novel *Once Upon a Time When We Were Colored* (1989), about a family in Mississippi. Place was such an affectively invested construct for Tony, so wrapped up in family, friends, music, and so on, that he identified with this book immediately. His interest in this text was as intense as his interest in Southern rap. Such connections, again, seem key for educators trying to invest curriculum with meaning for the young, but they are not self-evident. Indeed, recall here my efforts to bring in a broader range of texts about the Black Panthers, including the *Eyes on the Prize* documentary, and my failure to raise real interest. Clearly, more accounts documenting such struggles would help us all sharpen our perspectives on these emergent, unpredictable, and critically important processes.

I realize that institutional constraints play a big role here—more so than when this book was first published in 2001—and, as such, I have avoided making broad, sweeping claims about what educators need to do. There is a danger, in this kind of work, of letting our discourse get ahead of us, of making our language of critique so abstract and our demands so sweeping that we wind up placing the burden of change unfairly on already overworked teachers. I have instead sought to highlight here the complexity of young people's relationship with texts, to challenge the ways in which we might assume such relationships to be predictable, to open up a broader discussion about texts in daily practice. As indicated throughout, the prevalence of rap, and gangsta rap in particular, points for many to the broad moral decay of an out-of-control generation of youth. For me, after working for four years in the complex world of youth, rap's multiple uses show us all the ways young people are creatively coping with the vicissitudes of their increasingly difficult and dangerous lives—and the ways we as teachers must rise to this challenge. Indeed, if texts and practices are always in performance, they are open to re-articulation by interested educators—the ultimate lesson, I hope, of this book.

# · 7 ·

# PERFORMING METHODS IN
# POPULAR CULTURE

I

Throughout this book, I have argued for the importance of popular culture in the lives of young people. The impulse was to contextualize more and more deeply the relationship young people have to and with this culture. Getting closer and closer to the lives of young people meant renegotiating my research role over time—a point I only gestured toward in the original edition of this book (here, in chapter 3). In this final chapter, I would like to offer some methodological reflections on my time conducting this work, including the ways in which my own agenda and my own roles were re-articulated. But perhaps more important, I would like to offer some more specific and related thoughts on the methodological implications for studying young people and popular culture today. As noted throughout, as I got closer and closer to the lives of these young people, I began to see popular culture as a resource for survival, as one way in which these young people dealt with a harsh and unforgiving material and social context. Like many of us who do this work, I prefigured the importance of hip hop in the lives of these youth: It was what I proposed to study when I entered the field. Over time, however, I began to see hip hop as just one set of resources these young people drew upon. That is, as I saw popular culture in the context of their lives, I had to de-center its primary importance.

This study, over time, was not only about hip hop or about popular culture; it was about the myriad symbolic and material ways in which youth deal with life on the margins. Understanding this powerful de-centering process is vital to our understanding of method and of popular culture more broadly.

II

As I noted in chapter 3, my role in the field changed over time, as did my relationship with the youth in this study. These two interconnected events largely de-centered the research project outlined earlier. As noted, I came to the club late in 1995, as a researcher, to conduct these weekly discussion groups, which would become empirical material for a larger project which interrogated how young people create senses of self, history, and place through talk about black popular culture. However, in early 1997, the games room supervisor quit his job. The games room was a large room, central to the club, that contained several ping pong and pool tables. I asked whether I could fill in as a volunteer until they found a full-time person. They said yes. I began to volunteer weekly, watching this main floor every Tuesday and Friday from 3 p.m. to 9 p.m. until late spring. For this five-month period, I was both researcher and volunteer, conducting discussion groups on Monday nights and watching the floor on Tuesdays and Fridays. Finally, the unit director offered me a staff position for the summer of 1997. I became responsible for an entire area of the club, a room which could be used for a variety of activities, for this three-month period, 40 children at a time, three times a day, on a rotating basis (in groups of 7–8-, 9–10-, and 11–12-year-olds). After that summer, I volunteered regularly, several days a week, for a number of activities and jobs around the club.

Thus, I occupied the identities of researcher, volunteer, and staff member. Of course, there was always some overlap between these different positions. While researching, I was unavoidably considered a "volunteer" by many of the children and had to enforce certain club rules (no fighting, etc.). Also, as a staff member, I volunteered (unpaid) two hours a day (as a way to try to stay in everyone's good graces). Finally, I was always in some sense a researcher. I was always observing, always talking mental notes, even when performing as mundane a task as serving lunch or cleaning the bathroom. Toward the end of my involvement at the club, I occupied all three positions. I volunteered to do many mundane tasks, roughly 15 hours a week, while conducting formal research/focus groups every Monday. Although no longer staff, I was perceived

by the club members and other staff as being more than a regular volunteer. My role at this site was critical, as this club (like others) was underfunded and found it necessary to rely on as much unpaid help as possible.

In parallel with this renegotiation of my roles at the club, my relationship with Rufus and Tony (discussed in chapter 3) deepened and grew. In fact, the story of my relationship with them evolved into its own book—*Friendship, Cliques, and Gangs: Young Black Men Coming of Age in Urban America* (Dimitriadis, 2003). In many respects, my focus on popular culture was derailed by the immediacies of their lives, as they came to rely more and more on me for meeting their everyday material demands. I was one more resource to meet the myriad and often unpredictable demands that face young people at the margins.

This renegotiation of roles can usefully be seen as part of the "performative turn" in the social sciences, noted in chapter 1. This turn has allowed us to see the world as always already in motion, with no firm ontological foundations to provide us stable footing in our research endeavors. This turn has helped to challenge several long-standing ideas about the ethnographic project, including the clear distinctions between research, pedagogy, and activism. It has also allowed us to see our role in the field as open to constant renegotiation. The clear kinds of objectivity often implied by the so-called research act, the clear splits between researcher and researched, no longer hold. Just as we put demands on our research participants, they put demands upon us. In short, we must be responsible for the relationships we forge with the people with whom we work.

My individual and collective relationships with Tony and Rufus were central to the re-articulation of this study. Importantly, these relationships were in many ways forged around the particular, immediate, and functional. They were not about "giving voice" or "cultural competency" or any of the other tropes that often dominate such discussions. They were about support, around events not of my own choosing. For Tony, providing this support meant trips to McDonald's, or rides to the store or work, or copies of rap CDs. After he was assaulted and nearly killed for intervening in a conflict involving his cousin, it meant visits to the hospital with various goods or simple companionship when he was in fear of further retaliation from his rivals. According to Tony, a conflict had been building between his cousin and several other youth for some time. They agreed to fight it out, man-to-man, one-on-one. Tony showed up to make sure his cousin had a fair fight. For whatever reason, one of the other youth's friends thought he was a threatening presence and hit him in the head with a

baseball bat. He was hospitalized for a time and immobilized for several months when he returned home. During this period, Tony needed personal and material support from those around him. For me, this meant constant visits, DVDs, magazines, trips to fast-food places—anything to distract him from his pain. For Rufus, who lived with only his mom, providing this support meant hauling large bags of clothes to the Laundromat, cashing social security checks, and going grocery shopping at discount stores out of town. It also included, when Rufus's mom became increasingly ill, constant trips back and forth with Rufus to the hospital, the nursing home, and the dialysis center. Mary had been diagnosed and misdiagnosed with a variety of medical problems stemming from her diabetes. Her long spells in the hospital left Rufus on his own, having not only to tend to his own needs and the needs of their household, but to help navigate the Byzantine health and social services agencies in which his mother's life was enmeshed. All of this helped me understand the importance and immediacies of day-to-day survival for these teens. I could never predict quite what these would be. But they were always extremely particular and extremely immediate.

Meeting these needs allowed me to renegotiate my particular relationship with each of these teens and also the young people at the community center more broadly. Yet, the story was not a linear one, with my moving from simple "outsider" to "insider" status. As an older white male from the university, there were parts of their lives to which I could never have access. But the ways we connected around their immediate needs helped open up and deepen my relationship with each. I was always, as a result, negotiating and renegotiating my own sense of whiteness as it was read and re-read through evolving everyday realities. In addition, I was always negotiating my class status. As I had grown up relatively privileged, class became more "visible" to me than it ever had been. In particular, it became clear to me how the most mundane of material pressures could radically alter and derail their lives. For example, Tony's glasses were broken in the fight mentioned above. While he was applying for assistance to replace them—a process which took several weeks—he was nearly blind. He could only listen to TV while he recovered from his injuries. He surely could not look for work until he had them. In addition, Rufus developed a severe toothache while his mother was in the hospital. He tried ignoring it, applying tubes of Anbesol to numb the pain. But it was unbearable, and he spent many nights crying, couldn't concentrate in school, couldn't work, and eventually had to have several teeth removed. In both cases, small problems—the kind that I would have handled or had handled for me growing up—could alter the course of their lives. Like other nodes of power, class is often invisible to those who

benefit from its privileges. While I might have "known" this on some level going into the study, it took on a new resonance for me as this study unfolded.

## III

My focus on popular culture was thus de-centered. That is to say, I could no longer privilege the cultural dimensions of these young people's lives; I had to see them as always set alongside and against their everyday material demands and pressures. While I called them a "resource for survival" in this book, they were only one such resource—a vital one but perhaps not as vital as I had originally thought.

The personal dimension of this de-centering is perhaps worth reflecting upon. Work on popular culture typically prefigures the importance of a particular object of study or analysis—as I did in my initial focus on hip hop. My interest in hip hop took hold in the late 1980s, during my college years, and quickly became an academic project. As for many people, my interest in popular culture seemed to find a natural home in the humanities (in general) and English departments (more specifically). My impulse was to examine hip hop recordings as "texts," as a modern-day poetics. This meant, of course, looking past the cultural distinctions which had buttressed my formal education—distinctions between what I had to study in school (so-called high culture) and what I consumed for leisure (so-called popular culture). The burgeoning (for me) hip hop world suddenly seemed as important to me as any social or political movement which had been enshrined in the academy. The hip hop recordings I was newly exposed to suddenly seemed educative and serious—profoundly so. In many respects, this interest spoke to the moment in hip hop when I first began to engage it—the mid- to late 1980s. This is the moment I treated in some detail in chapter 2.

I quickly came up against the limits of such an approach and conducted the ethnographic study detailed in chapters 3–5. The ethnographic impulse looked to challenge the kinds of critical, interpretive readings of texts I and others had traditionally privileged. This took me from more humanistic approaches to more social scientific ones. The goal was to understand how the young people in this study understood or read these texts. The goal was to understand in a "ground up" way what sense young people themselves made out of these texts, and how. This charge had a particular resonance in the years when I began conducting this study, the mid-1990s. So-called gangsta rap had firmly entrenched itself as a dominant cultural movement—one that attracted young people across the

racial, ethnic, and class spectra. As noted throughout this book, many cultural commentators (from both liberal and conservative positions) used these texts to diagnose a generation of young black males as violent, nihilistic, and misogynistic. Understanding the role and place of these texts in the realities of young people's quotidian lives seemed critical—a way both to understand and to challenge these often-reductive readings.

Yet, as I got closer and closer to the lives of these young people, my own privileging of hip hop was challenged. That is, while hip hop was an important node in their lives, it was only one of many such nodes. Increasingly, the material backdrop against which these young people lived their lives became pronounced. In some respects, then, this might be seen as a shift from a focus on "culture" to a focus of "class." Yet, I would in the end resist such a reading. The lives of young people rarely allow us such comfortable hermeneutics. Indeed, the language of multicultural education has fostered what have been called "additive" or "interlocking" approaches to oppression. (The former implies that one becomes "more" oppressed as one adds various nodes of oppression—being a woman, a lesbian, poor, black, etc. The latter implies that one must look at particular situations to see how these oppressive forces interact.) While I am certainly more sympathetic with the latter approach, each implies that we can look at and separate race, class, gender, disability, sexuality, and so on as distinct axes of analysis. The work of James Banks (2005) and other multicultural educators often betrays an impulse to create neat taxonomies to help explain away young people's lives. One assumes that young people's experiences of their raced, classed, or gendered selves can be pulled apart for heuristic value—and then put back together again.

Our encounters with young people typically exceed these distinctions in critical ways. Embodied narratives such as these disrupt ideas about cultural competence. As we get closer and closer to the particularities of young people's lives, we see how they live in the middle of multiple, overlapping, and often contradictory modes of identification. It is very difficult in a study such as mine to offer simple "take-away" lessons that can be applied in rote and unthinking fashion in other contexts. Rufus's and Tony's lives were motivated by the immediate and pressing demands of being young, poor, and black. This complex, particular nexus resists the kind of heuristics that many multicultural educators offer. Such embodied narratives put us in the middle of questions, issues, and struggles to think though—not to master or "solve" in ready-to-hand ways.

Studies of popular culture must take this concern seriously; that is, they must be willing to see popular culture in radical context. This means challenging

the primacy of popular culture itself and its potential role in transforming school life. As noted above, many studies of popular culture (in general) and hip hop (in particular) see it as a key way in which to build bridges between in-school and out-of-school knowledges and literacies. These calls must always be challenged by the young people themselves, the complexities of their individual biographies, and their broader cultural and material circumstances. Failure to do so limits our ability, as researchers and educators, to understand the most salient and determining vectors operating in young people's lives today. The cost, of course, can be abandoning one's initial intellectual agenda.

# IV

Such concerns will only become more pressing in years to come. As the world economy realigns itself, new (global) winners and losers are rapidly emerging. In particular, global economic shifts over the past several decades—marked by the rise of neoliberalism and neoliberal logics—have been profound, concentrating increasing amounts of wealth and opportunity in the hands of very, very few. As is well documented, the vast majority of jobs being created now are not jobs in the so-called knowledge economy. Rather, they are low-paying service-sector jobs that provide minimal income, few if any benefits, and little job security. It is worth recalling that Walmart is the single-largest employer in the United States today. As Lois Weis and I argue elsewhere, we need to see how young people's cultural lives intersect and articulate with these pressures of neoliberalism, the new economic realities which are "setting youth up" (Weis & Dimitriadis, 2008). This remains a great challenge for those of us working with "urban youth" in the new millennium. Even as many of us have looked to the nonformal educative lives of youth—the kinds discussed throughout this book—we need to understand more acutely how they "smack against" global, structural economic forces and the various social mechanisms that sort their lives. We must avoid assuming that popular culture and aesthetics bear the burden of social transformation (Sterne, 2004).

The point is an important one. The long-standing focus on "culture" in critical education circles has been remarkably useful for understanding the particular nuances of young people's lives. Such work has expanded our notion of what count as educational "texts" and "sites," often challenging reductive and technocratic definitions. For my study, it meant challenging the ways hip hop (in general) and urban youth (in particular) have been demonized in the popular

imagination. Yet, many critical scholars are too quick to assume that broad social transformation will follow from these seeds of resistance and critique. Culture, again, has borne perhaps too large a burden here. In some cases, this has led to an elision of serious focus on broader social and economic structures. This is extremely unfortunate—and not tenable considering our contemporary global economic realignment. More than ever, then, we must be flexible in our methodological and theoretical presuppositions and assumptions. We must be open to whatever will help us understand and act upon a global reality that is rapidly sorting out the lives of youth in brutally unfair and unforgiving ways. Popular culture is one important front in this struggle—but it cannot be the only one.

# REFERENCES

Abercrombie, N., & Longhurst, B. (1998). *Audiences: A sociological theory of performance and imagination.* Thousand Oaks, CA: Sage.

Abrahams, R. (1970). *Deep down in the jungle: Negro narrative folklore from the streets of Philadelphia.* Chicago: Aldine De Gruyter.

Allen, H. (1994, June). The destruction of hip-hop culture: 1970–2020. *Rap Pages,* 35–43.

Anderson, B. (1991). *Imagined communities: Reflections on the origin and spread of nationalism.* London: Verso.

Anderson, E. (1990). *Streetwise: Race, class, and change in an urban community.* Chicago: University of Chicago Press.

Anderson, E. (1999). *Code of the street: Decency, violence, and the moral life of the inner city.* New York: W.W. Norton.

Ang, I. (1985). *Watching Dallas.* London: Methuen.

Appadurai, A. (1996). *Modernity at large: Cultural dimensions of globalization.* Minneapolis: University of Minnesota Press.

Apple, M. (1993). *Official knowledge: Democratic education in a conservative age.* New York: Routledge.

Bakhtin, M. M. (1986). *Speech genres and other late essays* (V. W. McGee, Trans.). Austin: University of Texas Press.

Banks, J. (2005). *Race, culture, and education.* New York: Routledge.

Bauman, R. (1986). *Story, performance, event: Contextual studies of oral narratives.* Cambridge: Cambridge University Press.

Bauman, R. (1992a). Contextualization, tradition, and the dialogue of genres: Icelandic legends of the *Kraftaskald.* In A. Duranti, & C. Goodwin (Eds.), *Rethinking context: Language as an interactive phenomenon* (pp. 125–145). Cambridge: Cambridge University Press.

Bauman, R. (1992b). Performance. In R. Bauman (Ed.), *Folklore, cultural performance, and popular entertainments: A communications-centered handbook* (pp. 41–49). Oxford: Oxford University Press.

Becker, H. (1982). *Art worlds*. Berkeley: University of California Press.

Benjamin, W. (1968). The work of art in the age of mechanical reproduction. In *Illuminations: Essays and reflections* (H. Zohn, Trans.). (pp. 217–242). New York: Shocken Books.

Berger, A. (1999). *Narratives in popular culture, media, and everyday life*. Thousand Oaks, CA: Sage.

Besiner, N. (1990). Language and affect. *Annual Review of Anthropology, 19*, 419–451.

Beyer, L., & Apple, M. (Eds.). (1998). *The curriculum: Problems, politics, and possibilities*. Albany: SUNY Press.

Bourdieu, P. (1984). *Distinction: A social critique of the judgment of taste* (R. Nice, Trans.). Cambridge, MA: Harvard University Press.

Boyd, T. (2002). *The new H.N.I.C. (head niggas in charge): The death of civil rights and the reign of hip hop*. New York: NYU Press.

Bruner, J. (1990). *Acts of meaning*. Cambridge, MA: Harvard University Press.

Brunner, C., & Tally, W. (1999). *The new media literacy handbook: An educator's guide to bringing new media into the classroom*. New York: Doubleday.

Buckingham, D. (1993). *Children talking television: The making of television literacy*. London: Falmer Press.

Burke, K. (1941). *The philosophy of literary form: Studies in symbolic action*. Berkeley: University of California Press.

Burke, K. (1969). *A grammar of motives*. Berkeley: University of California Press.

Buttny, R. (1993). *Social accountability in communication*. Thousand Oaks, CA: Sage.

Chang, J. (2005). *Can't stop, won't stop: A history of the hip hop generation*. New York: St. Martin's Press.

Chernoff, J. (1979). *African rhythm and African sensibility: Aesthetics and social action in African musical idioms*. Chicago: University of Chicago Press.

Cleaver, K. (1998). Three ways that Martin Luther King changed my life. *Black Renaissance, 2*(1), 51–62.

Clifford, J. (1997). *Routes: Travel and translation in the late twentieth century*. Cambridge, MA: Harvard University Press.

Condry, I. (2006). *Hip hop Japan: Rap and the paths of cultural globalization*. Durham, NC: Duke University Press.

Conquergood, D. (1991). Rethinking ethnography: Towards a critical cultural politics. *Communication Monographs, 58*, 179–194.

Conquergood, D. (1992). Ethnography, rhetoric, and performance. *Quarterly Journal of Speech, 78*(1), 80–96.

Cornbleth, C. (1990). *Curriculum in context*. London: Falmer Press.

Coupland, N., & Nussbaum, J. (Eds.). (1993). *Discourse and lifespan identity*. Thousand Oaks, CA: Sage.

Cross, B. (1993). *It's not about a salary: Rap, race, and resistance in Los Angeles*. London: Verso.

Curran, J. (1996). The new revisionism in mass communication research. In J. Curran, D. Morley, & V. Walkerdine (Eds.), *Cultural studies and communications* (pp. 256–278). London: Arnold.

Daspit, T., & Weaver, J. (1999). *Popular culture and critical pedagogy: Reading, constructing, connecting*. New York: Garland.

Davidson, A. (1996). *Making and molding identity in schools: Student narratives on race, gender, and academic achievement*. Albany: SUNY Press.

Decker, J. (1994). The state of rap: Time and place in hip hop nationalism. In A. Ross, & T. Rose (Eds.), *Microphone fiends: Youth music and youth culture* (pp. 99–121). New York: Routledge.

de Certeau, M. (1984). *The practice of everyday life* (S. Rendall, Trans.). Berkeley: University of California Press.

D-Dub. (1992, June). So ya still wanna be a record producer? *Rap Pages*, 10–11.

Denzin, N. (1992). *Symbolic interactionism and cultural studies*. Cambridge: Blackwell.

Denzin, N. (1997). *Interpretive ethnography*. Thousand Oaks, CA: Sage.

Denzin, N. (1998). Reading the cinema of racial violence. *Perspectives on Social Problems, 10,* 31–60.

Denzin, N. (2003). *Performance ethnography: Critical pedagogy and the politics of culture.* Thousand Oakes, CA: Sage.

Denzin, N., & Lincoln, Y. (Eds.). (1994). *Handbook of qualitative research.* Thousand Oaks, CA: Sage.

Dimitriadis, G. (1996). Hip hop: From live performance to mediated narrative. *Popular Music, 15*(2), 179–194.

Dimitriadis, G. (1999a). Hip hop to rap: Some implications of an historically situated approach to performance. *Text and Performance Quarterly, 19*(4), 355–369.

Dimitriadis, G. (1999b). Popular culture and the boundaries of pedagogy: Constructing selves and social relations at a local community center. Ph.D. dissertation, University of Illinois at Urbana-Champaign.

Dimitriadis, G. (2003). *Friendship, cliques, and gangs: Young black men coming of age in urban America.* New York: Teachers College Press.

Dimitriadis, G., & Kamberelis, G. (with W. Deal, & T. Beal). (2005). *Theory for education.* New York: Routledge.

Dimitriadis, G., & McCarthy, C. (2001). *Reading and teaching the postcolonial: From Baldwin to Basquiat and beyond.* New York: Teachers College Press.

Dolby, N. (2001). *Constructing race: Youth, identity, and popular culture in South Africa.* New York: SUNY Press.

Duneier, M. (1992). *Slim's table: Race, respectability, and masculinity.* Chicago: University of Chicago Press.

Dyson, M. (1993). *Reflecting black: African-American cultural criticism.* Minneapolis, MN: University of Minnesota Press.

Dyson, M. (1996). *Race rules: Navigating the color line.* Reading, MA: Addison-Wesley.

Dyson, M. (2002). *Holler if you hear me: Searching for Tupac Shakur.* New York: Basic Books.

Dyson, M. (2007). *Know what I mean?* New York: Basic Books.

Ellison, R. (1947). *Invisible man.* New York: Vintage.

Ellison, R. (2001). *Living with music.* New York: Vintage.

Eure, J., & Spady, J. (1991). *Nation conscious rap.* New York: PC International Press.

Ex, K. (2008, June). It's over: Pt. 2. *XXL Magazine,* 84–88.

Fairclough, N. (1992). *Discourse and social change.* Cambridge: Polity Press.

Fairclough, N. (1995). *Critical discourse analysis: The critical study of language.* London: Longman.

Farley, C. (1999, February 8). Hip hop nation. *Time,* 54–64.

Fennessey, S. (2007, November). The 77 best Lil' Wayne songs of 2007. *XXL Magazine,* 122–123.

Ferguson, M., & Golding, P. (Eds.). (1997). *Cultural studies in question.* Thousand Oaks, CA: Sage.

Fine, M. (1994). Working the hyphens: Reinventing self and other in qualitative research. In N. Denzin, & Y. Lincoln (Eds.), *Handbook of qualitative research* (pp. 70–82). Thousand Oaks, CA: Sage.

Fine, M., & Weis, L. (1998). *The unknown city: Lives of poor and working-class young adults.* Boston: Beacon Press.

Finnegan, W. (1998). *Cold new world: Growing up in a harder country.* New York: Random House.

Fiske, J. (1987). *Television culture.* London: Methuen.

Fiske, J., & Dawson, R. (1996). Audiencing: Watching homeless men watch *Die hard.* In J. Hay, L. Grossberg, & E. Wartella (Eds.), *The audience and its landscape* (pp. 297–316). New York: Westview Press.

Forman, M., & Neal, M. (Eds.). (2004). *That's the joint: The hip hop studies reader.* New York: Routledge.

Frith, S., & McRobbie, A. (1990). Rock and sexuality. In S. Frith, & A. Goodwin (Eds.), *On record: Rock, pop, and the written word* (pp. 371–389). New York: Pantheon Books.

George, N. (1993, November). Hip-hop's founding fathers speak the truth. *The Source,* 44–50.

George, N. (1994). *Blackface: Reflections on African Americans and the movies.* New York: HarperCollins.

Gilroy, P. (1997). Exer(or)cising power: Black bodies in the black public sphere. In H. Thomas (Ed.), *Dance in the city* (pp. 21–34). New York: St. Martin's Press.

Giroux, H. (1996). *Fugitive cultures: Race, violence, and youth.* New York: Routledge.

Giroux, H. (2000). *Impure acts: The practical politics of cultural studies.* New York: Routledge.

Giroux, H. (2006). *Beyond the spectacle of terrorism: Global uncertainty and the challenge of the new media.* Boulder, CO: Paradigm.

Gray, J., Sandovass, C., & Harrington, L. (2007). *Fandom: Identities and communities in a mediated world.* New York: NYU Press.

Griffin, F. (1995). *"Who set you flowin'?": The African-American migration narrative.* New York: Oxford University Press.

Grossberg, L., Nelson, C., & Treichler, P. (Eds.). (1992). *Cultural studies.* New York: Routledge.

Guevara, N. (1996). Women writin' rappin' breakin.' In W. Perkins (Ed.), *Droppin' science: Critical essays on rap music and hip hop culture* (pp. 49–62). Philadelphia: Temple.

Gupta, A., & Ferguson, J. (Eds.). (1997). *Culture, power, place: Explorations in critical anthropology.* Durham, NC: Duke University Press.

Hager, S. (1984). *Hip hop: The illustrated history of break dancing, rap music, and graffiti.* New York: St. Martin's Press.

Hamera, J. (Ed.). (2006). *Opening acts.* Thousand Oaks, CA: Sage.

hampton, d. (1997). Holler if ya see me. In *Vibe* (Ed.), *Tupac Shakur* (p. 134). New York: Crown.

Harvey, D. (1990). *The condition of postmodernity.* Cambridge: Blackwell.

Heath, S. B., & McLaughlin, M. (Eds.). (1993). *Identity and inner-city youth: Beyond ethnicity and gender.* New York: Teachers College Press.

Hebdige, D. (1987). *Cut 'n' mix.* Boston: Methuen.

Hersch, P. (1998). *A tribe apart: A journey into the heart of American adolescence.* New York: Fawcett.

Hill, M. (in press). *Beats, rhymes, and classroom life.* New York: Teachers College Press.

hooks, b. (1992). *Black looks: Race and representation.* Boston: South End Press.

Jackson, B. (1974). *"Get your ass in the water and swim like me": Narrative poetry from the black oral tradition.* Cambridge, MA: Harvard University Press.

Jameson, F., & Miyoshi, M. (Eds.). (1999). *The cultures of globalization*. Durham, NC: Duke University Press.

Jankowski, M. S. (1991). *Islands in the street: Gangs and American urban society*. Berkeley: University of California Press.

Jencks, C. (1996). *What is postmodernism?* London: Academic Editions.

Jenkins, H. (1992). *Textual poaching: Television fans and participatory culture*. New York: Routledge.

Jenkins, H. (Ed.). (1998). *The children's culture reader*. New York: NYU Press.

Jenkins, H. (2006). *Convergence culture: Where old and new media collide*. New York: NYU Press.

Johnson, S. (2006). *Everything bad is good for you: How today's popular culture is actually making us smarter*. New York: Riverhead.

Jones, G., Jones, B., & Hargrove, T. (2003). *The unintended consequences of high stakes testing*. Walnut Creek, CA: Rowman & Littlefield.

Jones, L. (1963). *Blues people: The Negro experiences in white America and the music that developed from it*. New York: Morrow Quill Paperbacks.

Joseph, M. (1999). Introduction: New hybrid identities and performance. In M. Joseph, & J. Fink (Eds.), *Performing hybridity* (pp. 1–24). Minneapolis: University of Minnesota Press.

Julien, I. (1992). "Black is, black ain't": Notes on de-essentializing black identities. In G. Dent. (Ed.), *Black popular culture* (pp. 255–263). Seattle, WA: Bay Press.

Kamberelis, G. (1995). Genre as institutionally formed social practice. *Journal of Contemporary Legal Issues, 6*, 115–171.

Kamberelis, G., & Dimitriadis, G. (1999). Talkin' Tupac: Speech genres and the mediation of cultural knowledge. In C. McCarthy, G. Hudak, S. Miklaucic, & P. Saukko (Eds.), *Sound identities: Popular music and the cultural politics of education* (pp. 119–150). New York: Peter Lang.

Karenga, R. (1972). Black art: Mute matter given form and function. In A. Chapman (Ed.), *New black voices: An anthology of contemporary Afro-American literature* (pp. 477–482). New York: Mentor.

Keil, C. (1966). *Urban blues*. Chicago: University of Chicago Press.

Keil, C. (1994). Motion and feeling through music. In C. Keil, & S. Feld (Eds.), *Music grooves* (pp. 53–76). Chicago: University of Chicago Press.

Keiser, D. (2000). Battlin' nihilism at an urban high school: Pedagogy, perseverance, and hope. In K. McClafferty, C. Torres, & T. Mitchell (Eds.), *Challenges of urban education: Sociological perspectives for the next century* (pp. 271–295). New York: SUNY Press.

Kelley, R. (1996). Kickin' reality, kickin' ballistics: Gangsta rap and postindustrial Los Angeles. In W. Perkins (Ed.), *Droppin' science: Critical essays on rap music and hip hop culture* (pp. 117–158). Philadelphia: Temple.

Kellner, D. (1995). *Media culture: Cultural studies, identity and politics between the modern and postmodern*. New York: Routledge.

Kellner, D. (1997). Beavis and Butt-Head: No future for postmodern youth. In S. Steinberg, & J. Kincheloe (Eds.), *Kinderculture: The corporate construction of childhood* (pp. 85–101). New York: Westview Press.

Kitwana, B. (2002). *The hip hop generation: Young black and the crisis in African-American culture*. New York: Basic Books.

Kubey, R., & Baker, F. (1999, October 27). Had media literacy found a curricular foothold? *Education Week*. Retrieved October 1, 2008, from http://www.edweek.org/ew/articles/1999/10/27/09ubey2.h19.html

Labov, W. (1972). *Language in the inner city: Studies in the black English vernacular*. Philadelphia: University of Pennsylvania Press.

Lash, S., & Urry, J. (1994). *Economies of signs and space*. Thousand Oaks, CA: Sage.

Lashua, B. (2005). Making music, re-making leisure in The Beat of Boyle Street. Ph.D. dissertation, University of Alberta.

Lee, J. (1999). Disciplining theater and drama in the English department: Some reflections on "performance" and institutional history. *Text and Performance Quarterly, 19*(2), 145–158.

Lee, S. (1992). *By any means necessary: The trials and tribulations of making* Malcolm X. New York: Hyperion.

Leland, J., & Samuels, A. (1997, March 17). The new generation gap. *Newsweek*, 53 ff.

Liebes, T., & Katz, E. (1990). *The export of meaning: Cross-cultural readings of* Dallas. Oxford: Oxford University Press.

Light, A. (1990, November 15). Kings of rap. *Rolling Stone*, 110 ff.

Lipsitz, G. (1996). *Dangerous crossroads: Popular music, postmodernism, and the poetics of place*. New York: Verso.

Madison, D. (2006). Performing theory/embodied writing. In J. Hamera (Ed.), *Opening acts* (pp. 243–265). Thousand Oaks, CA: Sage.

Mahiri, J. (1998). *Shooting for excellence: African American and youth culture in new century schools*. Urbana, IL: National Council of Teachers of Education.

Males, M. (1996). *The scapegoat generation: America's war on adolescence*. Monroe, ME: Common Courage Press.

Manning, P., & Cullum-Swan, B. (1994). Narrative, content, and semiotic analysis. In N. Denzin, & Y. Lincoln (Eds.), *Handbook of qualitative research* (pp. 463–477). Thousand Oaks, CA: Sage.

Manuel, P. (1988). *Popular musics of the non-Western world: An introductory survey*. New York: Oxford University Press.

Marcus, G. (1975). *Mystery train: Images of America in rock 'n' roll music*. New York: Plume Books.

McCarthy, C. (1998). *The uses of culture: Education and the limits of ethnic affiliation*. New York: Routledge.

McCarthy, C., & Dimitriadis, G. (1998). All consuming identities: Race and the pedagogy of resentment in the age of difference. *Australian Universities Review, 41*(2), 9–12.

McCarthy, C., Hudak, G., Miklaucic, S., & Saukko, P. (Eds.). (1999). *Sound identities: Popular music and the cultural politics of education*. New York: Peter Lang.

Mercer, K. (1994). *Welcome to the jungle: New positions in black cultural studies*. New York: Routledge.

Mitchell, T. (2001). *Kia kahoa* (Be strong!): Maori and Pacific Islander hip hop in Aotearoa-New Zealand. In T. Mitchell. (Ed.), *Global hip hop: Rap and hip hop outside the USA* (pp. 280–305). Durham, NC: Duke University Press.

Miyakawa, F. (2005). *Five percenter rap: God hop's music, message, and black Muslim mission*. Bloomington: Indiana University Press.

Morley, D. (1980). *The "Nationwide" audience: Structure and decoding*. London: British Film Institute.

Morley, D. (1997). Theoretical orthodoxies: Textualism, constructivism and the "new orthodoxy" in cultural studies. In M. Ferguson, & P. Golding (Eds.), *Cultural studies in question* (pp. 121–137). Thousand Oaks, CA: Sage.

Morley, D., & Chen, K. (Eds.). (1996). *Stuart Hall: Critical dialogues in cultural studies*. New York: Routledge.

Morley, D., & Robins, K. (1995). *Spaces of identity: Global media, electronic landscapes and cultural boundaries*. New York: Routledge.

Morrell, E. (2004). *Becoming critical researchers: Literacy and empowerment for urban youth.* New York: Peter Lang.

Morrell, E. (2008). *Critical literacy and urban youth: Pedagogies of access, dissent, and liberation.* New York: Routledge.

Morrell, E., & Duncan-Andrade, J. (2002). Promoting academic literacy with urban youth through engaging hip hop culture. *English Journal, 91* (6), 88–92.

Motley, C., & Henderson, G. (2008). The global hip hop Diaspora: Understanding the culture. *Journal of Business Research, 61,* 243–253

Neal, M. (2002). *Soul babies: Black popular culture and the post-soul aesthetic.* New York: Routledge.

Nolan, K. (2007). Disciplining urban youth: An ethnographic study of a Bronx high school. Ph.D. dissertation, CUNY Graduate Center.

Nolan, K., & Anyon, J. (2004). Learning to do time. In N. Dolby, G. Dimitriadis, & P. Willis (Eds.), *Learning to labor in new times* (pp. 133–149). New York: Routledge.

Perinbanayagam, R. (1991). *Discursive acts.* New York: Aldine De Gruyter.

Perkins, U. (1987). *Explosion of Chicago's black street gangs: 1900 to present.* Chicago: Third World Press.

Perlsen, L. (2004). *Not much just chillin': The hidden lives of middle schoolers.* New York: Ballantine.

Pollock, D. (Ed.). (1998). *Exceptional spaces: Essays in performance and history.* Chapel Hill: University of North Carolina Press.

Potter, R. (1995). *Spectacular vernaculars: Hip-hop and the politics of postmodernism.* Albany: SUNY Press.

Press, A. (1991). *Women watching television: Gender, class, and generation in the American television experience.* Philadelphia: University of Pennsylvania Press.

Radway, J. (1984). *Reading the romance: Women, patriarchy, and popular culture.* Chapel Hill: University of North Carolina Press.

Richards, C. (1999). *Teen spirits: Music and identity in media education.* London: UCL Press.

Rodman, G. (1996). *Elvis after Elvis: The posthumous career of a living legend.* New York: Routledge.

Rose, T. (1994). *Black noise: Rap music and black culture in contemporary America.* Hanover, MA: Wesleyan University Press.

Sanneh, K. (2005, April 17). The strangest sound in hip hop goes national. *New York Times.* Retrieved on June 4, 2008, from http://www.nytimes.com/2005/04/17/arts/music/17sann.html.

Sarig, R. (2007). *Third coast: Outkast, Timbaland, and how hip hop became a Southern thing.* New York: Da Capo Press.

Scarry, E. (1985). *The body in pain: The making and unmaking of the world.* New York: Oxford University Press.

Sexton, A. (Ed.). (1995). *Rap on rap: Straight-up talk on hip-hop culture.* New York: Dell.

Shattuc, J. (1997). *The talking cure: TV talk shows and women.* New York: Routledge.

Skelton, T., & Valentine, G. (Eds.). (1998). *Cool places: Geographies of youth cultures.* New York: Routledge.

Small, C. (1998). *Musicking: The meanings of performing and listening.* Hanover, MA: Wesleyan University Press.

Stack, C. (1974). *All our kin: Strategies for survival in a black community.* New York: Harper Torchbook.

Steinberg, S., & Kincheloe, J. (Eds.). (1997). *Kinderculture: The corporate construction of childhood.* New York: Westview Press.

Steinberg, S., & Kincheloe, J. (Eds.). (2004). *Kinderculture: The corporate construction of childhood* (2nd edition). New York: Westview Press.

Sterne, J. (2004). The burden of culture. In M. Berube (Ed.), *The aesthetics of culture* (pp. 80–102). Malden, MA: Blackwell.

Stovall, D. (2006). We can relation: Hip hop, critical pedagogy, and the secondary classroom. *Urban Education, 41*(6), 585–602.

Sullivan, R. (2003). *LAbyrinth: A detective investigates the murders of Tupac Shakur and Notorious B.I.G., the implication of Death Row Records' Suge Knight, and the origins of the Los Angeles Police scandal.* New York: Atlantic Monthly Press.

Taulbert, C. (1989). *Once upon a time when we were colored.* Tulsa, OK: Counsel Oaks Books.

Tedlock, D., & Mannheim, B. (Eds.) (1995). *The dialogic emergence of culture.* Urbana: University of Illinois Press.

Tempelton, I. (2006). What's so German about it? Race and cultural identity in Berlin's hip hop community. Ph.D. dissertation, University of Stirling.

Thompson, J. (1990). *Ideology and modern culture.* Stanford: Stanford University Press.

Twenge, J. (2007). *Generation me: Why young Americans are more confident, assertive, entitled—and more miserable than ever before.* New York: Free Press.

Ugwu, C. (1995). *Let's get it on: The politics of black performance.* London: ICA.

Van Peebles, Mario (1995). The Film. In M. Peebles, U. Taylor, & J. Lewis, *Panther: A pictorial history of the Black Panthers and the story behind the film* (pp. 131–176). New York: Newmarket Press.

Van Peebles, Melvin (1995). *Panther: A novel.* New York: Thunder's Mouth Press.

Waterman, C. (1990). *JuJu: A social history and ethnography of an African popular music.* Chicago: University of Chicago Press.

A week in the life of a high school. (1999). *Time, 154*(17), 66–115.

Weis, L., & Dimitriadis, G. (2008). Dueling banjos: Shifting economic and cultural contexts in the lives of youth. *Teachers College Record, 110*(10), 2290–2316.

West, C. (1993). *Race matters.* Boston: Beacon Press.

Williams, R. (1966). *The long revolution.* New York: Columbia University Press.

Willis, P. (1990). *Common culture: Symbolic work at play in everyday cultures of the young.* Milton Keyes, UK: Open University Press.

Willis, P. (2003). Foot soldiers of modernity. *Harvard Educational Review, 73*(5), 390–415.

Wilson, E. (2007, October). Jay-Z: I'll still kill. *XXL Magazine.* Retrieved on October 1, 2008, from http://www.xxlmag.com/online/?p=15128

Zakaria, F. (2008). *The post-American world.* New York: W. W. Norton.

# INDEX

# Intersections in Communications and Culture

Global Approaches and Transdisciplinary Perspectives

**General Editors: Cameron McCarthy & Angharad N. Valdivia**

An Institute of Communications Research, University of Illinois Commemorative Series

This series aims to publish a range of new critical scholarship that seeks to engage and transcend the disciplinary isolationism and genre confinement that now characterizes so much of contemporary research in communication studies and related fields. The editors are particularly interested in manuscripts that address the broad intersections, movement, and hybrid trajectories that currently define the encounters between human groups in modern institutions and societies and the way these dynamic intersections are coded and represented in contemporary popular cultural forms and in the organization of knowledge. Works that emphasize methodological nuance, texture and dialogue across traditions and disciplines (communications, feminist studies, area and ethnic studies, arts, humanities, sciences, education, philosophy, etc.) and that engage the dynamics of variation, diversity and discontinuity in the local and international settings are strongly encouraged.

## LIST OF TOPICS

- Multidisciplinary Media Studies
- Cultural Studies
- Gender, Race, & Class
- Postcolonialism
- Globalization
- Diaspora Studies
- Border Studies
- Popular Culture
- Art & Representation
- Body Politics
- Governing Practices

- Histories of the Present
- Health (Policy) Studies
- Space and Identity
- (Im)migration
- Global Ethnographies
- Public Intellectuals
- World Music
- Virtual Identity Studies
- Queer Theory
- Critical Multiculturalism

Manuscripts should be sent to:

**Cameron McCarthy OR Angharad N. Valdivia**
Institute of Communications Research
University of Illinois at Urbana-Champaign
222B Armory Bldg., 555 E. Armory Avenue
Champaign, IL 61820

To order other books in this series, please contact our Customer Service Department:
(800) 770-LANG (within the U.S.)
(212) 647-7706 (outside the U.S.)
(212) 647-7707 FAX

Or browse online by series:
www.peterlang.com